Aired on Aug. 27th, 1978 on Nippon TV

"ONE MILLION-YEAR TRIP: BANDER BOOK"

BACKGROUND

An anime film that debuted during Nippon TV's first charity special "24-Hour Television: Love Saves the Earth" during the summer of 1978, Bander Book was the first such film to appear during these blocks and the first two-hour televised anime film of its kind in Japan. Osamu Tezuka wrote the original storyboard and strove for quality comparable to silver screen productions. While most of the original characters were created by Hisashi Sakaguchi, Tezuka had several of his own characters - such as Black Jack and Sharaku - make guest appearances.

SYNOPSIS

Earth is ruled by "Mother", a giant computer. Seeking to escape the planet, Dr. Kudo and his wife board a spaceship, but they're killed when it's blown up. However, their infant son survives, shot away in an escape capsule. He's found by the queen of Planet Zobi, who names him "Bander". Many years later, Bander discovers that he's actually an Earthling and comes to know of his past. Before long, Black Jack - a space pirate from Earth - attacks Zobi, which ends up setting Bander on a journey across the stars.

Concept, Storyboard, Rendition, and Character Design ◎ Osamu Tezuka

Planning ◎ Tadahiko Tsuzuki (Nippon TV)

Producers ◎ Akira Yoshikawa (Nippon TV), Hidehiko Takei (Nippon TV), Keiji Kaneda (Tezuka Productions)

Music Producer ◎ Yuji Ono

Chief Director, Character Design, Lead Artist, Mecha Designer ◎ Hisashi Sakaguchi

Motion Picture Director ◎ Hiroshi Nishimura

Art Director ◎ Mitsunari Makino

Finishing ◎ Tsutomu Tsukada

Art Settings ◎ Katsumi Hando,Tsuyoshi Matsumoto, Mistunari Makino

Backgrounds ◎ Toshimasa Toujou, Sangosho

Original Art: Kozo Masanobu, Akihiro Kanayama, Shigetaka Kiyoyama, Dai Yagi, Shinji Nagashima, Moribi Murano, Hisashi Sakaguchi, Osamu Tezuka

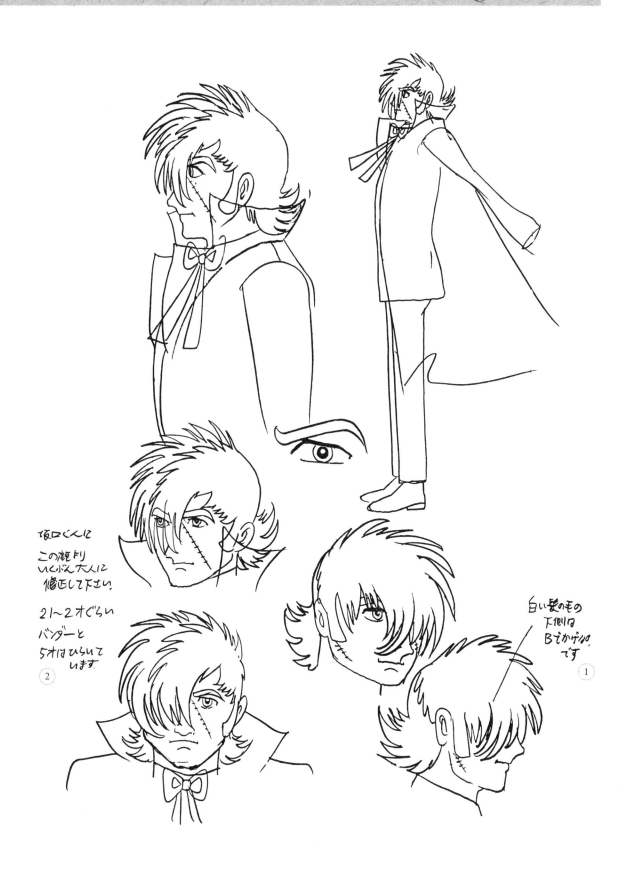

頂口くんに
この流リ
いくぶん大人に
修正して下さい。

21〜2才ぐらい
バンダーと
5才はひらいて
います。
②

白い髪のもの
下側は
Bでかげ心
です
①

1. The inner tips of the white parts of his hair should get darker at B.
2. Sakaguchi-kun,
 Make his face a bit older than it looks here.
 He should be around 21 or 22 1/2 years older than Bander.

Black Jack

2

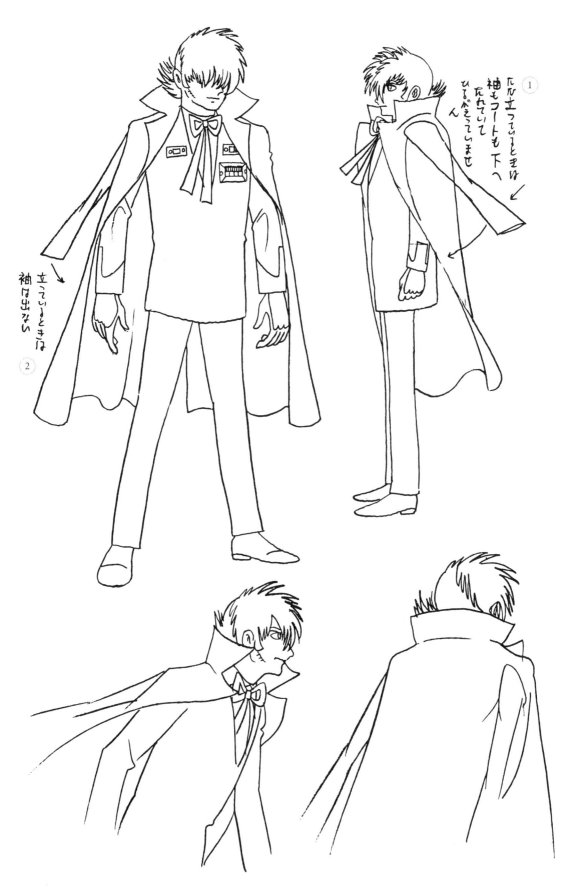

たゞ立っているときは
袖もコートも下へ
たれていて
ひろがっていません

①

立っていときは
袖は出ない

②

1. The sleeves and coat shouldn't flutter back when he's standing like this.
2. The sleeves shouldn't stick out when he's standing.

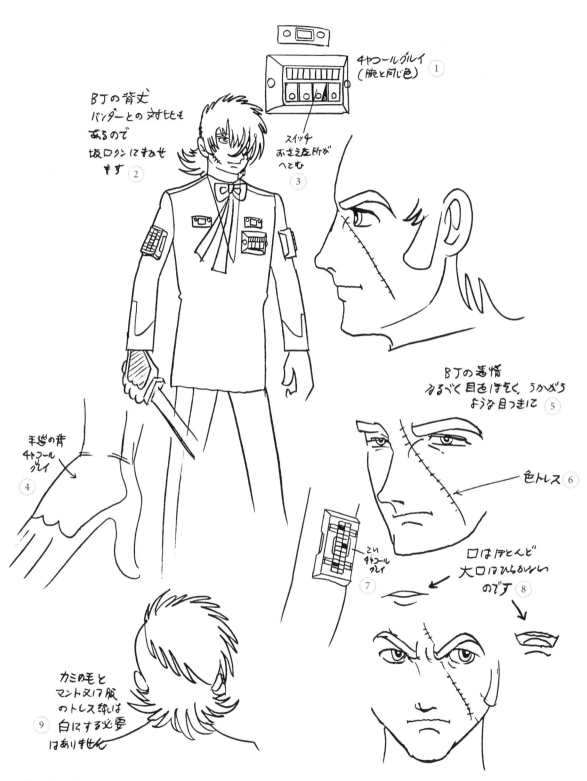

① 4ャツールグレイ（腕と同じ色）

② BJの背丈 バンダーとの寸比もあるので 坂口クンにまかせます

③ スイッチ おさえた所がへこむ

④ 手袋の背 4ャツールグレイ

⑤ BJの表情 なるべく目をほそく うかがうような目つきに

⑥ 色トレス

⑦ こい 4ャツールグレイ

⑧ 口はほとんど 大口はひらかないのでJ

⑨ カミの毛と マント又は服 のトレス線は 白にする必要 はありません

1. Charcoal gray (same as arms).
2. BJ's height should contrast with Bander's. I'll leave it up to Sakaguchi-kun.
3. Switch dents inward when pressed.
4. Back of gloves is charcoal gray.
5. BJ's expressions: Eyes should be thin, like he's suspicious of something.
6. Color hold.
7. Dark charcoal gray.
8. Mouth is rarely wide open.
9. No need to use white when tracing hair, cloak, and clothing.

Black Jack

Dr. Sharaku

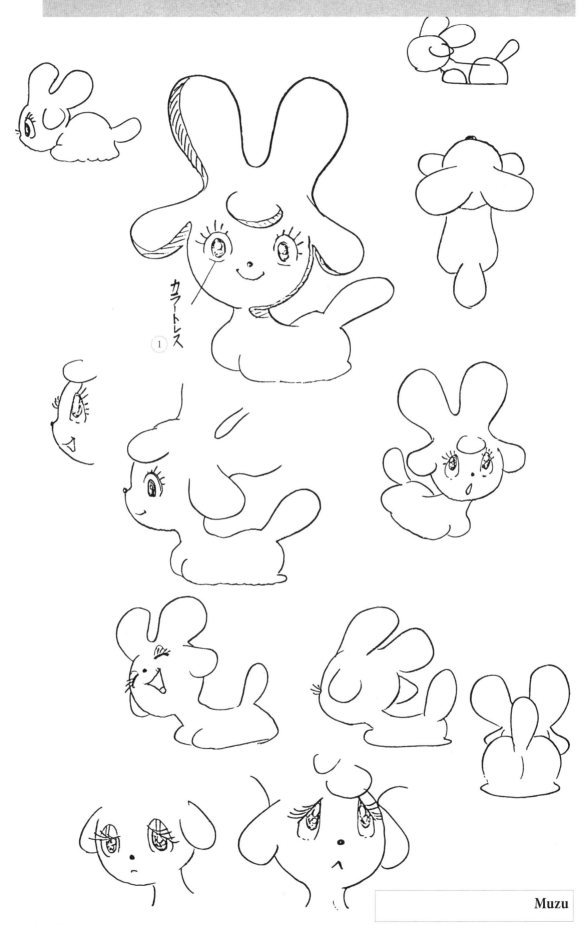

カラートレス
①

Muzu

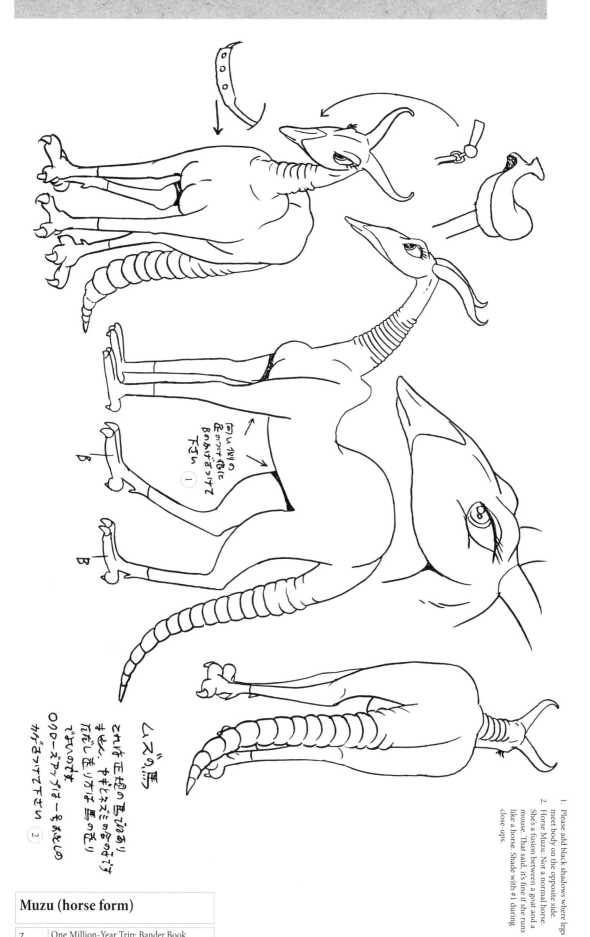

これは正規の馬ではあり
ません。ヤギとネズミの合体です
ただし走り方は馬の走り
方でいいのです
ロクローズアップの時は私の
カゲをつけて下さい ②

ムズの馬

B

B

①
ヨし反けりの
足のつけ根にに
見のカゲをつけて
下さい

Muzu (horse form)

1. Please add black shadows where legs
 meet body on the opposite side.
2. Horse Muzu: Not a normal horse.
 She's a fusion between a goat and a
 mouse. That said, it's fine if she runs
 like a horse. Shade with #1 during
 close-ups.

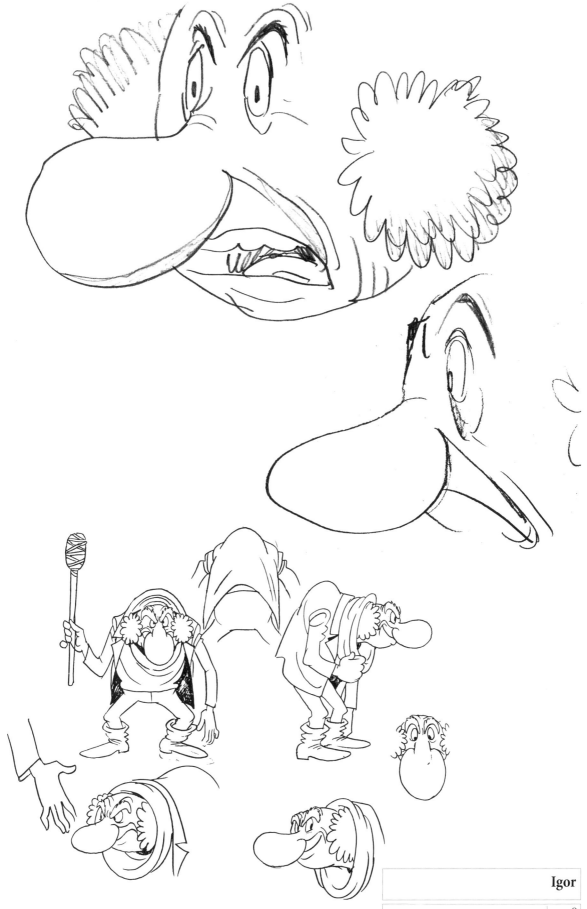

Igor

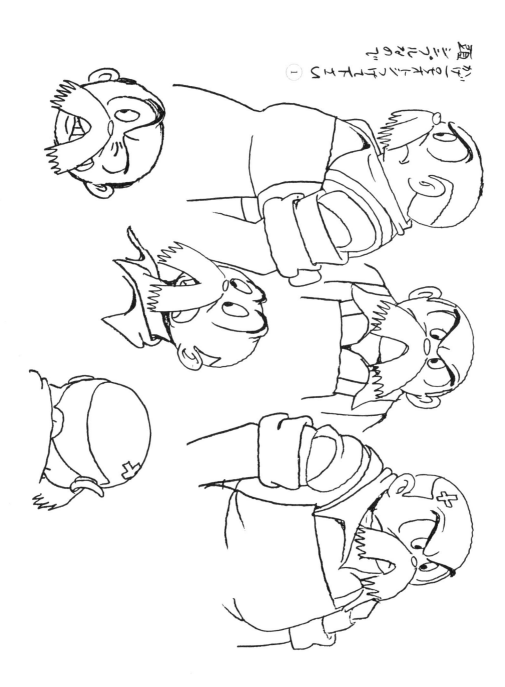

1. Use #1 for shading. Head is simple.

Ed

9 One Million-Year Trip: Bander Book

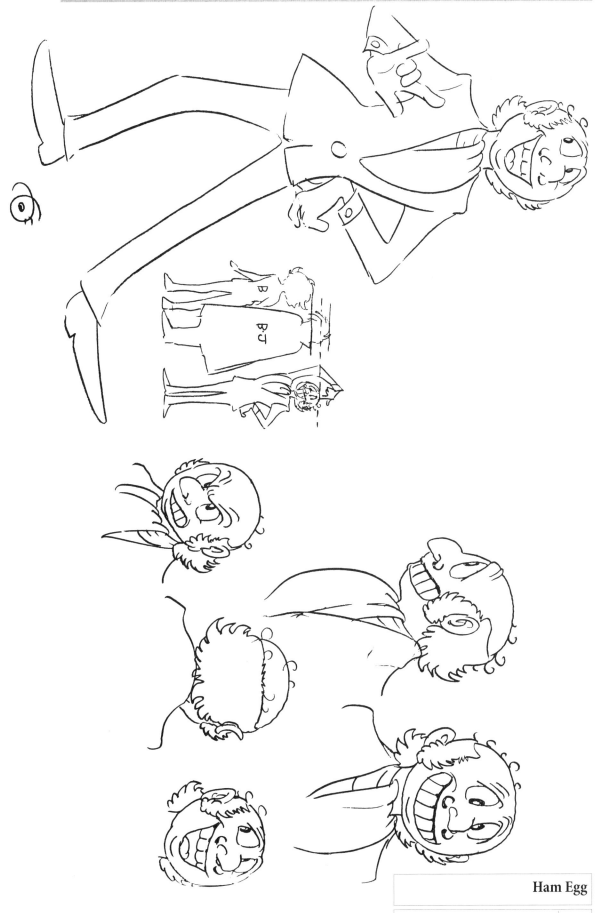

Ham Egg

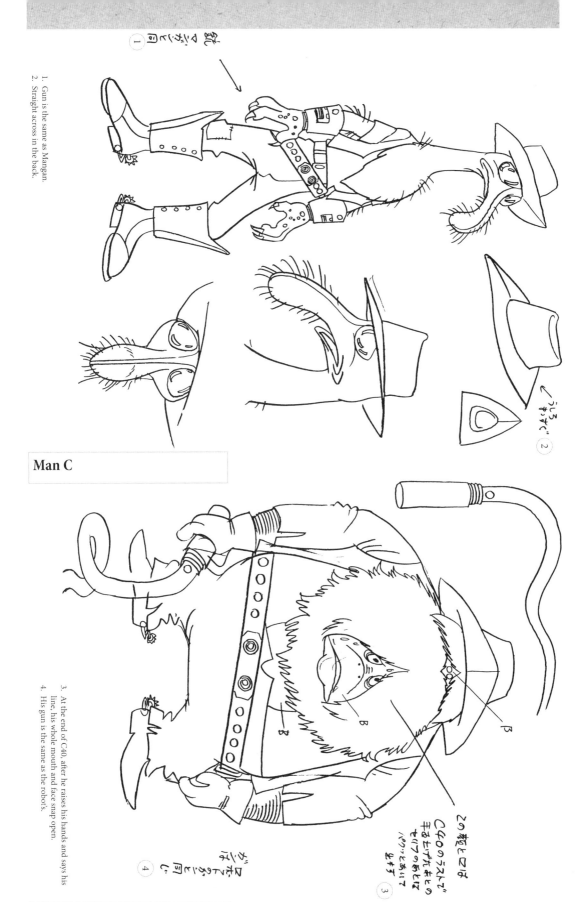

Man C

3. At the end of C-40, after he raises his hands and says his line, his whole mouth and face snap open.
4. His gun is the same as the robot's.

Man A

Maracas Alien

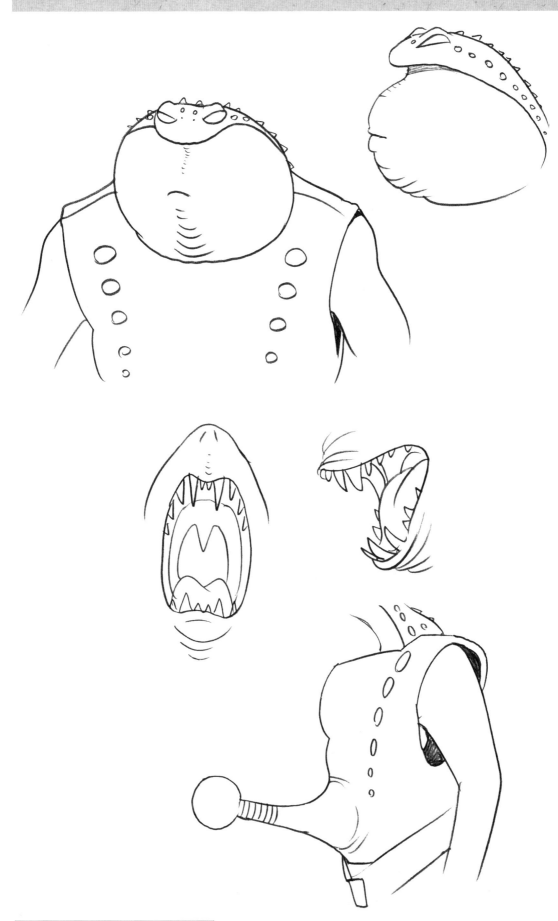

Dancing Woman

女性
顔てもとうん
つくって下さい
①

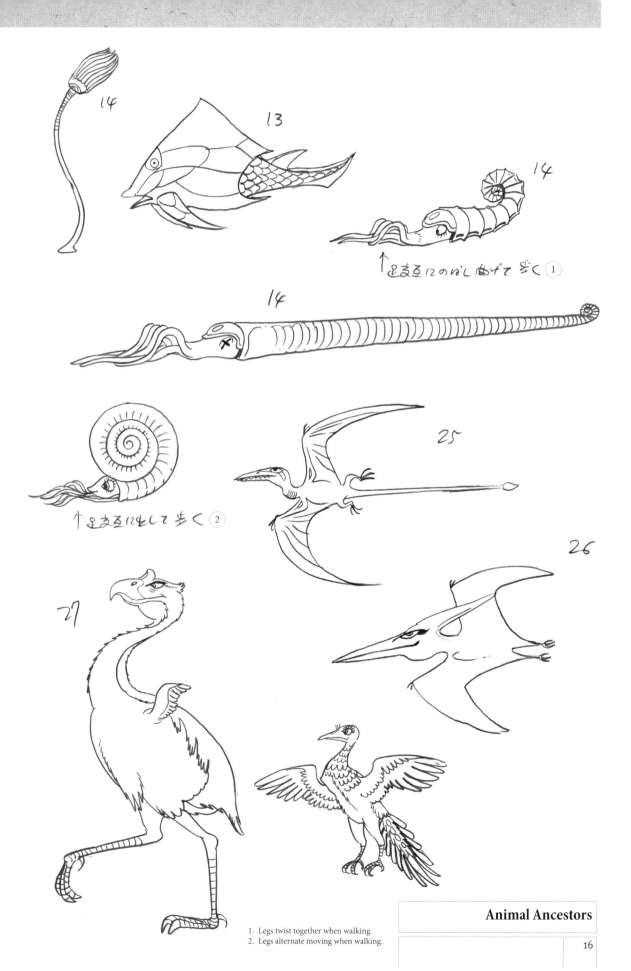

14

13

14

↑足を右に曲して歩く ①

14

↑足を右にして歩く ②

25

26

27

1. Legs twist together when walking.
2. Legs alternate moving when walking.

Animal Ancestors

1. They're all very dark. Barely more than silhouettes. Just their eyes sparkle.
2. Birds at the top of the tree.

Birds at the top of the tree

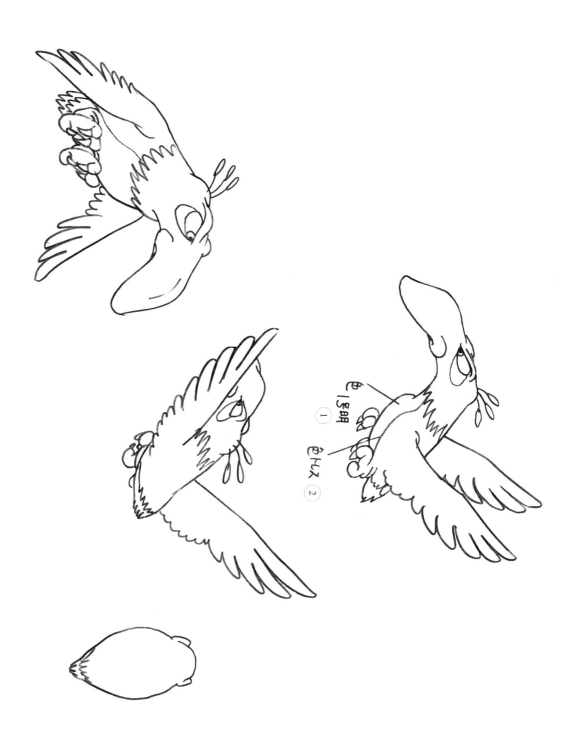

1. Color #1 bright.
2. Color tracing

Nose Bird

1. Birds that walk on the ground.
2. This type is the most abundant.
3. Make them all move a bit differently. But they all totter when they walk.

地面を歩いている鳥 ①

このタイプが一番多い ②

鳥の歩き方はみんなちょっとずつちがいますがみんなヨタヨタと歩きます ③

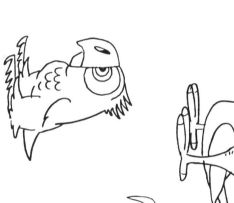

Birds that walk on the ground

海底超特急

Aired on Aug. 26th, 1979 on Nippon TV

"UNDERSEA SUPER TRAIN: MARINE EXPRESS"

BACKGROUND

The second two-hour TV anime special, which aired during the second "24-Hour Television: Love Saves the Earth". Osamu Tezuka once again created an original storyboard, following up on his work from the previous year. The fact that all of Tezuka's characters would appear became a sort of promotional line, and nearly every character in the film is one of his originals. While characters in animation are ordinarily drawn with pencil, ink pens were used for this film.

SYNOPSIS

In Los Angeles in the year 2002, private detective Shunsaku Ban ("played" by Tezuka standard Higeoyaji) gets tangled up in the murder case of Board Chairman Shylock, who worked for a corporation that built an ocean-crossing railroad at the bottom of the Pacific Ocean. The opening ceremony for the undersea super train, the "Marine Express", is held in San Francisco, where Higeoyaji discovers the murderer and ends up pursuing him onto the Japan-bound train. However, a sequence of events leads to the train being transported 10,000 years into the past, to the Mu Empire.

Concept, Storyboard, Rendition, Character Design, Animation ◎ Osamu Tezuka

Planning ◎ Akira Yoshikawa, Tadahiko Tsuzuki (Nippon TV)

Executive Producer ◎ Michitoshi Shimakata

Producers ◎ Hidehiko Takei, Satoru Yamamoto (Tezuka Productions)

Music Producer ◎ Yuji Ono

Chief Director ◎ Tetsu Dezaki

Settings Design ◎ Hisashi Sakaguchi

Art Director ◎ Mitsunari Makino

General Animation Director ◎ Shigetaka Kiyoyama

Animation Director ◎ Hiroshi Nishimura

Mechanical Supervisor ◎ Keizo Shimizu

Color Coordination ◎ Hiroshi Shinohara

Animation Directors ◎ Setsuko Shibuichi, Yukinari Senda, Mariko Suzuki

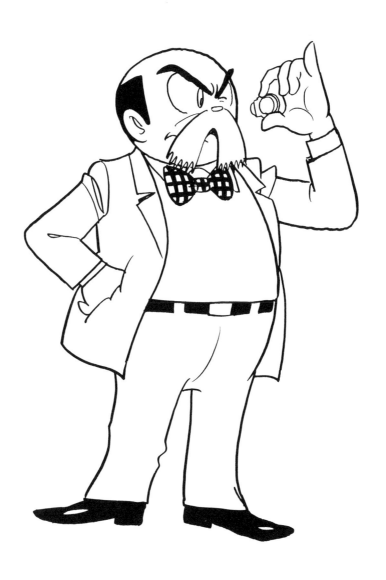

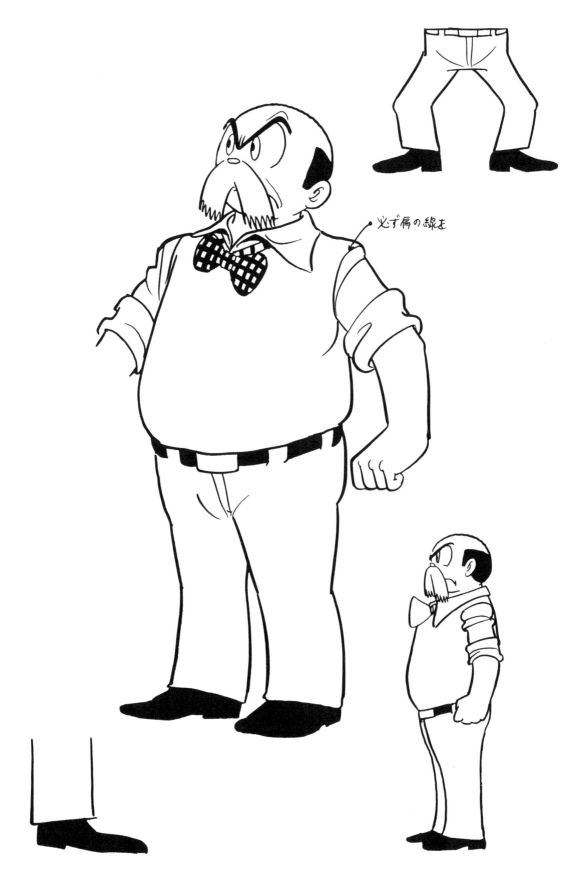

必ず肩の線を

1. Be sure to put a border at his shoulder.

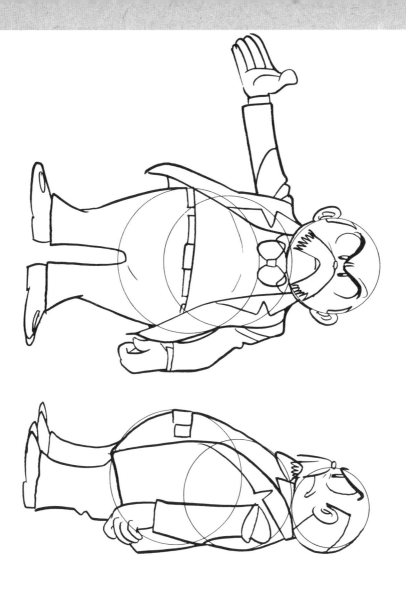

Higeoyaji

1. Close-up of ear.
2. Shadow
3. Shadow

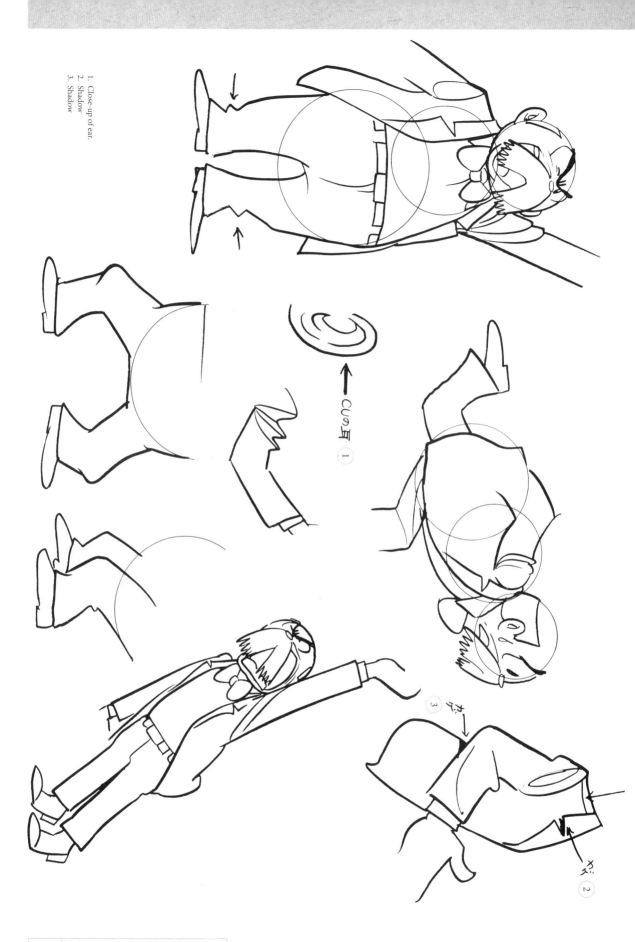

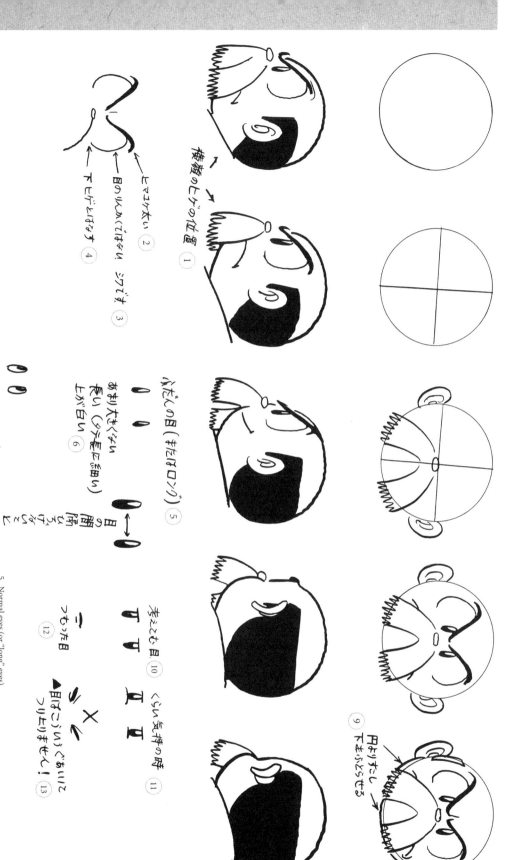

1. Side profile moustache placement.
2. Thick eyebrows.
3. Not the eye outline. This is a wrinkle.
4. Doesn't quite reach the mustache at the bottom.

5. Normal eyes (or "long" eyes).
6. Not too big.
 Long (thin and vertical).
7. Top part is white.
 Please give him "double" eyes when he's looking around and during close-ups.
8. Don't separate the eyes too much.

9. His head's not a perfect circle.
 The bottom sags out a bit.
10. Deep-in-thought eyes.
11. Bad-mood eyes.
12. Closed eye.
13. Eyes should never look like this.

横顔のヒゲの位置 ①

ヒマユゲ太い ②

目のりんかくではない シワです。③

下ヒゲとけない ④

ふだんの目（キたほロッ）⑤

あまり大きくない 長い（ウデモに細い）上が白い ⑥

目の間隔 ひとつ分あけ ⑧

どちらを見ているとき クローズアップのときは 一重目にしてください ⑦

考ごと目 ⑩

くらい気持の時 ⑪

つむった目 ⑫

目はこういうぐあいに つりあがりません！⑬

円ありすこし 下ふくらせる ⑨

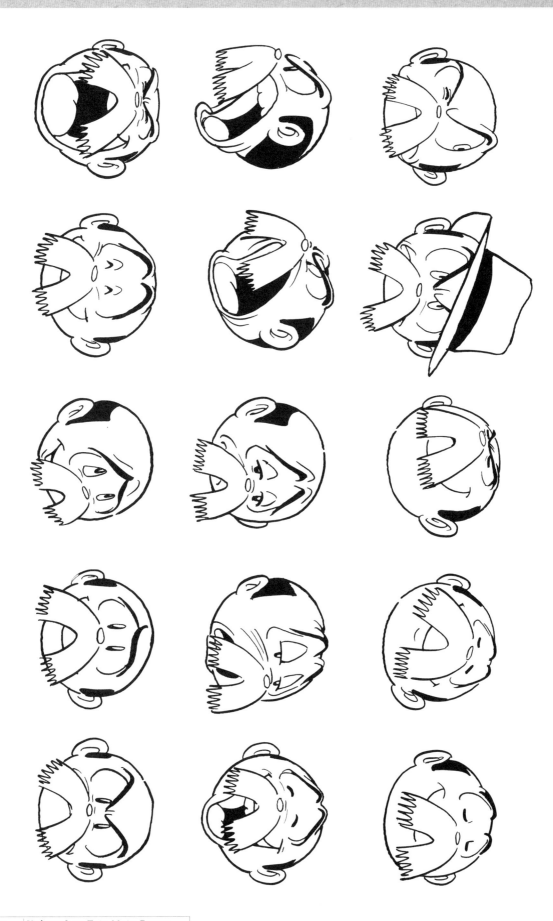

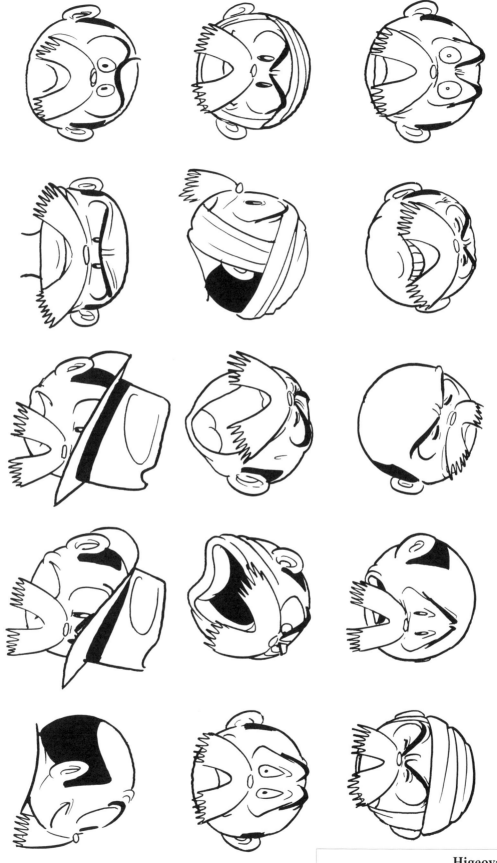

Higeoyaji

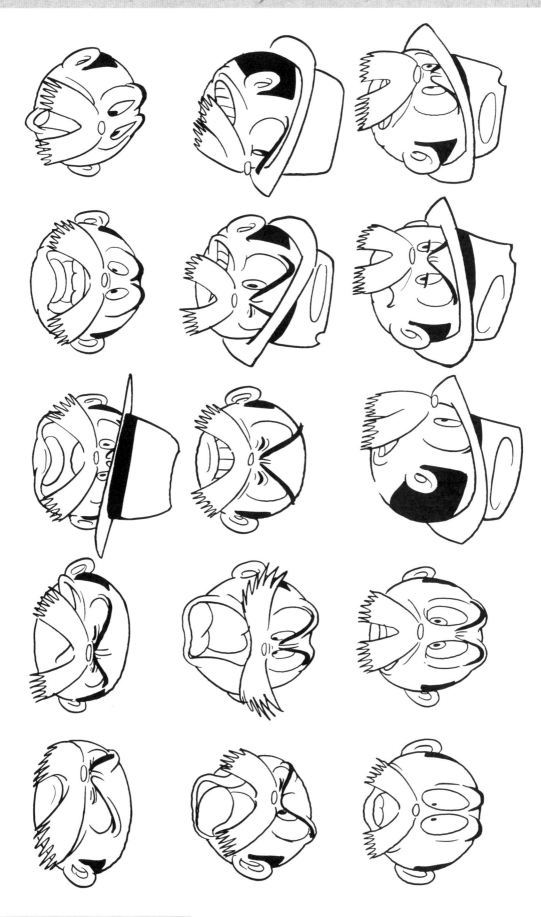

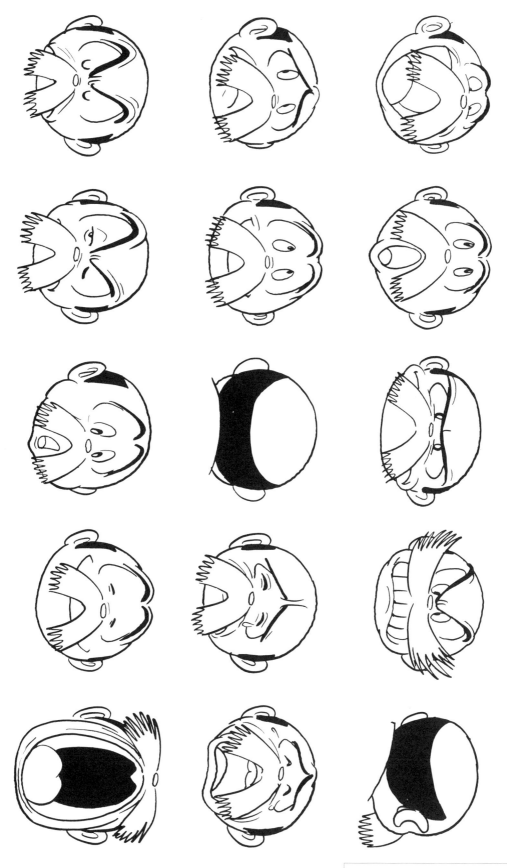

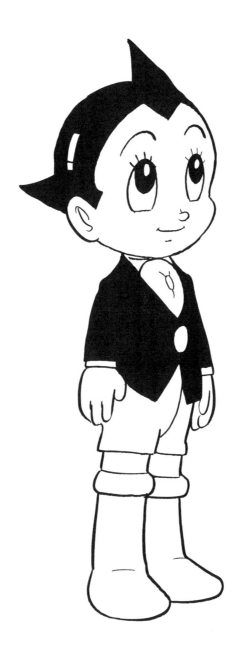

Adam

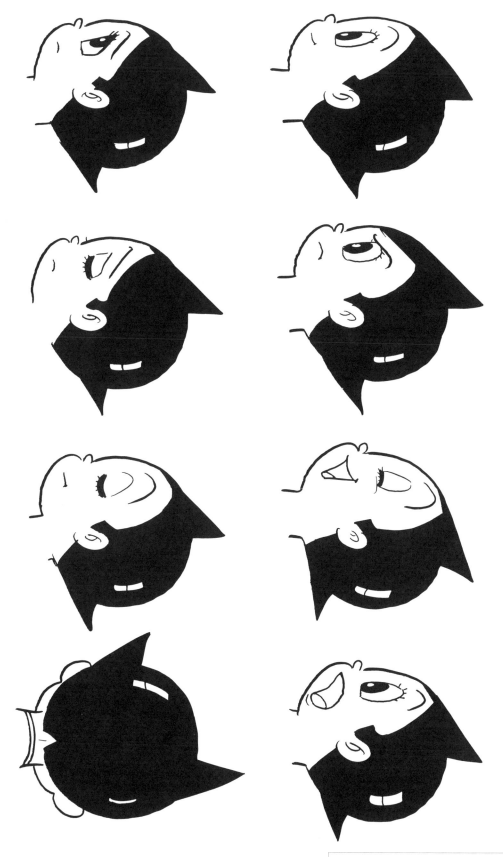

Adam

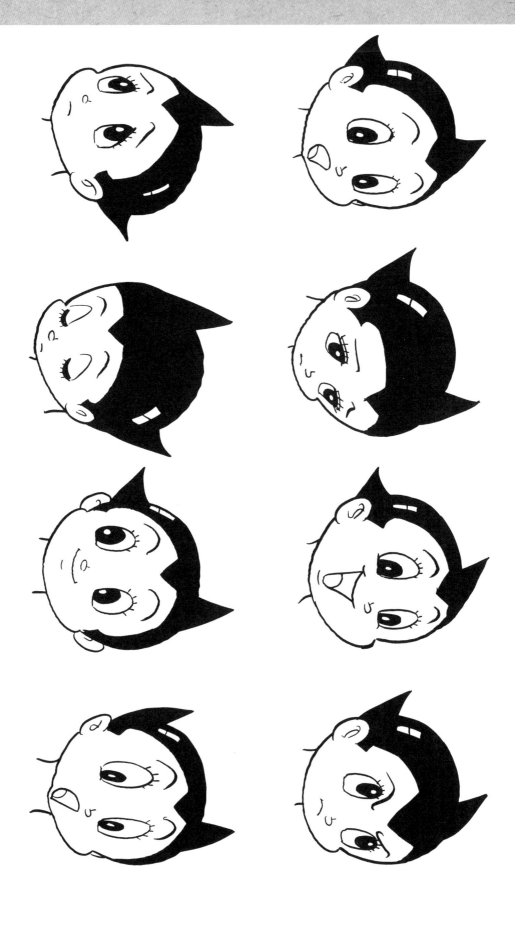

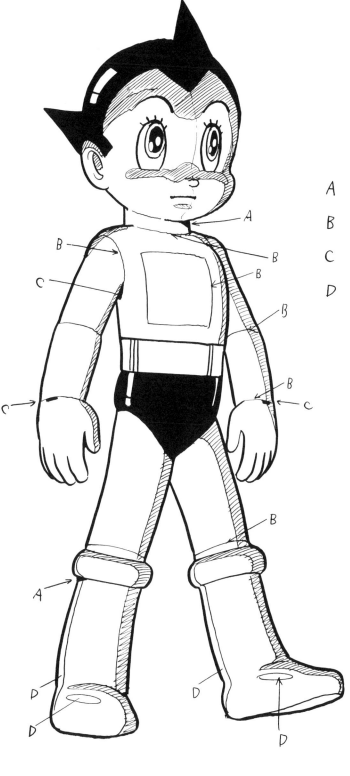

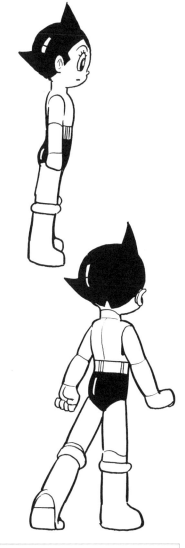

動電力車のアトム ①

すべて フットライトのかんじ
やや不気味に ②

A　かげがあります（くろ）

B　色トレス（ややといもの）

C　穴があります ③

D　ハイライト

1. Adam on the train. Lighting by footlights makes him a little eerie.
2. All as if he's being lit by footlights.
3. A: Shadows here (black).
 B: Color hold (somewhat heavy).
 C: Holes here.
 D: Highlights.

Adam

34

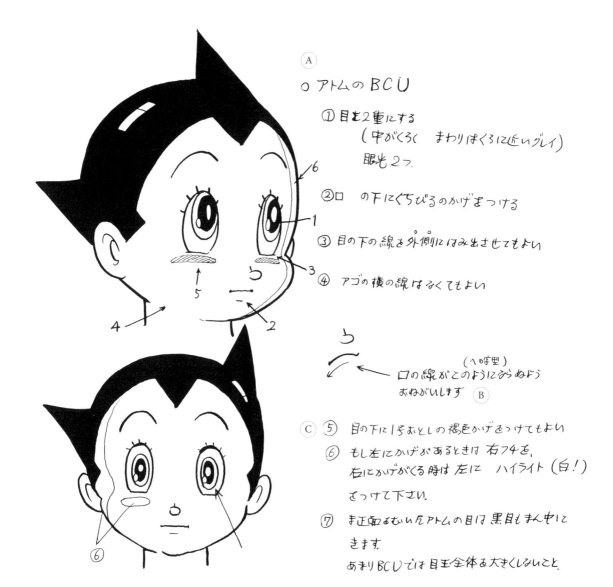

○ アトムの BCU

① 目を2重にする
（中がくろく　まわりはくろに近いグレイ）
眼光 2つ.

② 口　の下にくちびるのかげをつける

③ 目の下の線を外側にはみ出させてもよい

④ アゴの横の線はなくてもよい

（ヘの字型）
口の線がこのようにならぬよう
おねがいします

⑤ 目の下に1ちおとしの褐色かげをつけてもよい

⑥ もし左にかげがあるときは 右フ4を,
右にかげがくる時は 左に　ハイライト（白！）
をつけて下さい.

⑦ ま正面をむいたアトムの目は 黒目もまん中に
きます.
あまりBCUでは目玉全体を大きくしないこと.

A. Big close-up of Adam
 (1) Eyes are "double" eyes. (Inside is black. Around that is a very dark gray.) Eye glint 27.
 (2) Shadow of his lip below the mouth.
 (3) It's fine if the lines under his eyes stick out a bit.
 (4) The outline of his chin should vanish at this point.
B. (Like the character "ヘ")
 Please don't make his mouth go like this.
C. (5) Blush shading with #1 under the eyes.
 (6) If one side of the face is shaded, make sure to highlight the other (with white!).
 (7) Pupils are exactly in the middle when facing forward. Don't make eyes too big on the whole during big close-ups.

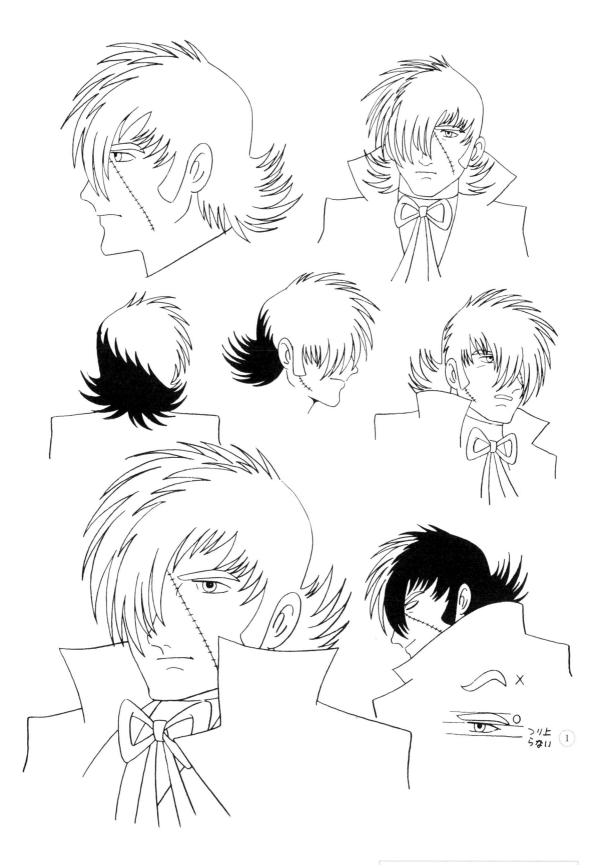

つり上
らない ①

Black Jack

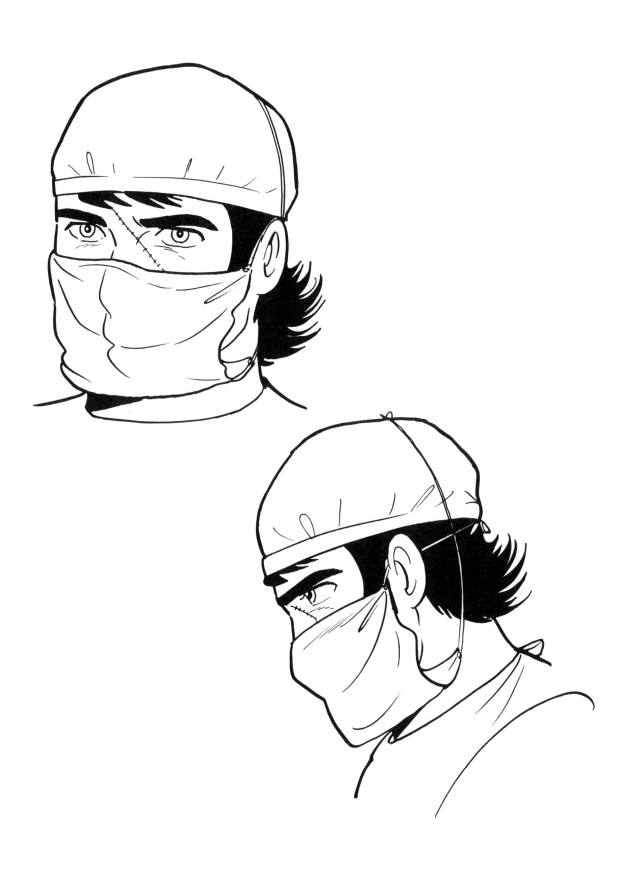

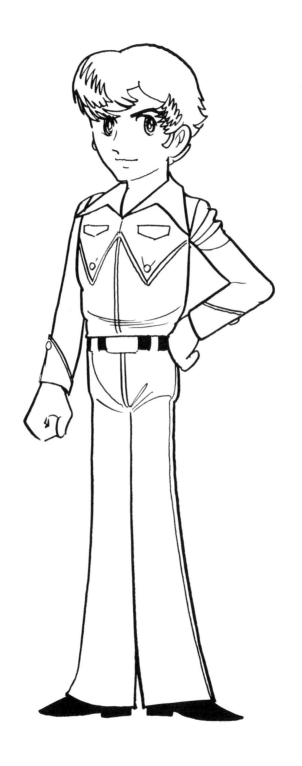

Rock

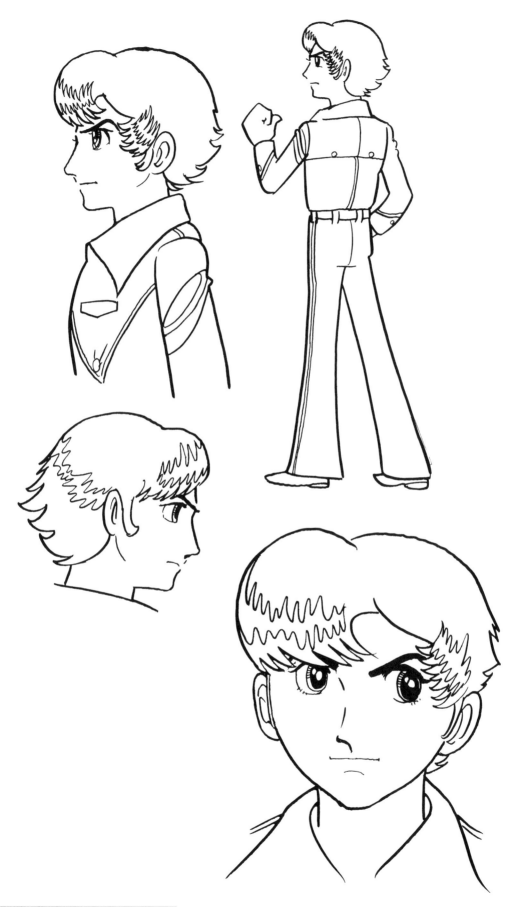

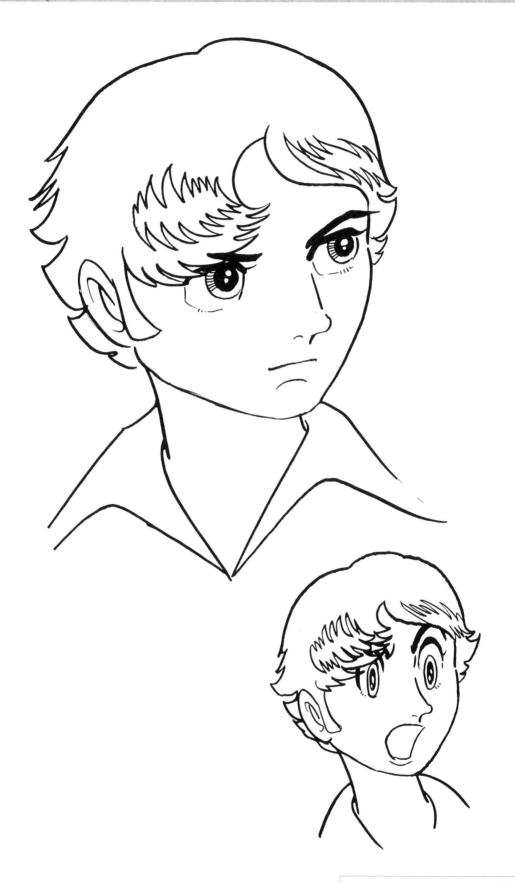

Rock

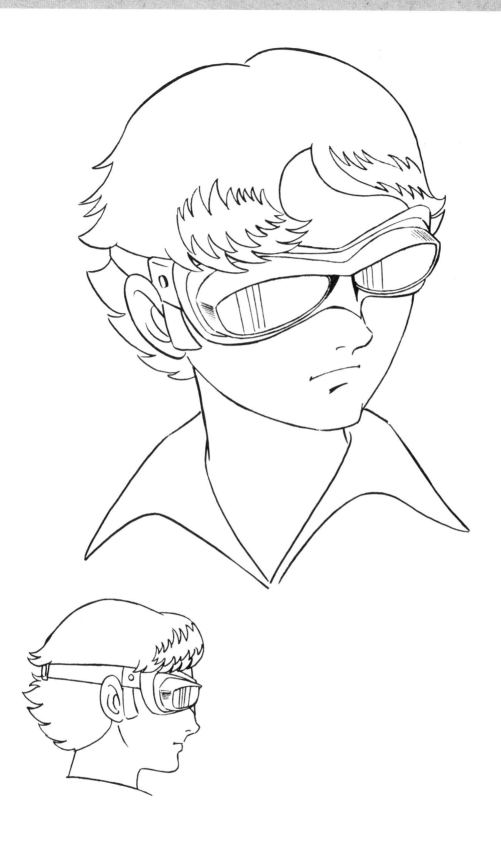

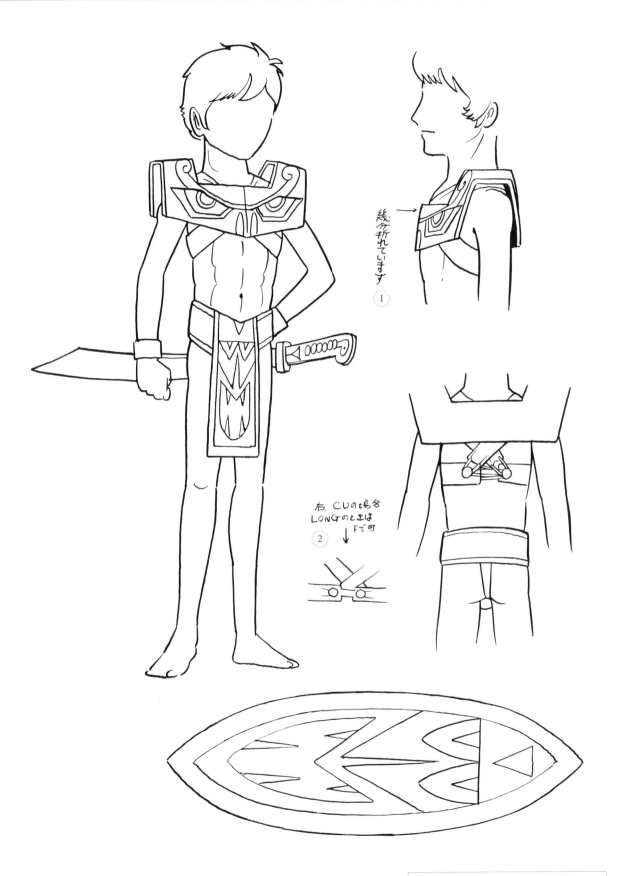

幾分折れています
①

右. CUの場合
LONGのときは
下で可
②

Rock

1. Should be somewhat cracked.
2. Like the image to the right during close-ups. Like the image below for long shots.

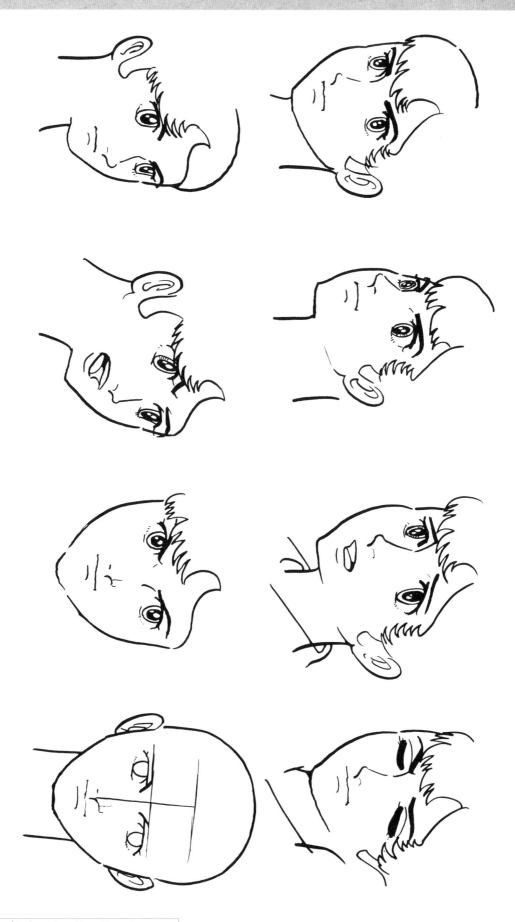

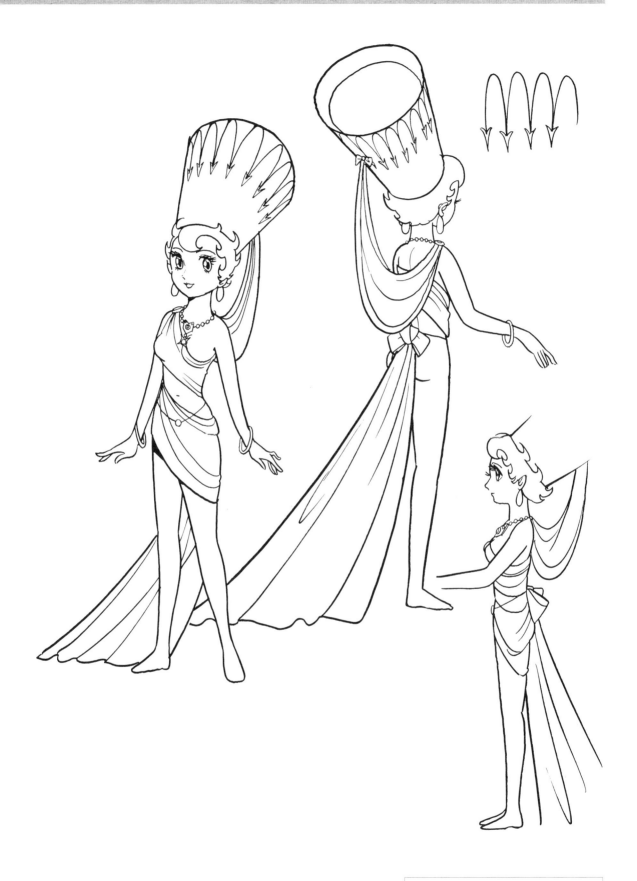

Princess Sapphire

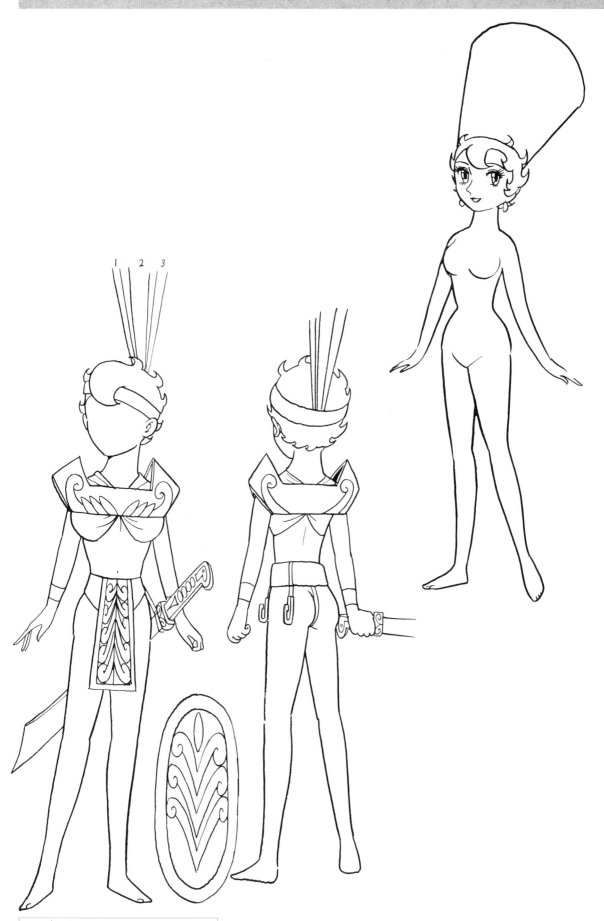

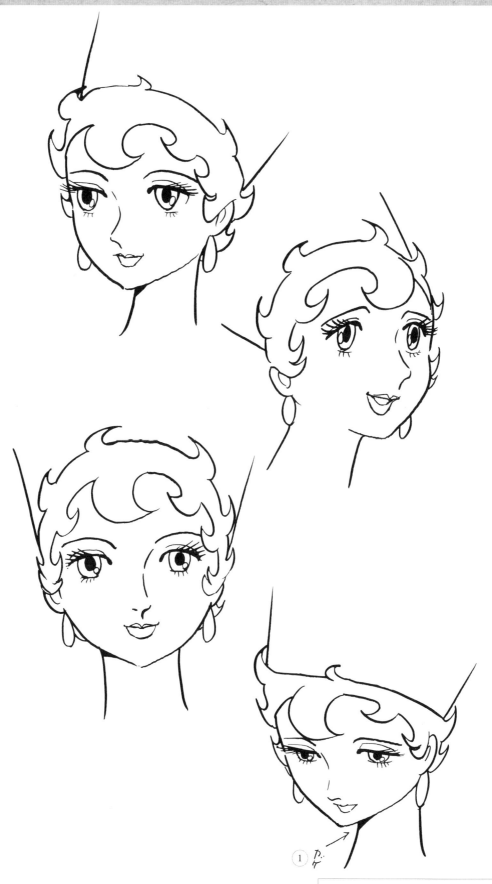

Princess Sapphire

1. Shadow.

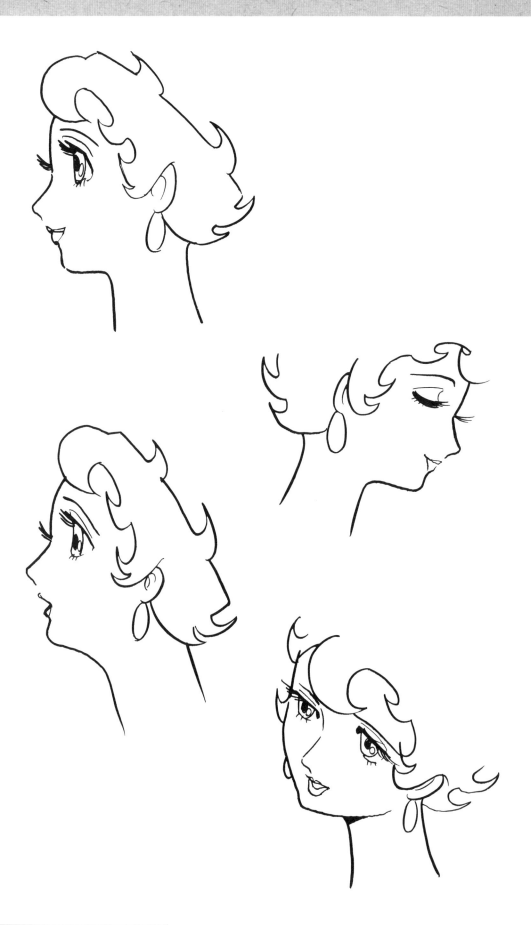

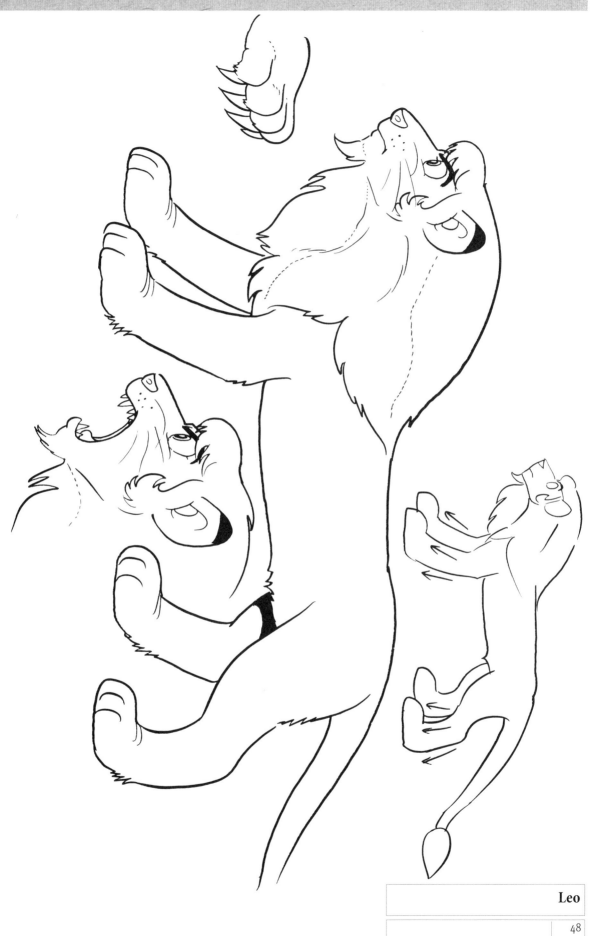

1. Add lots of shadows.

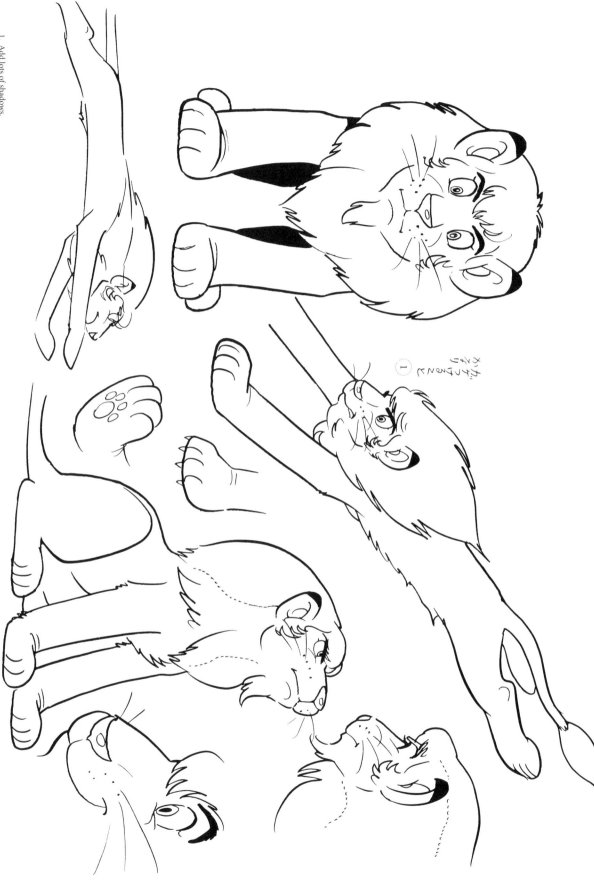

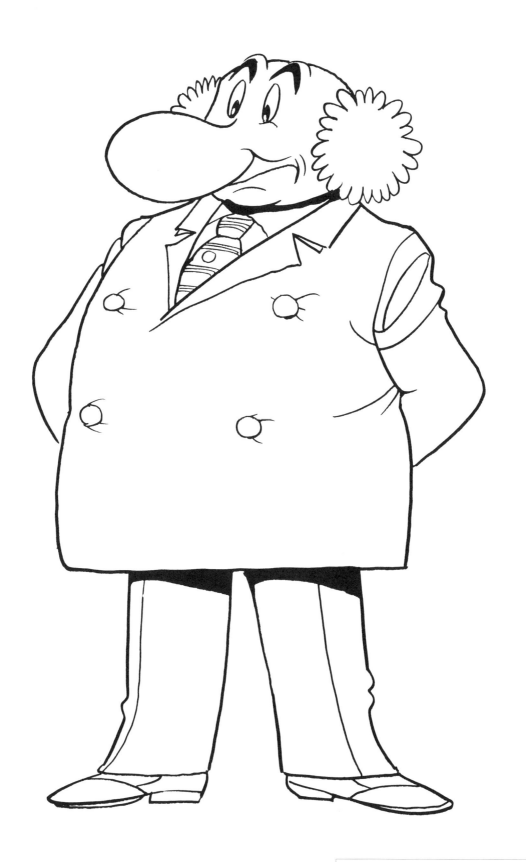

Dr. Narzenkopf

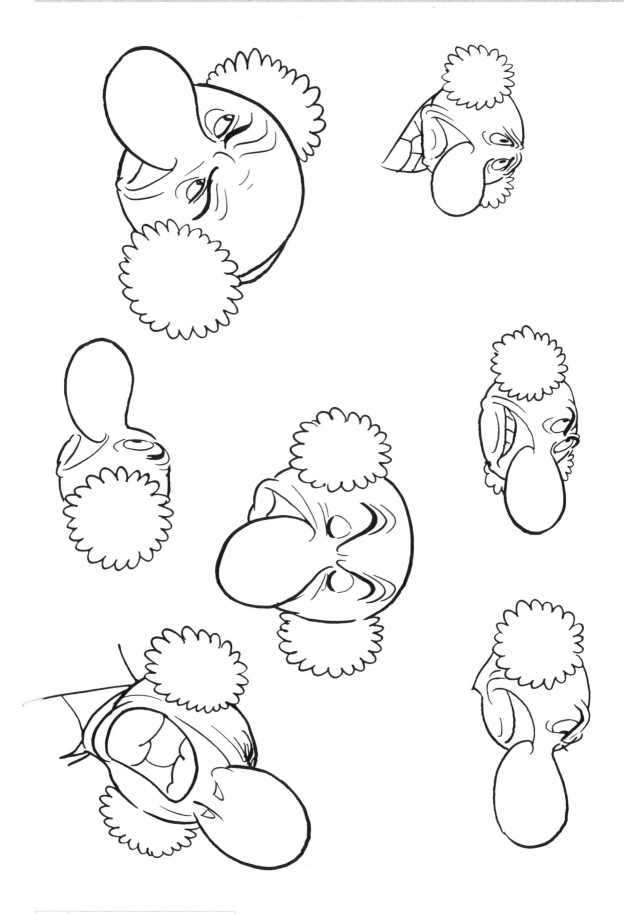

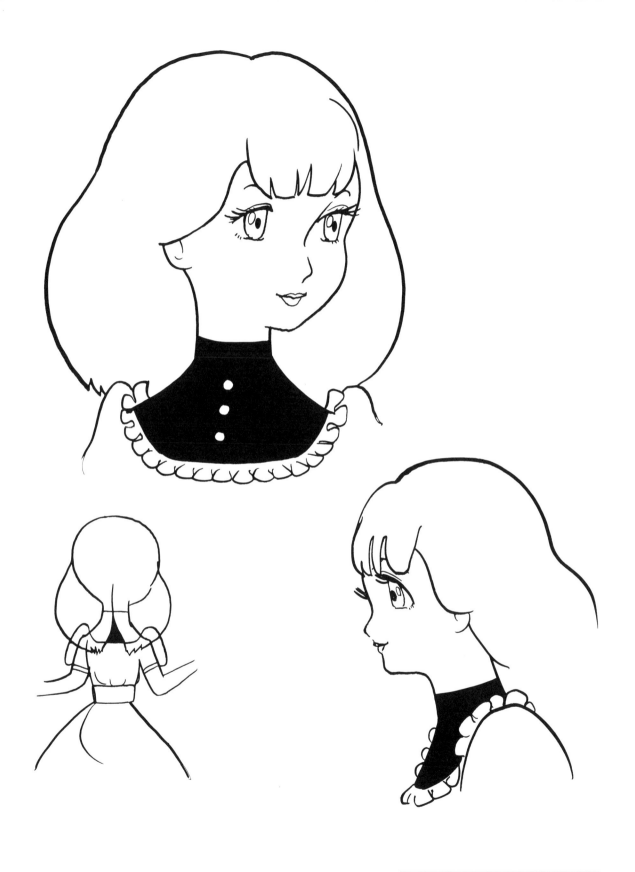

Milly

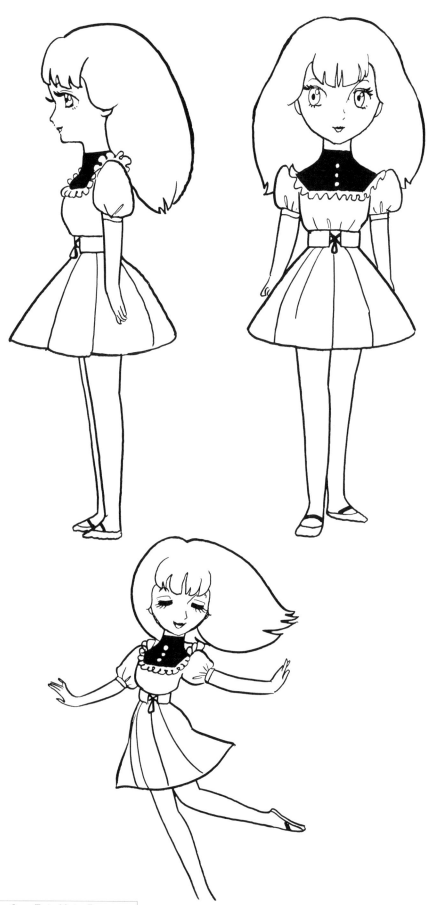

①

1. When she's really angry.

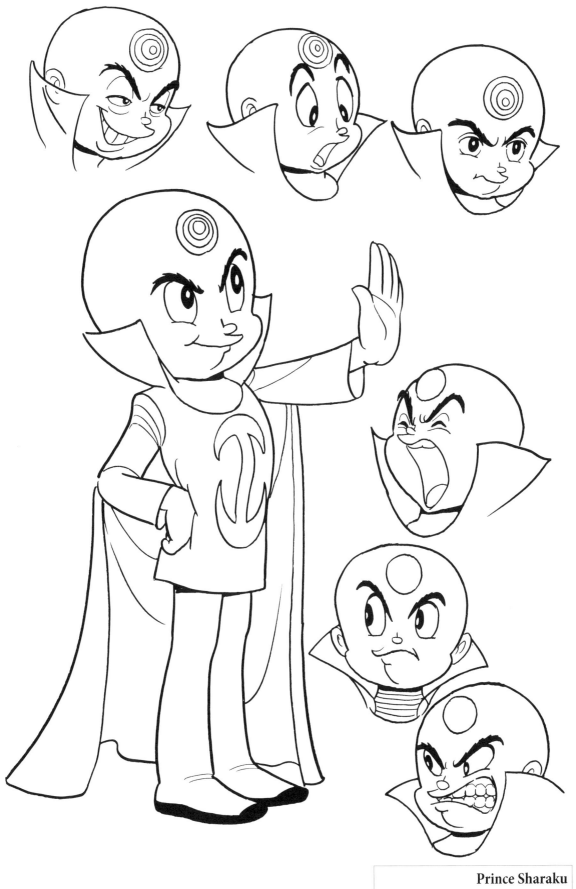

Prince Sharaku

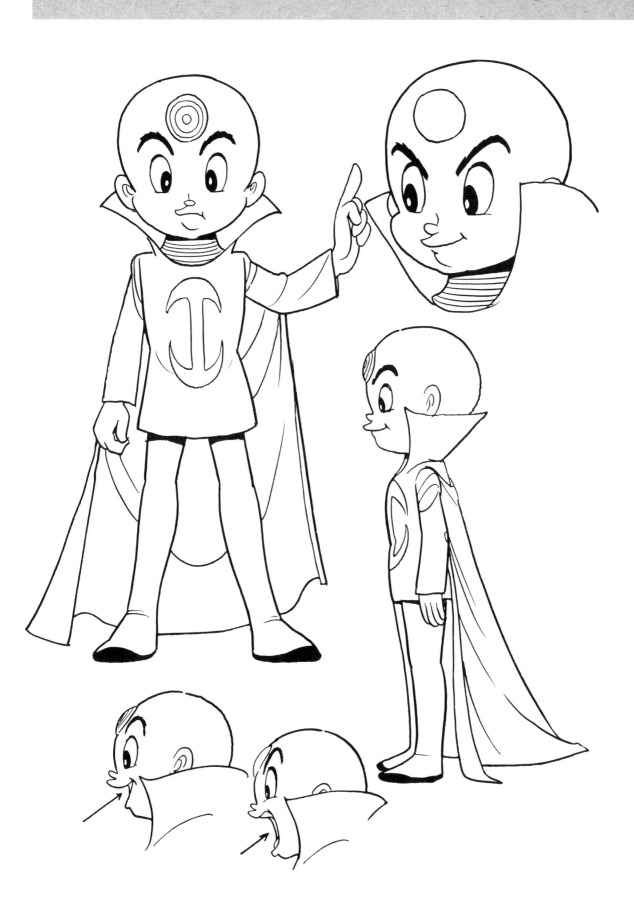

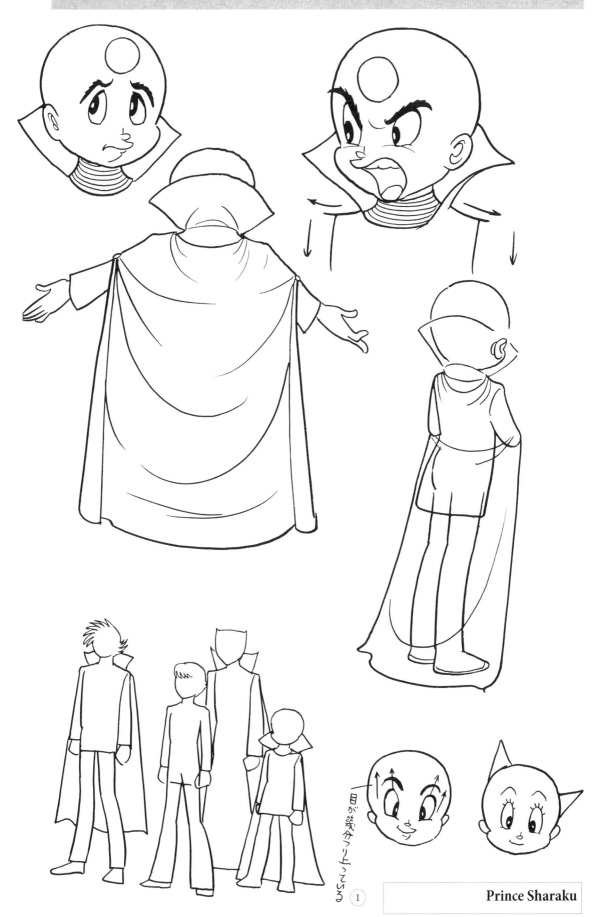

① 目が幾分つり上っている

1. Eyes should be raised a bit.

Prince Sharaku

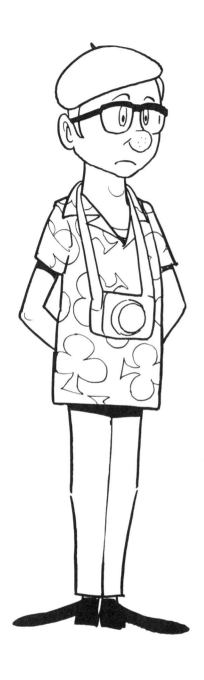
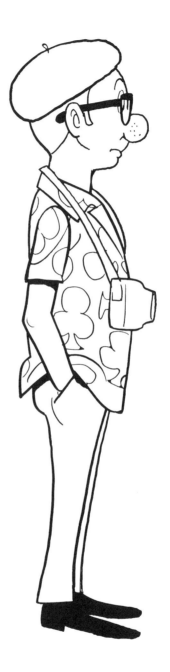

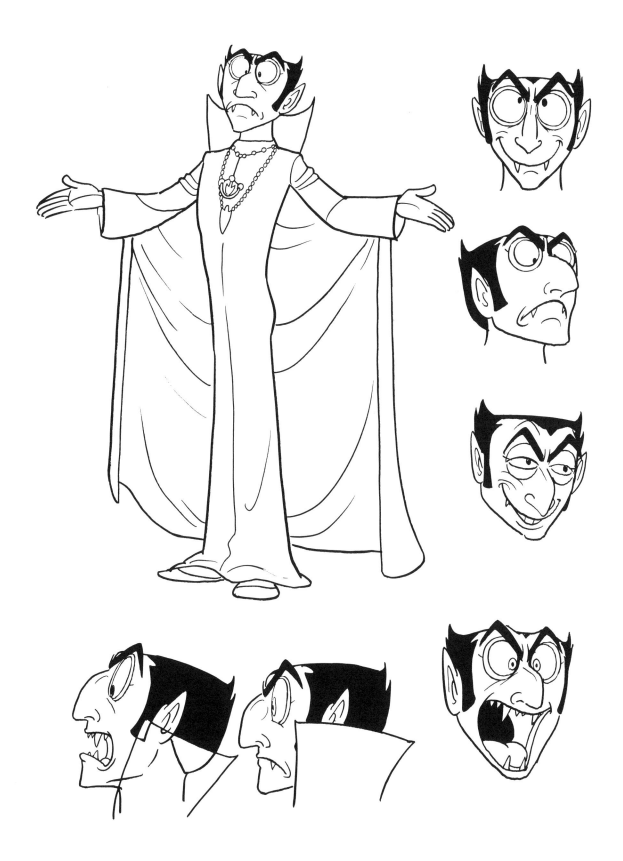

Dondora

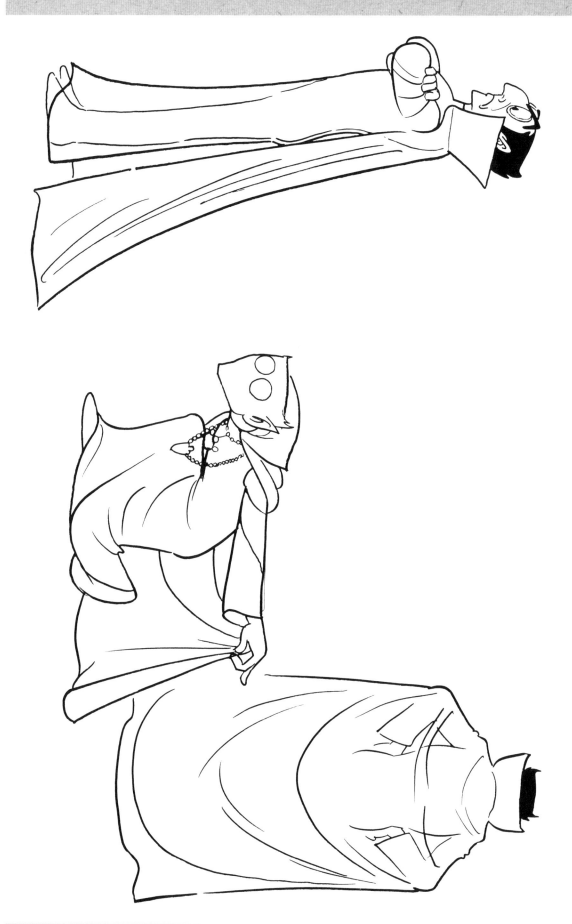

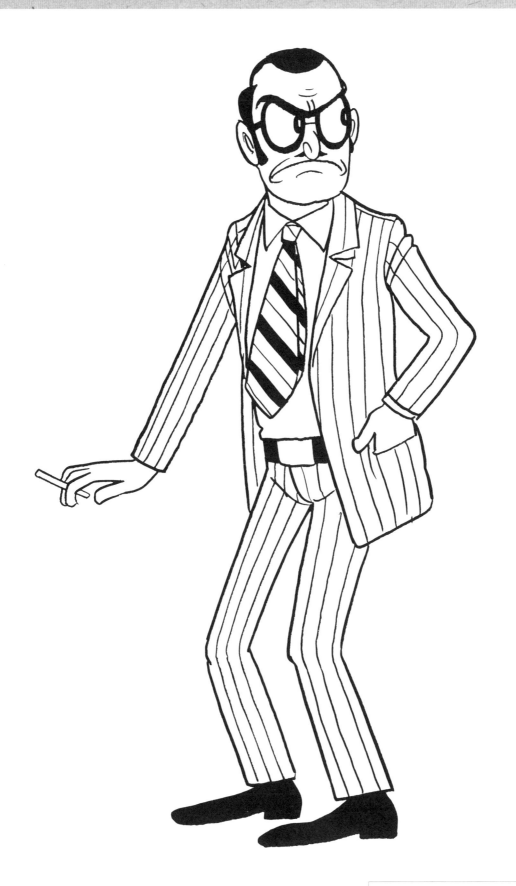

Acetylene Lamp

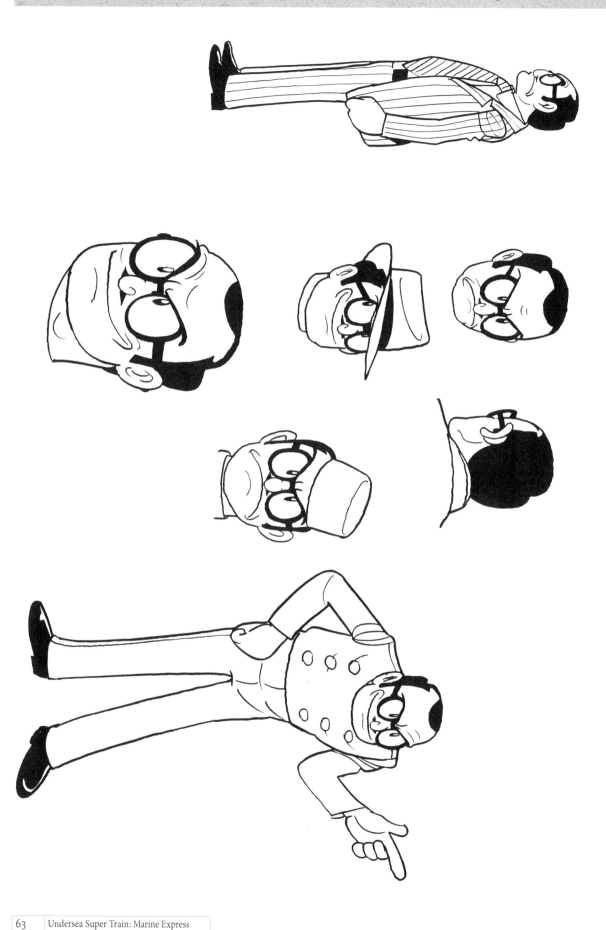

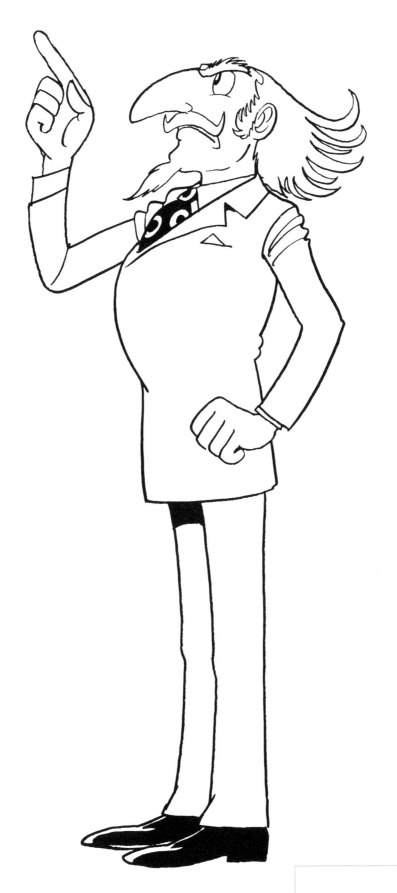

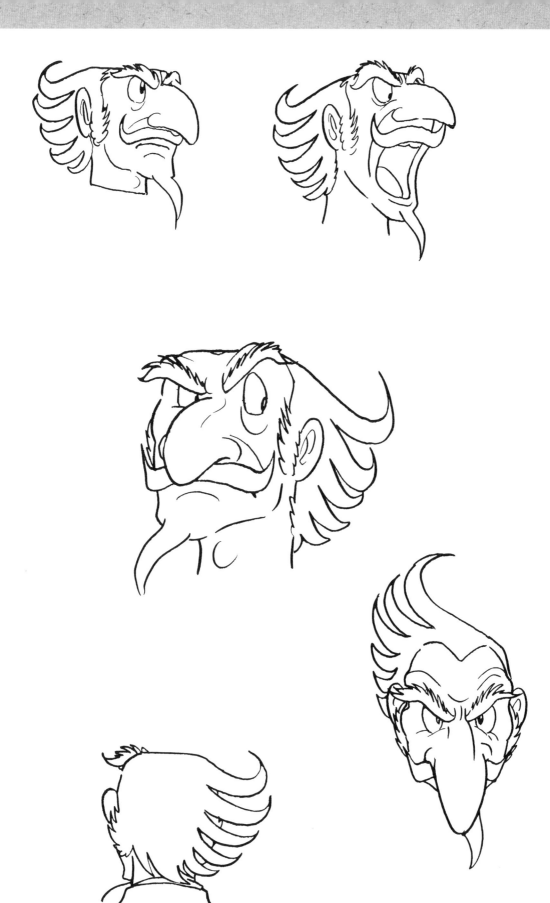

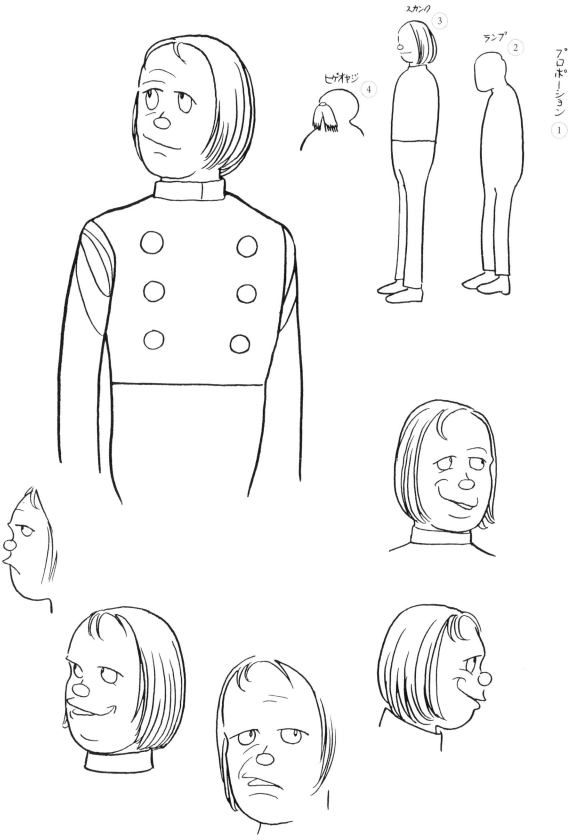

スカンク ③

ランプ ②

ヒゲオヤジ ④

プロポーション ①

1. Proportions
2. Lamp
3. Skunk
4. Higeoyaji

Skunk

Boon Marukubi

Big Mouth Vice Minister

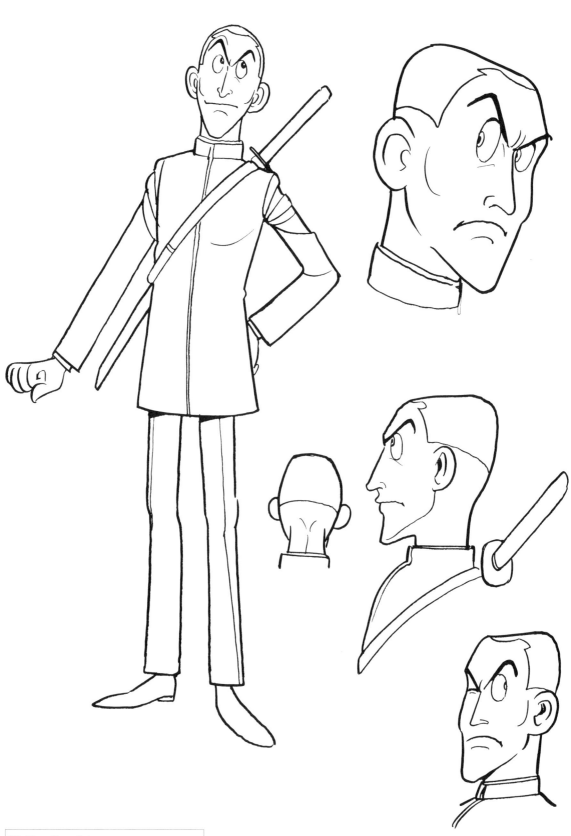

Kojiro Sasaki

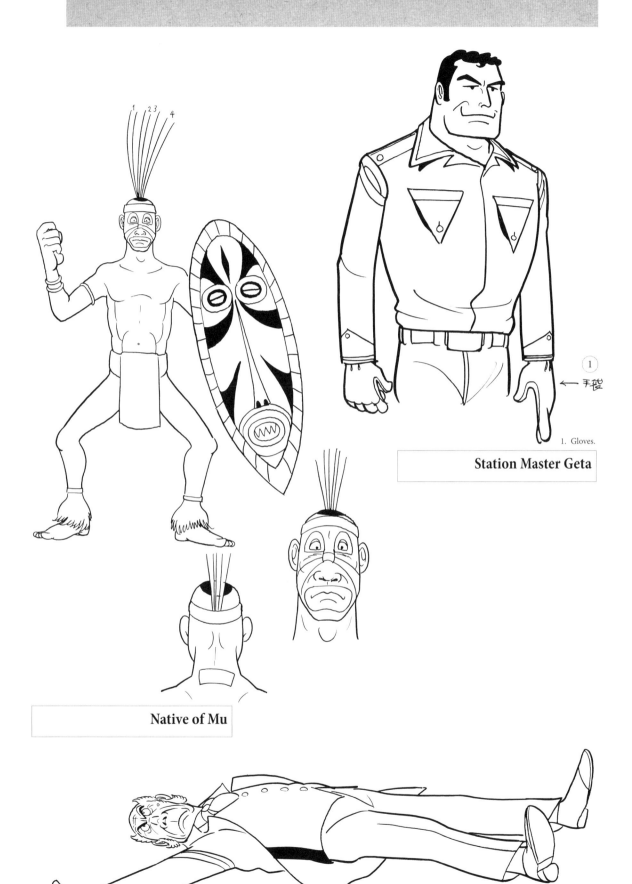

1. Gloves.

Station Master Geta

Native of Mu

Shylock

地獄の中の天使たち

Aired on Aug. 23rd, 1981 on Nippon TV

"BREMEN 4: ANGELS IN HELL"

BACKGROUND

Another two-hour TV anime special that aired during the fourth "24-Hour Television: Love Saves the Earth". Unlike the previous specials, Osamu Tezuka only wrote the original screenplay and created original characters for "Bremen 4". However, after the initial airing, Tezuka remastered about one-third of the film. Because subsequent airings had to be condensed to only 90 minutes, the August 1985 video release by VAP was the first time that the full, finished version became available to the public. Included alongside the images are symbols marking different cuts, indicating scenes added when Tezuka remastered the film.

SYNOPSIS

A boy named Trio is living peacefully in his village until Commander Presto launches an attack with his mechanized unit. Trio's mother is killed in the attack, and Trio's cat, Coda, gets separated from him. She soon meets Largo, a donkey; Minuet, a chicken; and Allegro, a dog. The four animals end up saving an alien, Rondo, who grants them the ability to transform into humans. They return to the village where, in order to find Trio, they form a band called the "Bremen 4". They become wildly popular.

Concept, Screenplay, Character Design, General Animation Director ◯ Osamu Tezuka

Rendition ◯ Hiroshi Sasagawa

Planning ◯ Akira Yoshikawa, Tadahiko Tsuzuki

Producers ◯ Hidehiko Takei, Toru Horikoshi (Nippon TV), Mitsuo Sato, Takayuki Matsutani

Music Producer ◯ Yasuo Higuchi

Rendition ◯ Katsuhito Akiyama

Animation Director ◯ Kazuhiko Udagawa

Art Director ◯ Mitsuki Nakamura

Mechanical Design ◯ Hisashi Sakaguchi

Original Art ◯ Hiroshi Nishimura, Masateru Yoshimura, Junji Kobayashi, Yutaka Tanizawa, Shinji Seya, Kaoru Kano, Toshi Noma, Yasuhiko Ogata, Osamu Tezuka

Backgrounds ◯ Studio BOP, Miniart, Mechaman, Artland, Mascot, Tsunehito Nonomiya

Production Assistant ◯ Yasuhiro Imagawa

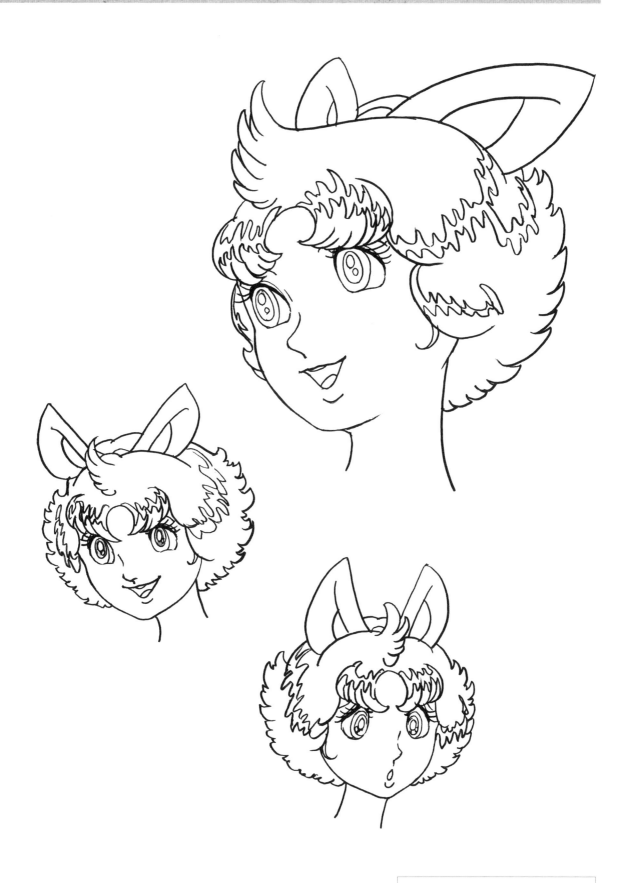

Coda, post-transformation

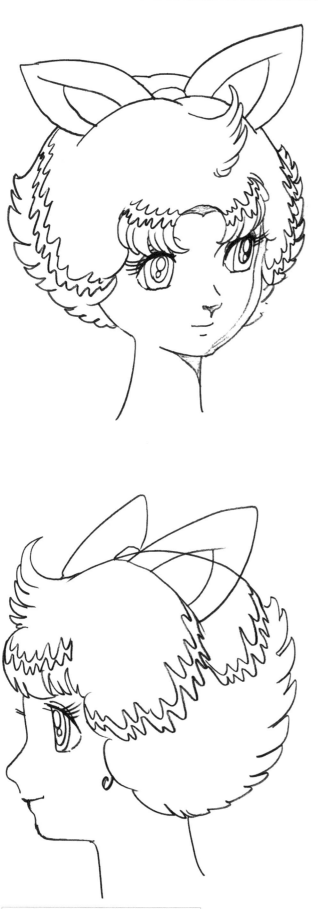

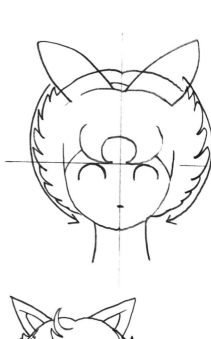

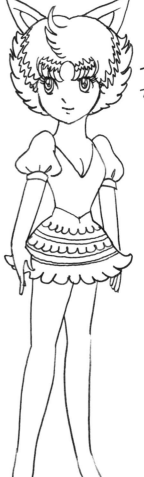

やせ色気
かわいくて
神泥りの

①

1. Slightly sexy. Cute.
Air of divinity.

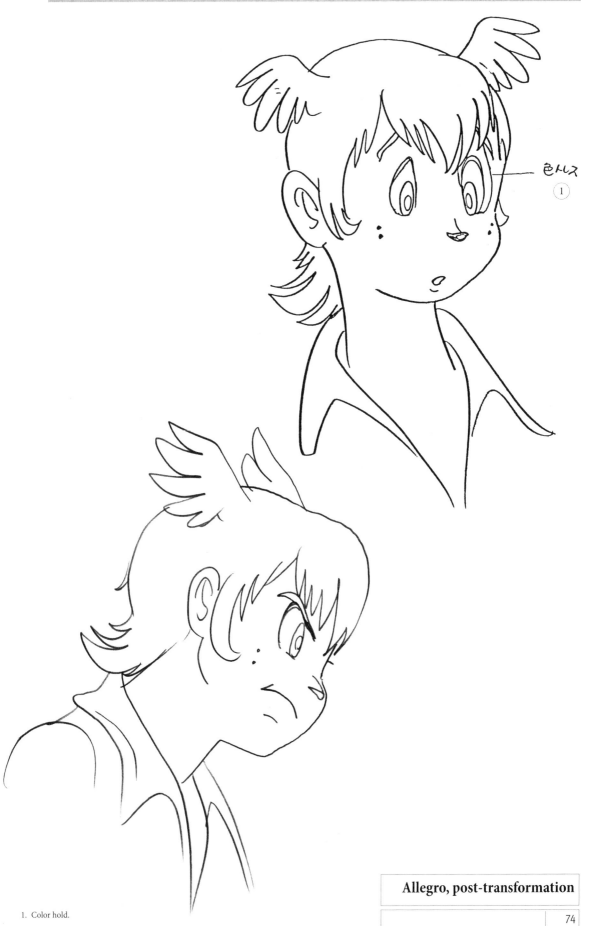

色トレス
①

Allegro, post-transformation

1. Color hold.

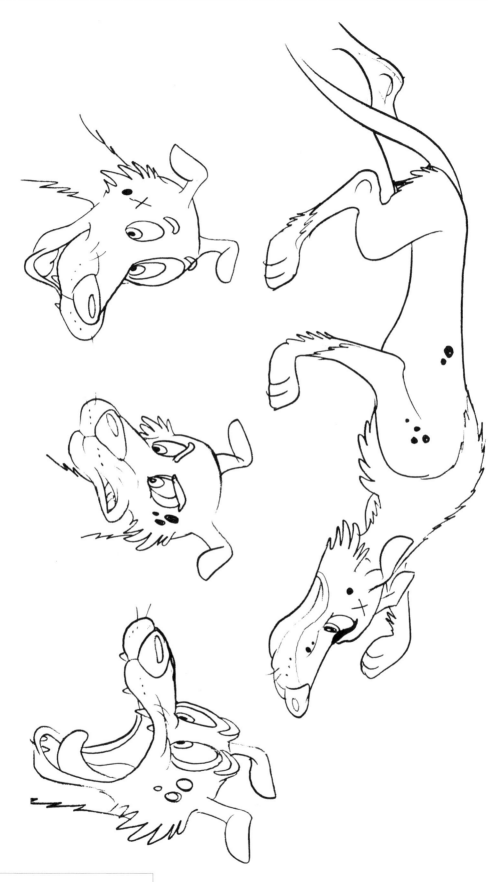

Allegro

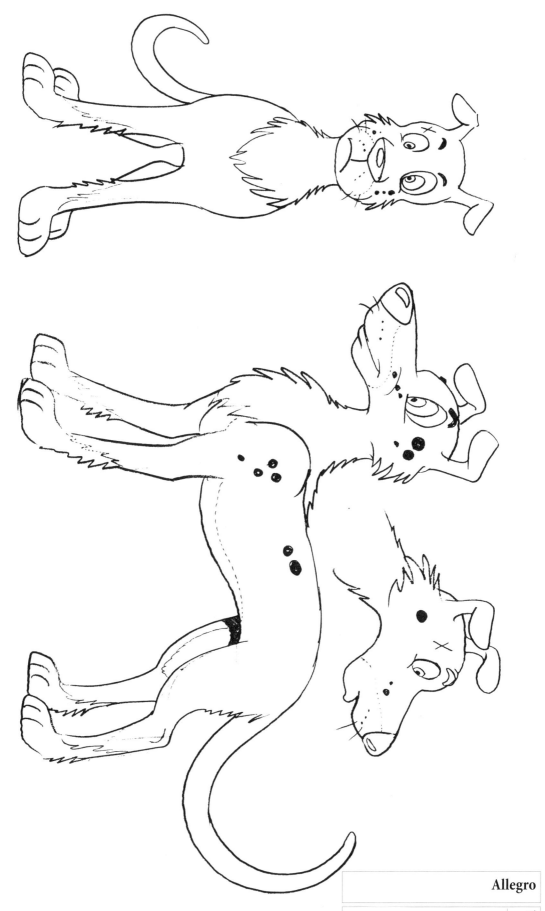

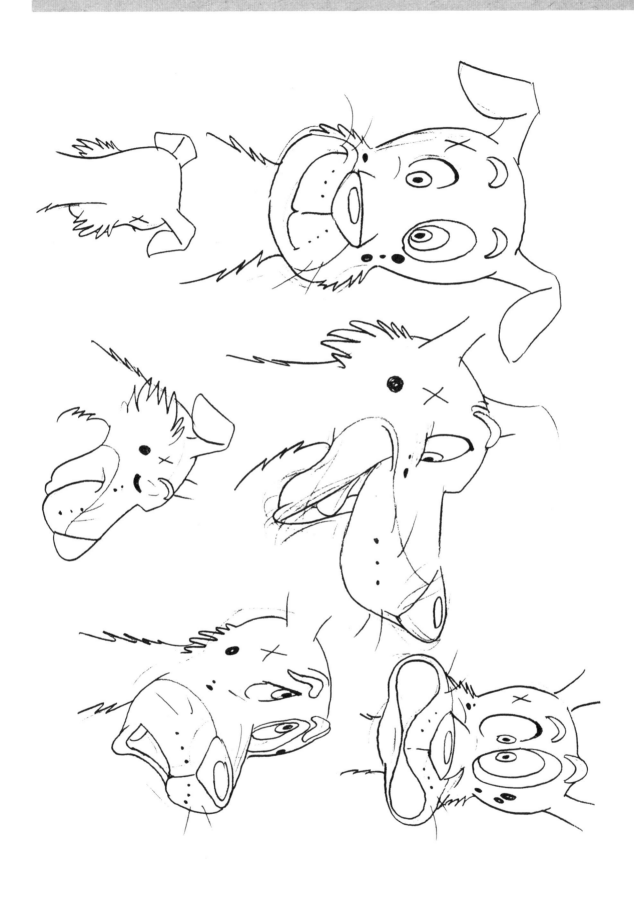

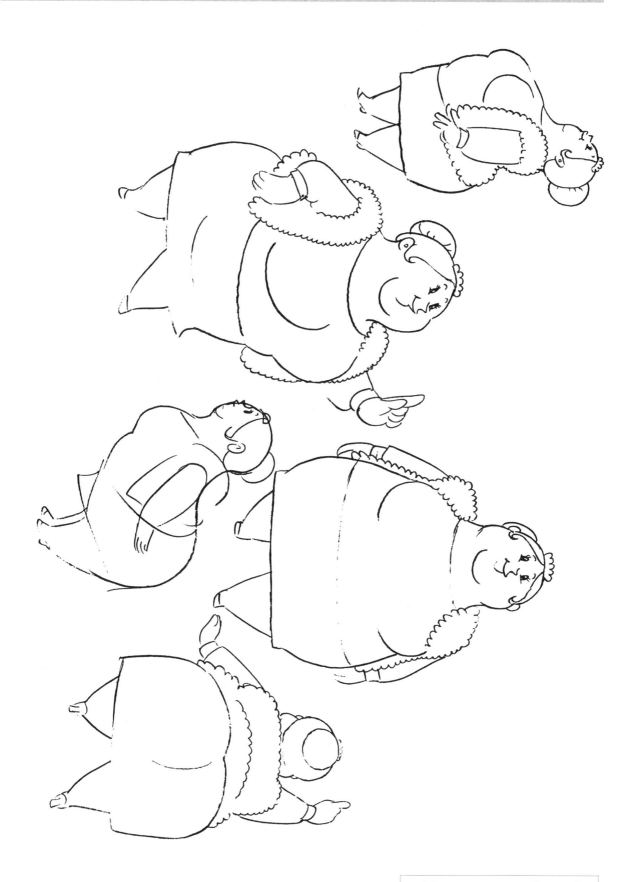

Minuet, post-transformation

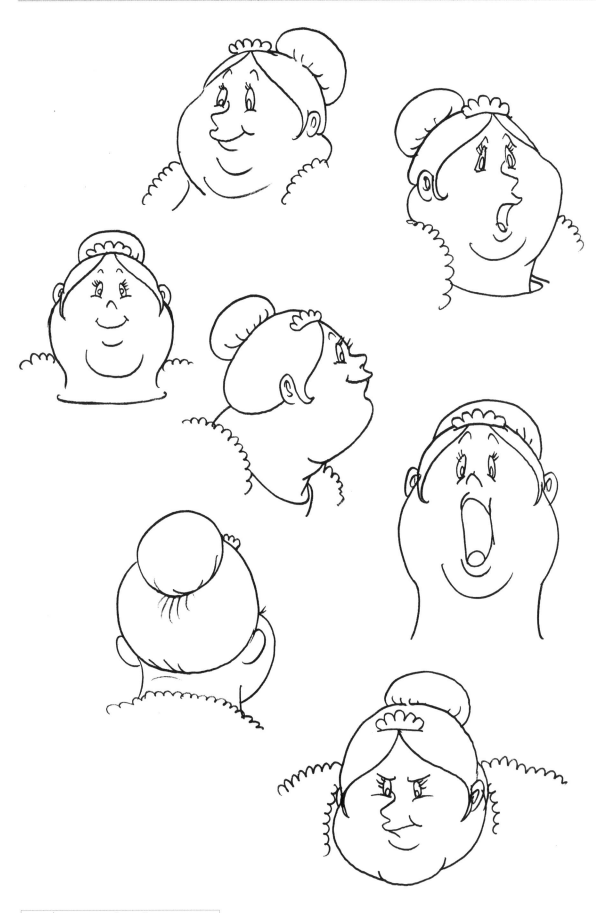

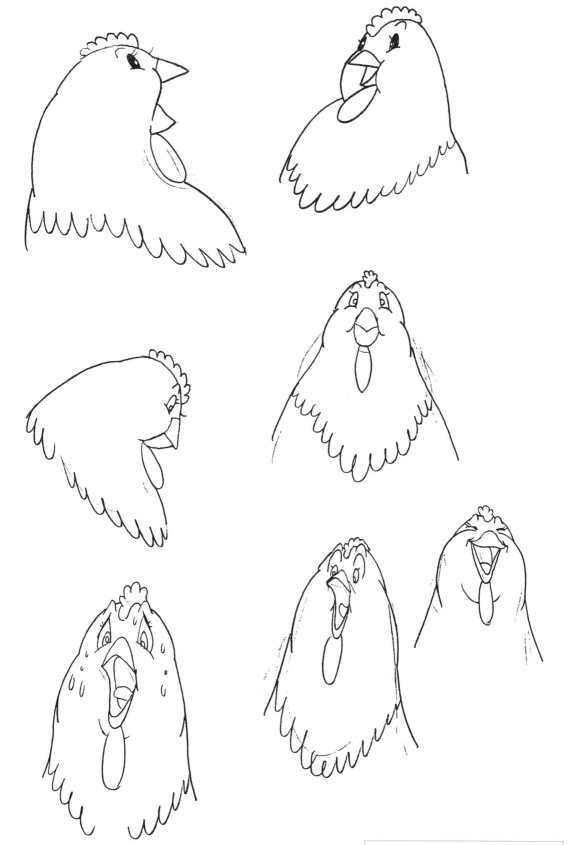

Minuet

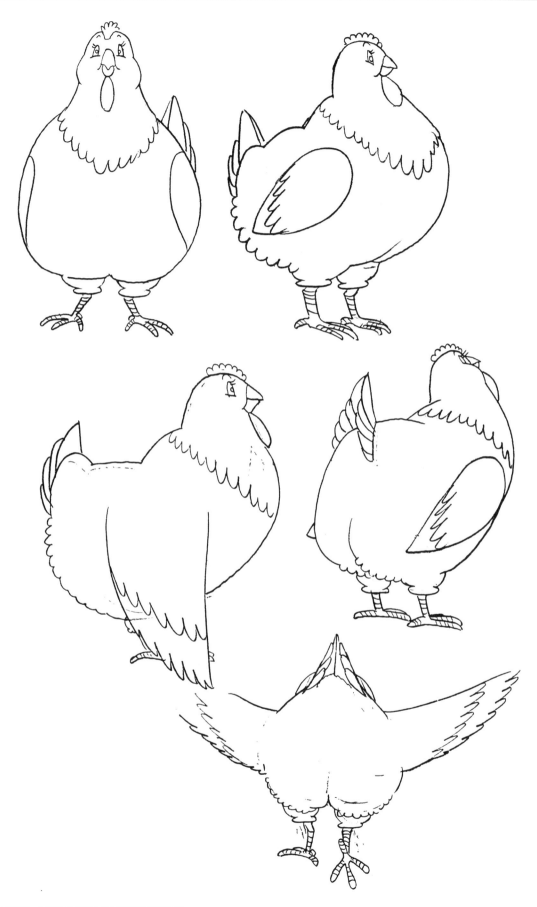

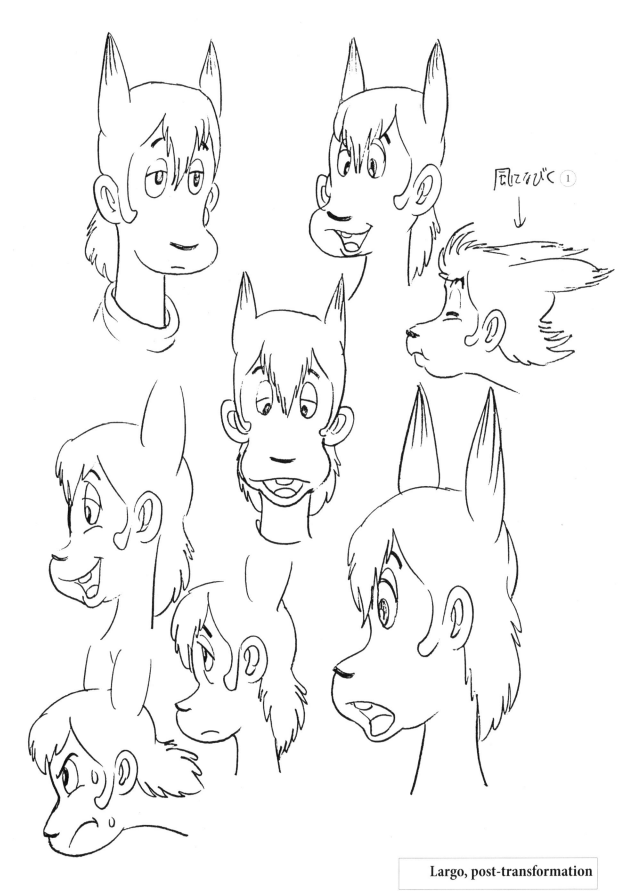

風になびく ①

Largo, post-transformation

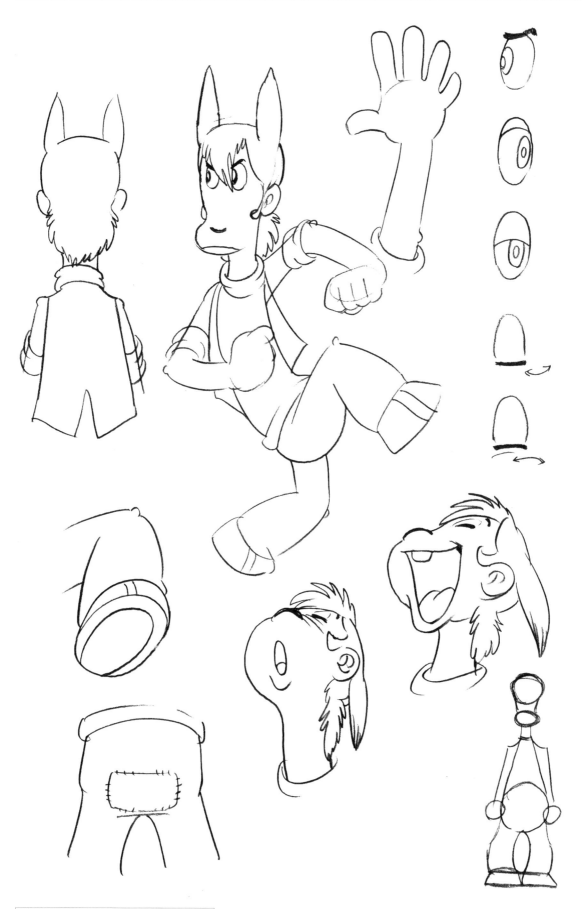

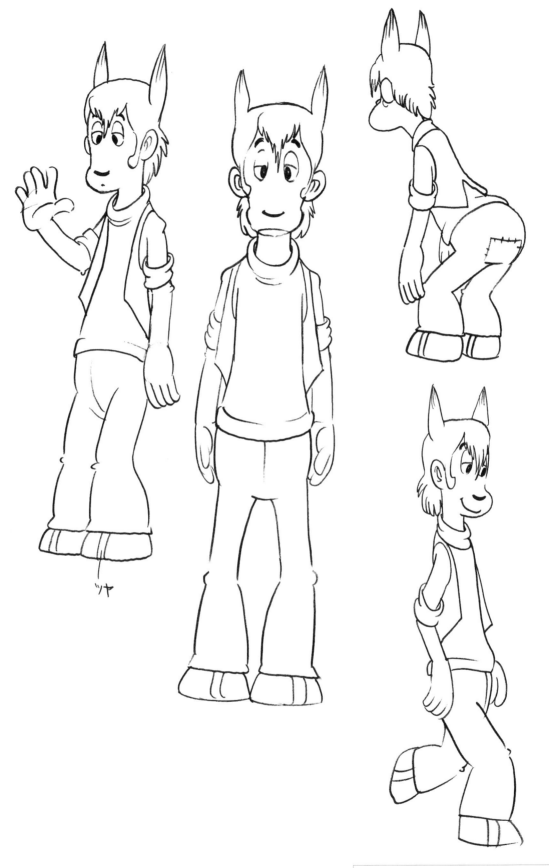

ツヤ

Largo, post-transformation

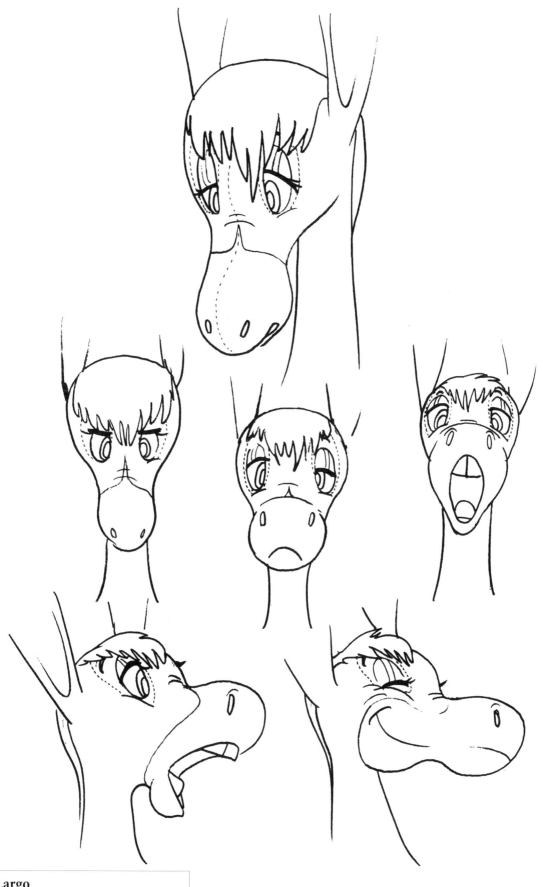

Largo

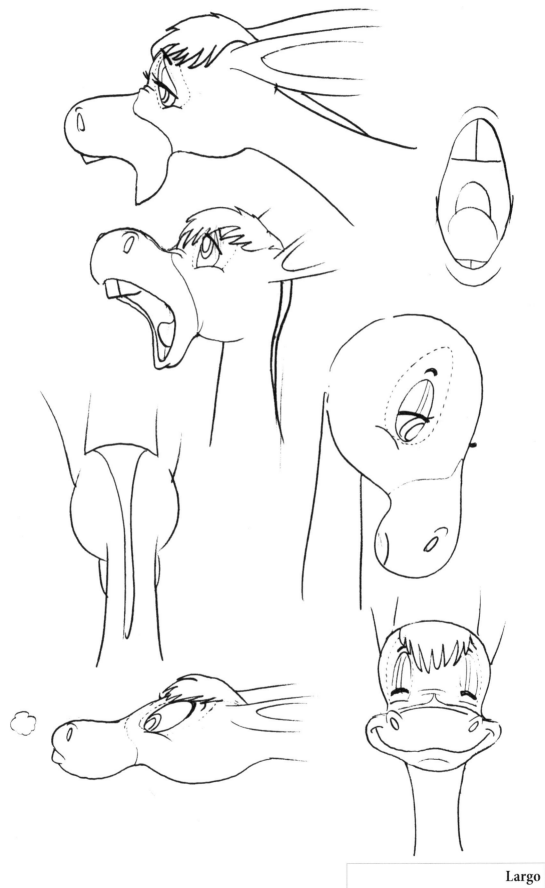

Comparison chart

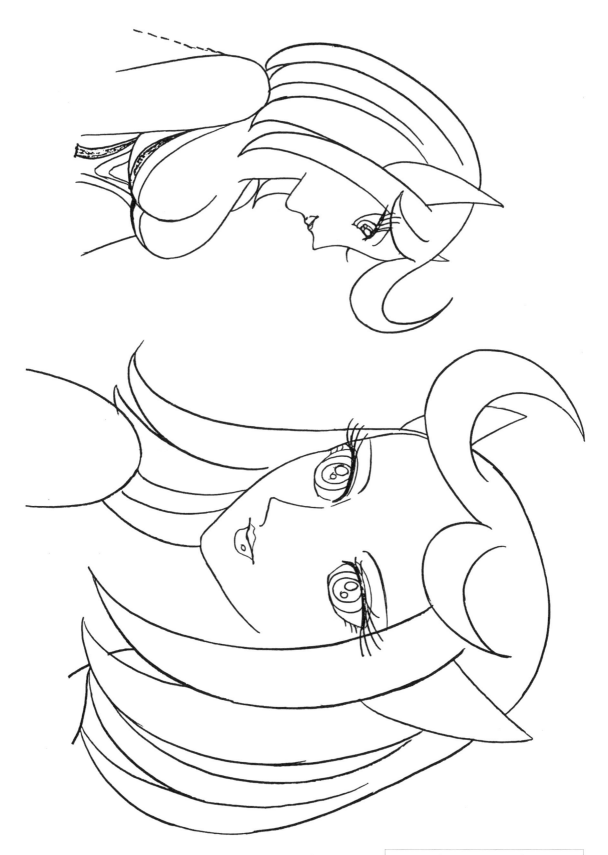

Rondo, post-transformation

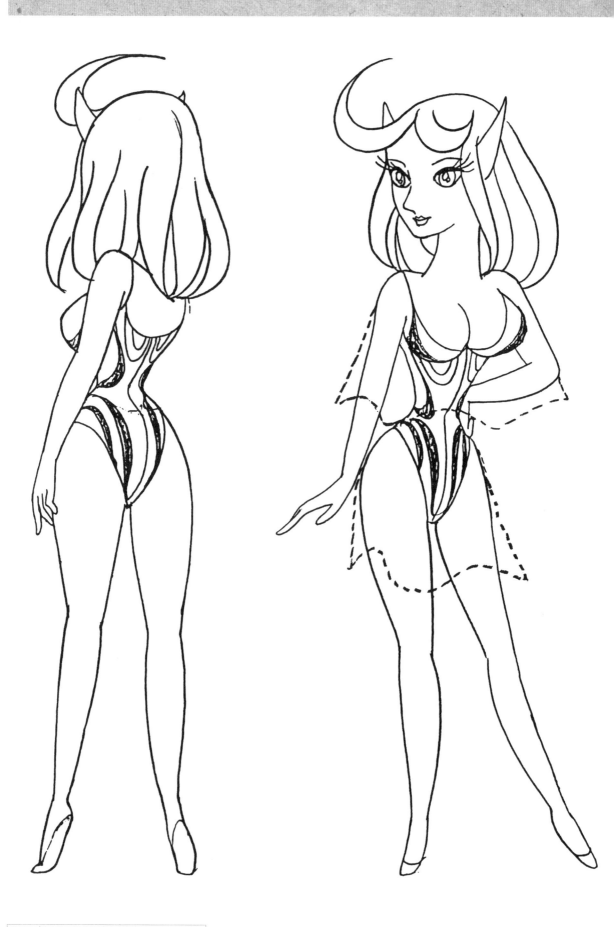

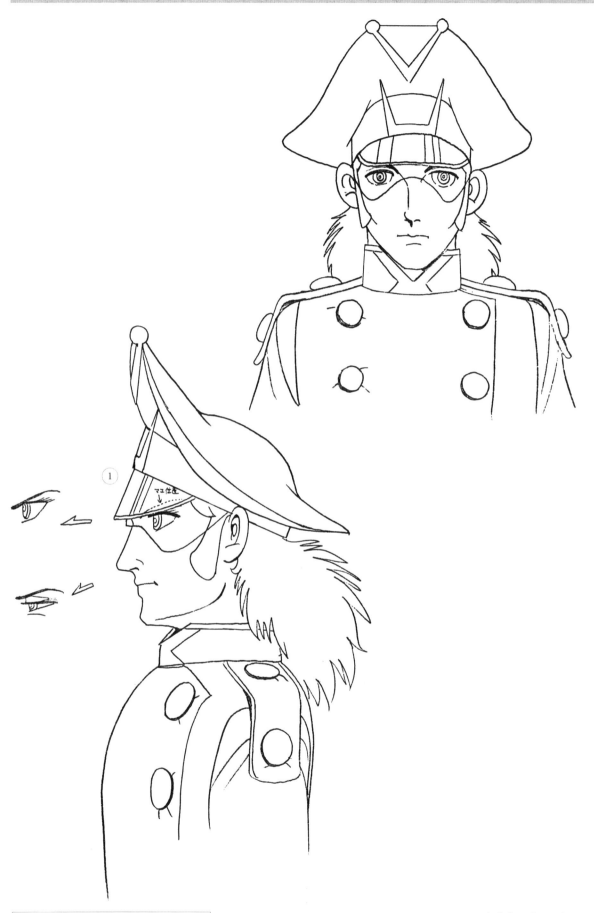

1. Eyebrow placement.

Trio

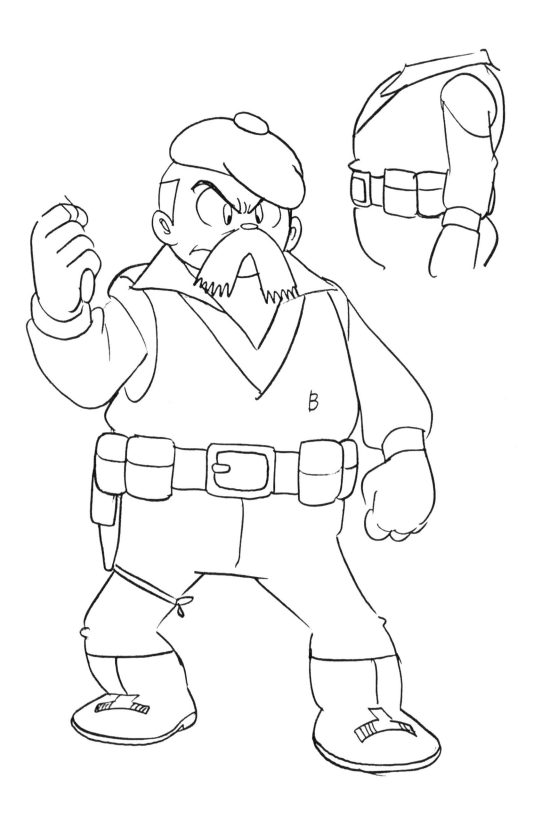

Adagio

レジスタンスの基本的なフォルム ①

顔ちいさめに　首太く ②

ベレーは せや前側に
なるめにかむっている ③

ひじ
小さなコブあり ⑥

手のひら
大きく
(顔ぐらい) ⑦

ひざ
小さなコブあり ⑧

くつの
すねの部分
みじかく ⑨

足 巨大に ⑩

④ アダジオ　もしくは
小柄なしジスタンス
の体格 ⑤

足のプロポー
ション ⑪

全体同じ
太もか
もしくは
下腿を下太りに ⑫

1. Basic form of the resistance members.
2. Small face, thick necks.
3. Beret should hang diagonally to the front.
4. Adagio
5. …and other small-size resistance members.
6. Little bumps on the elbows.
7. Large palms (as big as face).
8. Little bumps on the knees.
9. Shoes don't come up too high on the shins.
10. Giant feet.
11. Proportions of the legs.
12. Body should be equally thick top to bottom, OR crus can be thicker.

Basic form of the resistance members

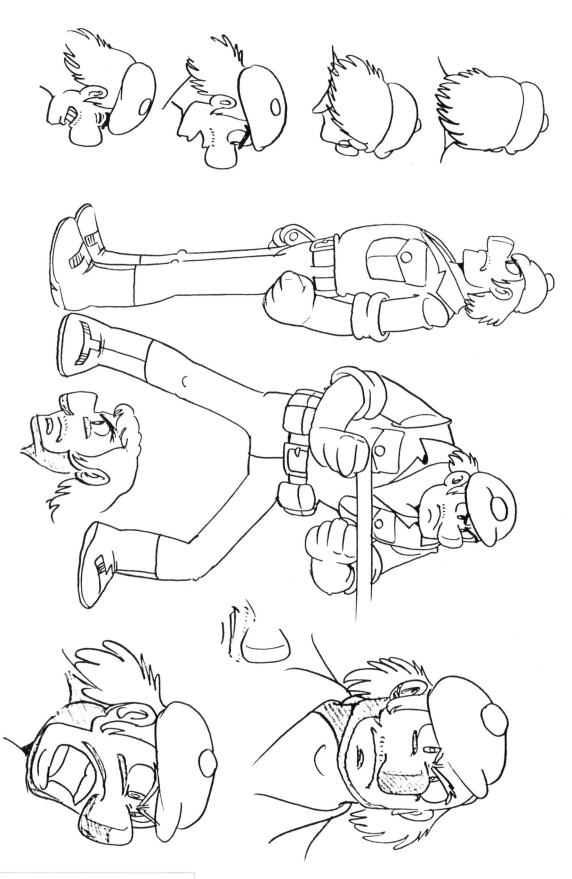

Sub-leader

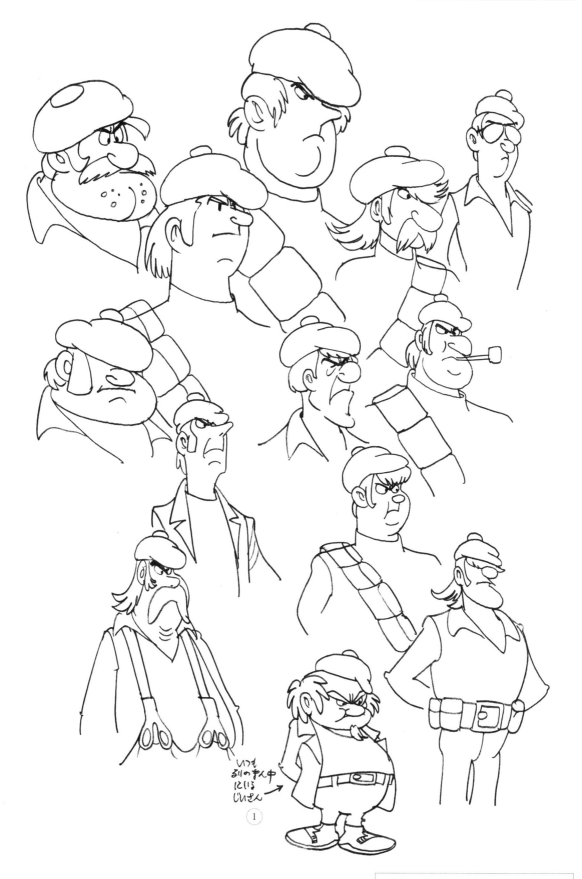

いつも
引の中
にいる
じいさん →

① 1

Resistance

1. This old man is always in the middle.

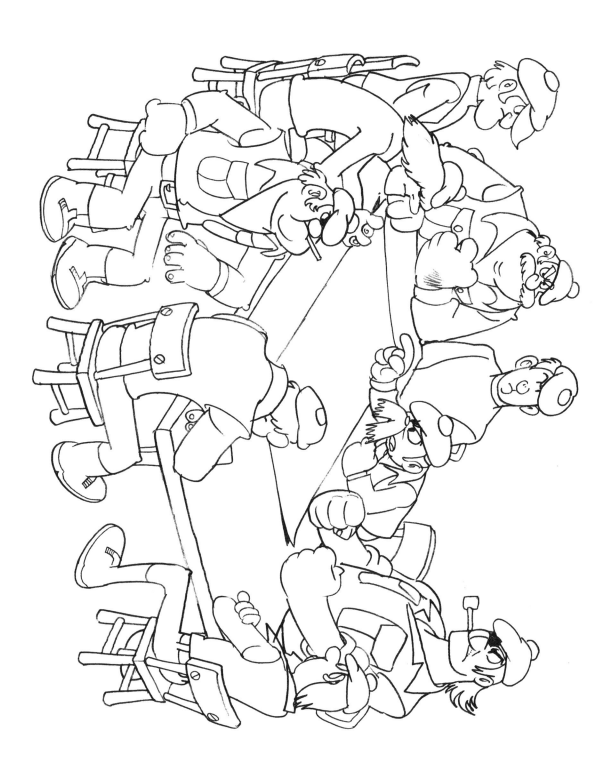

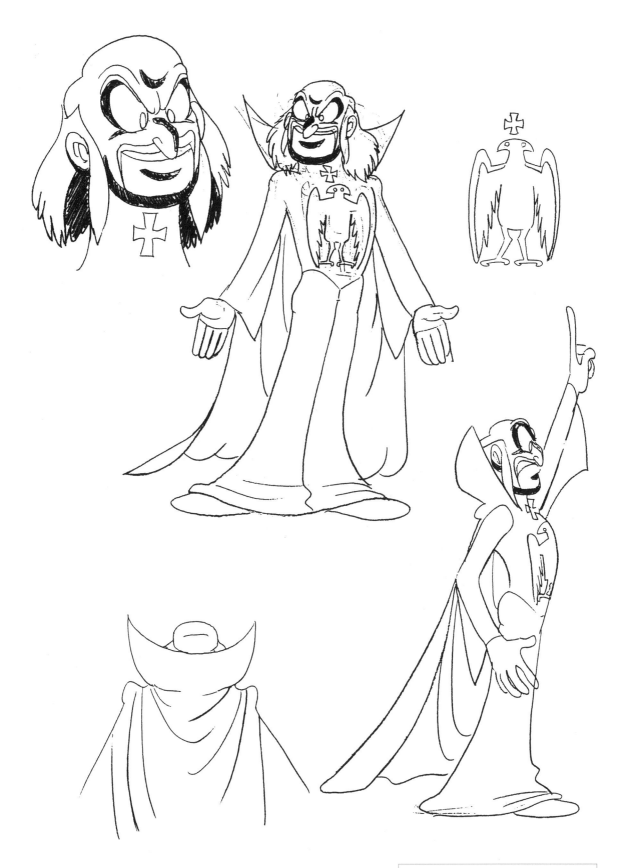

Old Presto

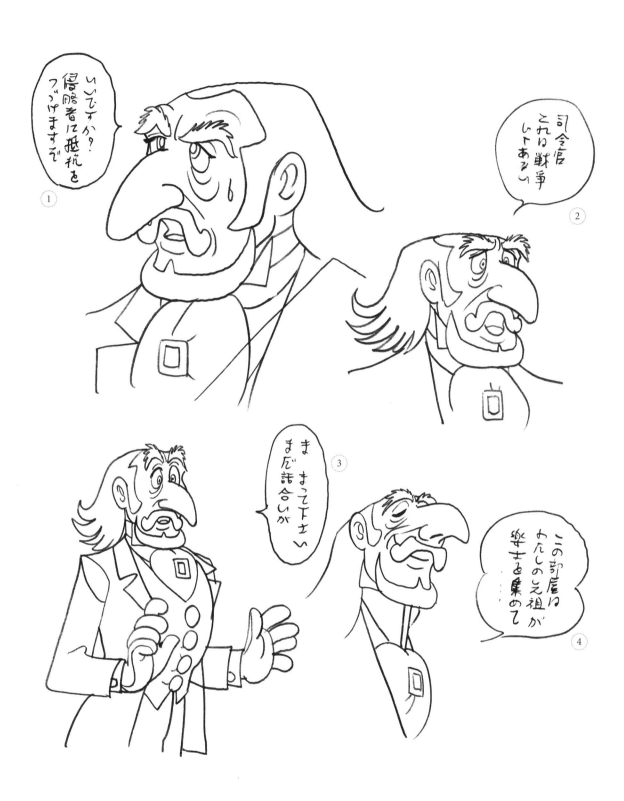

1. "Listen. We must repel the invaders."
2. "But Commander, we're not at war."
3. "P-Please wait. We're not done talking."
4. "My ancestors have always brought musicians to this room."

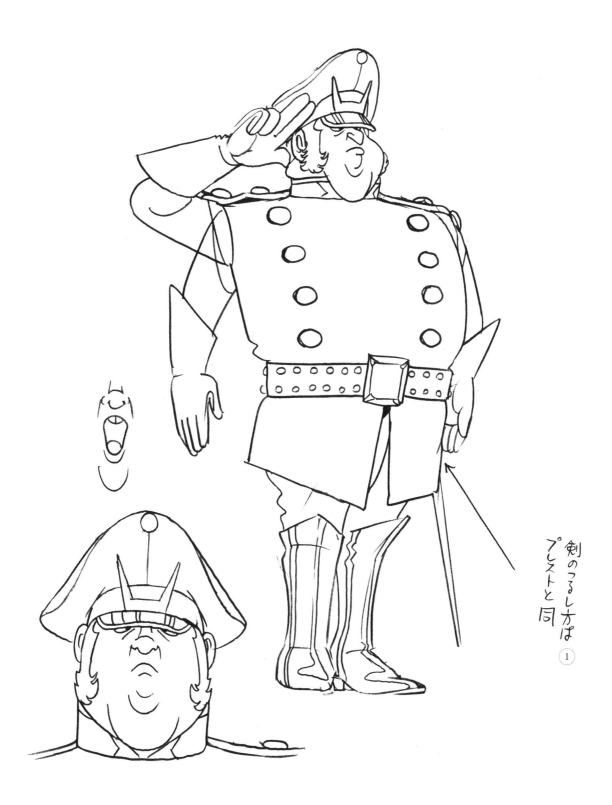

剣のつるし方は
プレストと同①

Adjutant

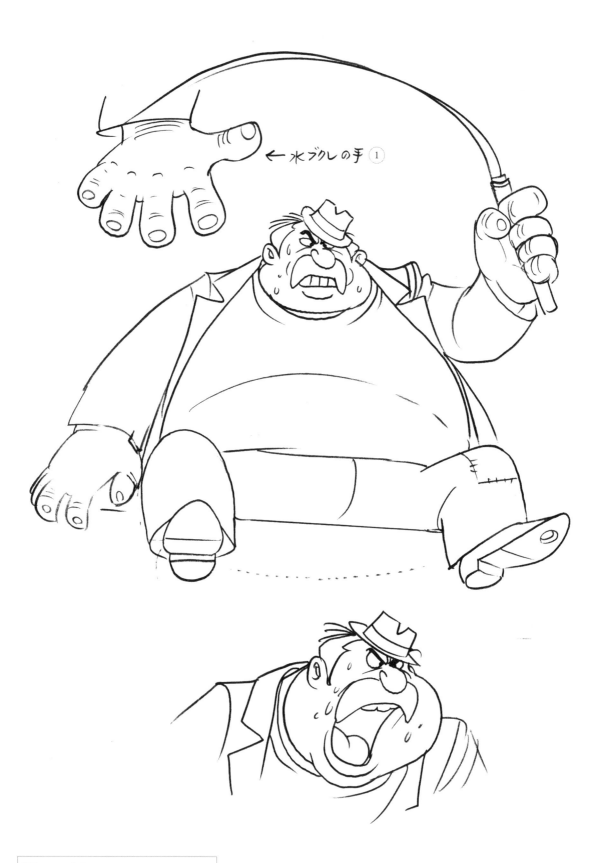

← 水ブクレの手 ①

Wagon driver

1. Bloated hands.

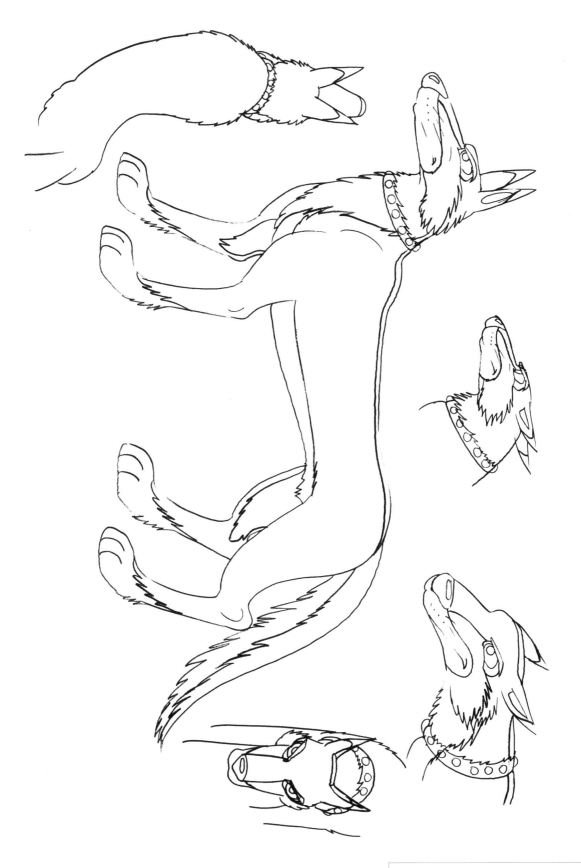

Dante

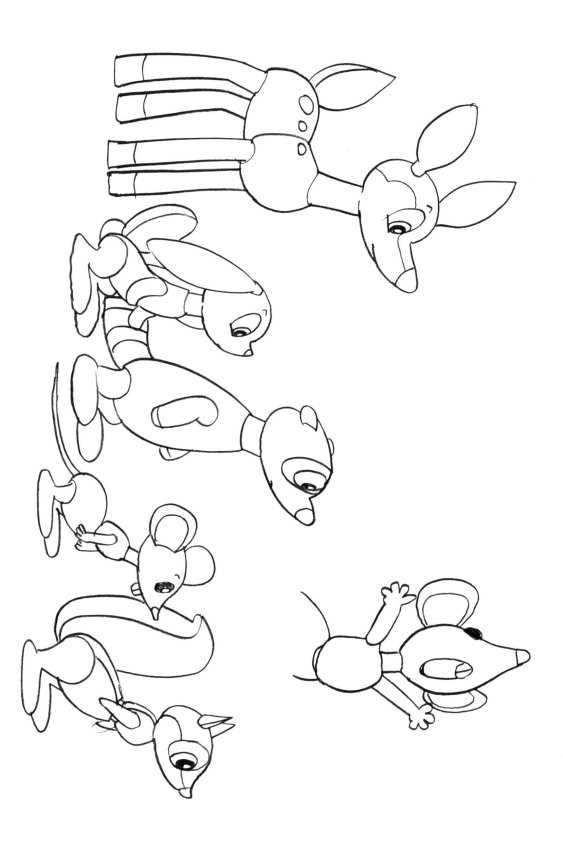

Animals of the forest (puppets in the Bremen puppet show)

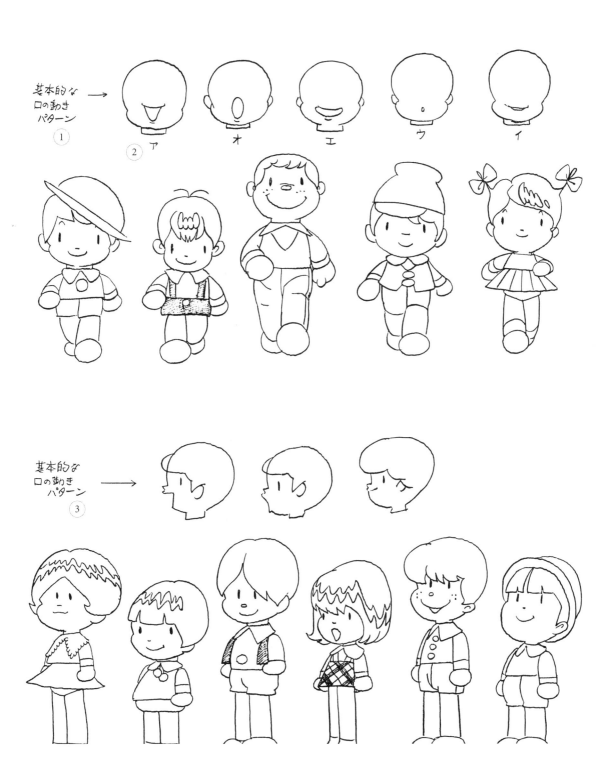

1. Basic mouth-movement patterns.
2. A - O - E - U - I
3. Basic mouth-movement patterns.

Kids and adults who chase after the Bremen 4

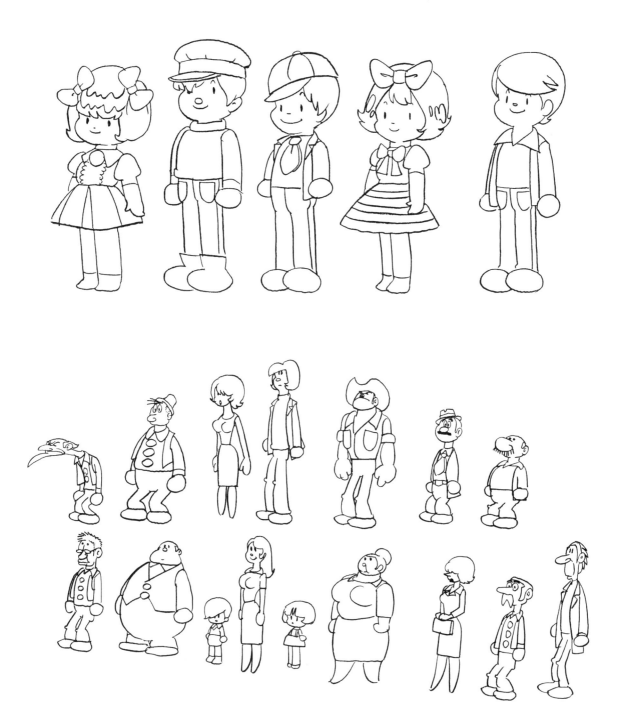

すこし大きな子（あまり数はいない）①

1. Make somewhat large (not too many of them).

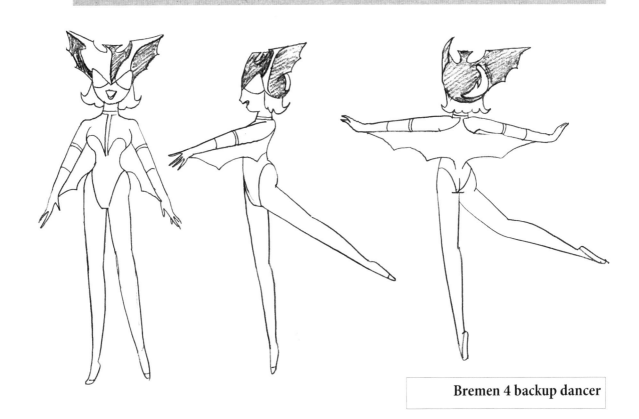

Bremen 4 backup dancer

Convenience store customer

Women preparing for the party

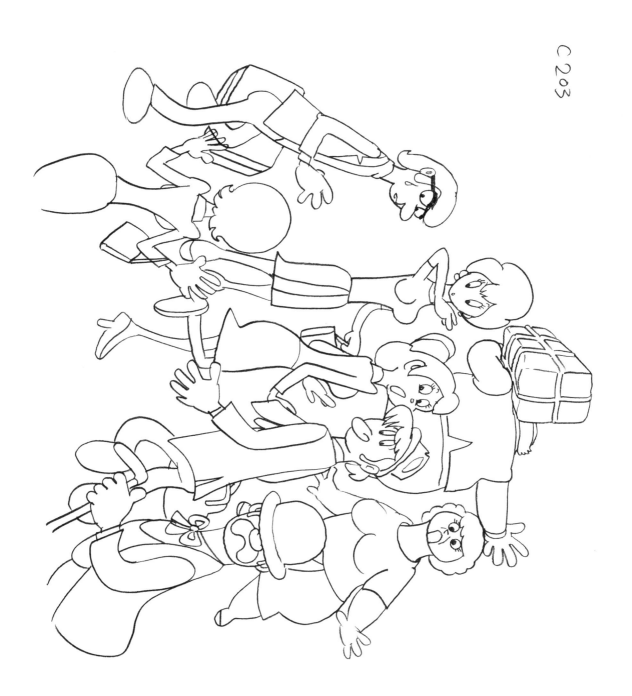

C 203

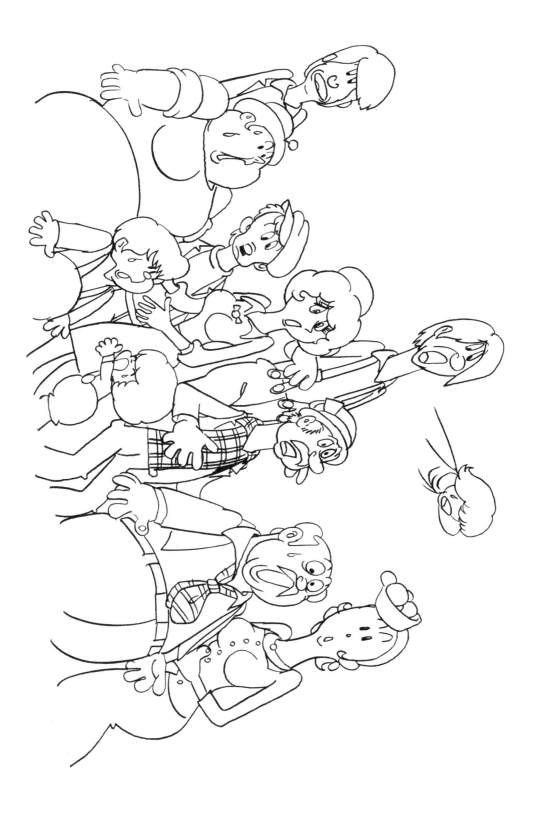

Evacuees (2)

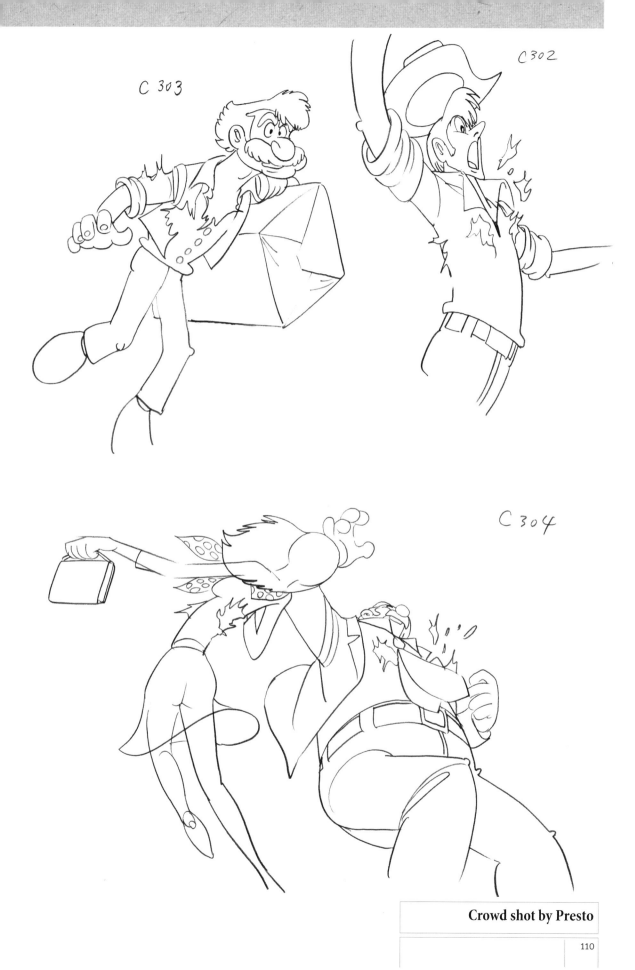

C 303

C 302

C 304

Crowd shot by Presto

C 305

C 306

299

C 309

Fat man

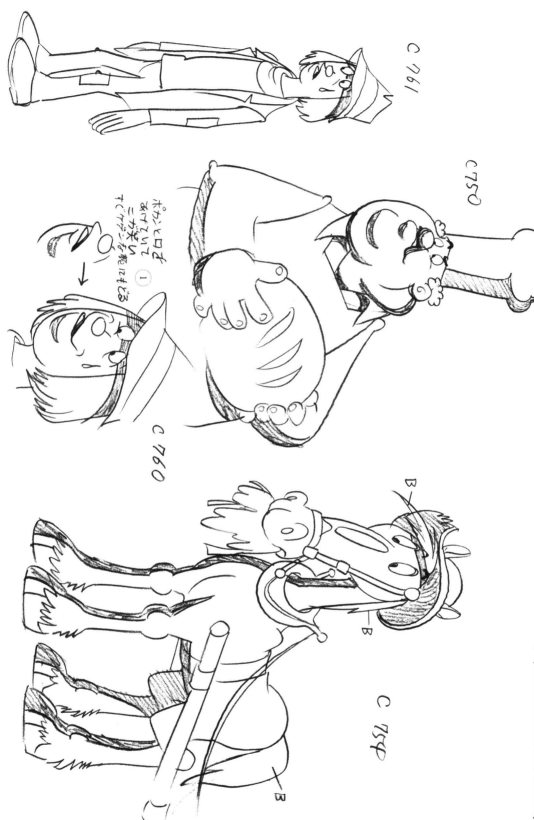

C 761

C 750

C 760

C 751

1. Open, vacant mouth; bitter smile; return to suspicious-looking face.

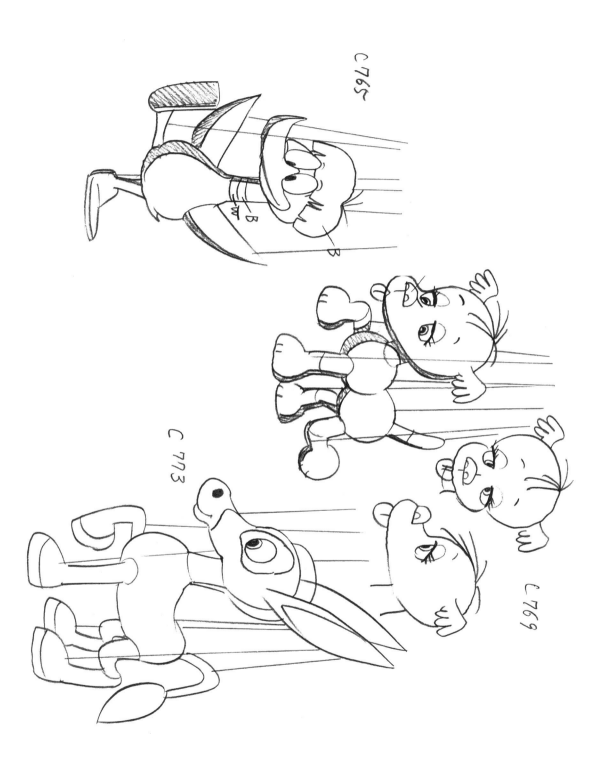

C 765

C 773

C 769

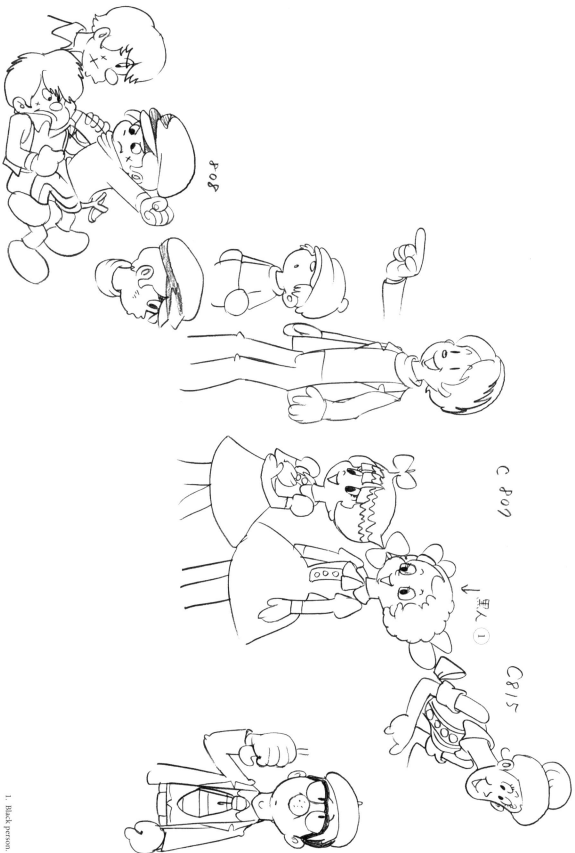

Bremen puppet show audience

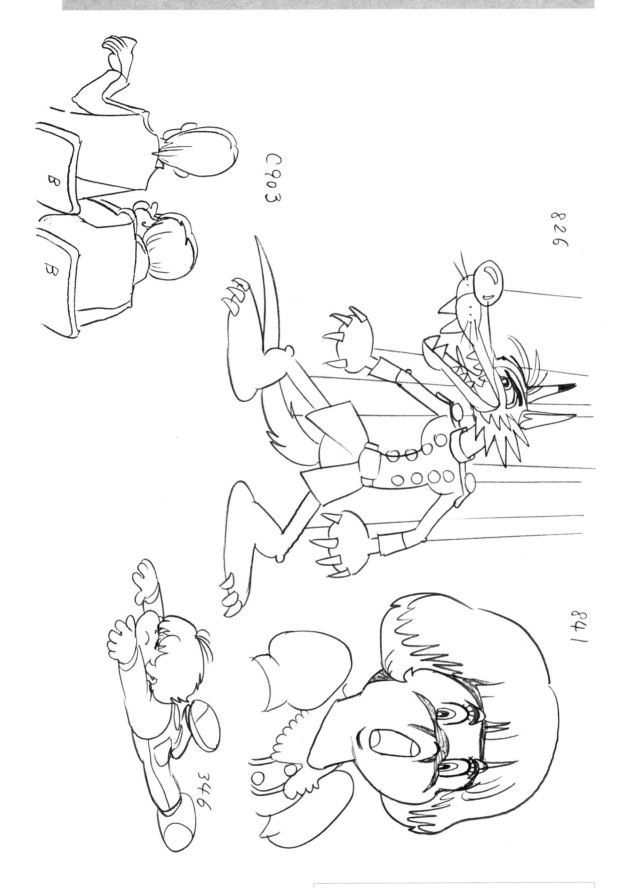

Bremen puppet show puppets and audience

C 883

C 950

Fans of Bremen 4

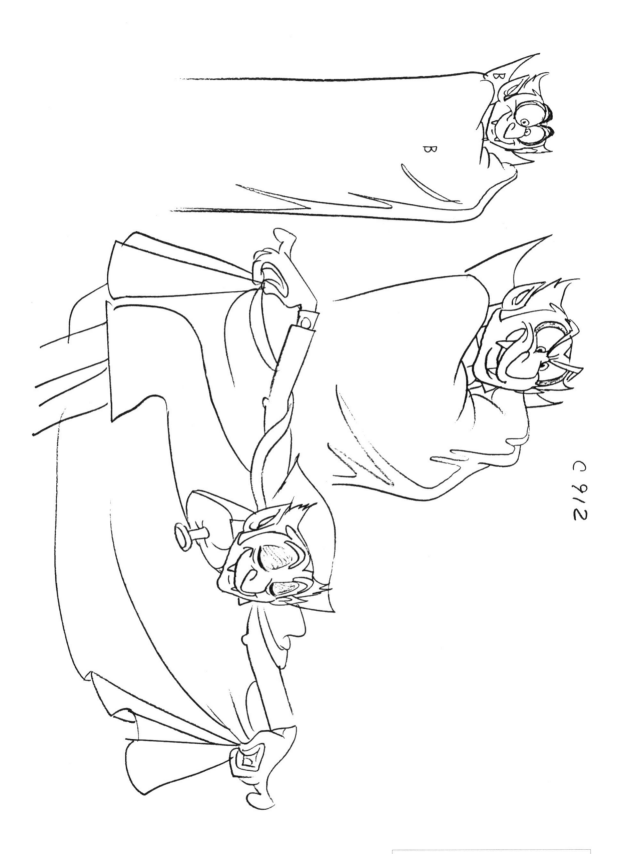

タイムスリップ10,000年 プライム・ローズ

Aired on Aug. 23rd, 1981 on Nippon TV

"A TIME SLIP OF 10,000 YEARS: PRIME ROSE"

BACKGROUND

The fifth two-hour TV anime special, which aired during the sixth "24-Hour Television: Love Saves the Earth", is an anime adaptation of the manga "Prime Rose", which was serialized in Weekly Shonen Champion from July 9th, 1982 until June 3rd, 1983. As the story hadn't finished by the time production began, Osamu Tezuka wrote a 25-page synopsis to serve as the basis for the film. Although images from the source material were used, the story in the film is different from that of the manga.

SYNOPSIS

The year is 19XX. An accident causes the orbiting military satellite "Death Mask" to split in two and crash down into Dallas (Texas, USA) and Kujukuri (Chiba, Japan). As a result, both cities are sent forward 10,000 years through time. In 20XX, Time Patroller Gai Tanbara uses a time machine to travel to Japan 10,000 years in the future in order to investigate. On a plateau covered with countless giant stone statues, Gai meets a young woman named Emiya, who is the daughter of the nobles of Kukurit: a nation ruled by rival country Guroman.

Concept, Composition, and Character Design ◉ Osamu Tezuka

Planning ◉ Tadahiko Tsuzuki

Producers ◉ Hidehiko Takei, Tetsu Dezaki (Magic Bus), Takayuki Matsutani

Director ◉ Tetsu Dezaki

Screenplay ◉ Keisuke Fujikawa

Music Producer ◉ Yuji Ono

Storyboard ◉ Noboru Ishiguro

Character Design ◉ Keizo Shimizu

Setting Design ◉ Tsuyoshi Matsumoto

Animation Director ◉ Keizo Shimizu

Art Director ◉ Shichiro Kobayashi

Original Art ◉ Setsuko Shibuichi, Yukari Kobayashi, Yutaka Kawasuji, Yuko Nakajima, Mayumi Ogura, Miki Kitagawa, Kiyoshi Nakamura, Shigetaka Kiyoyama, Kazuhiko Udagawa, and others

Director's Assistant ◉ Naoto Hashimoto

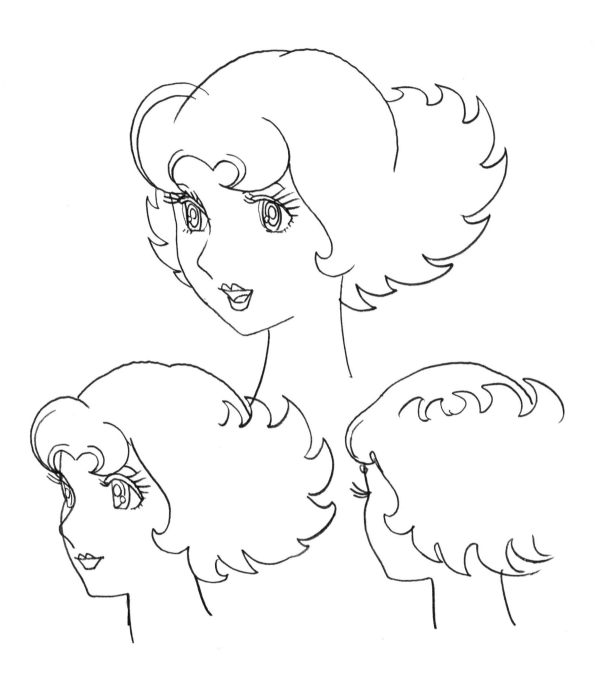

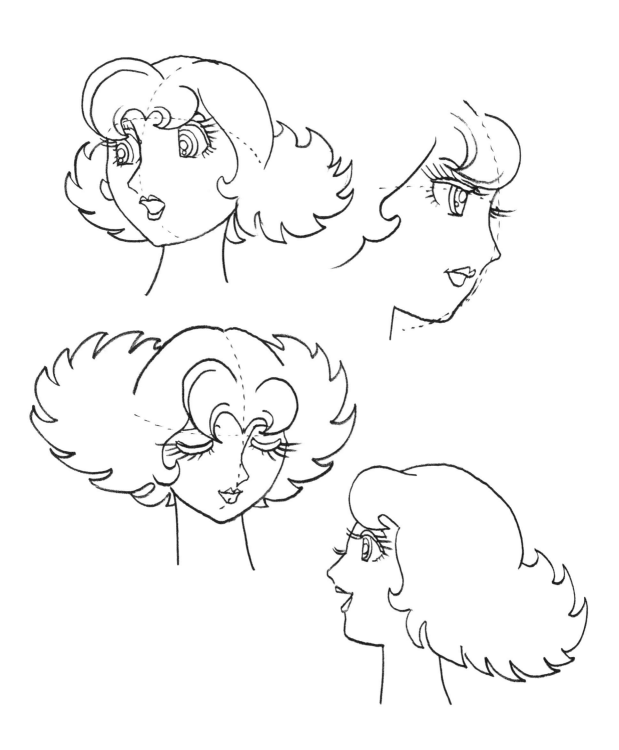

A Time Slip of 10,000 Years: Prime Rose

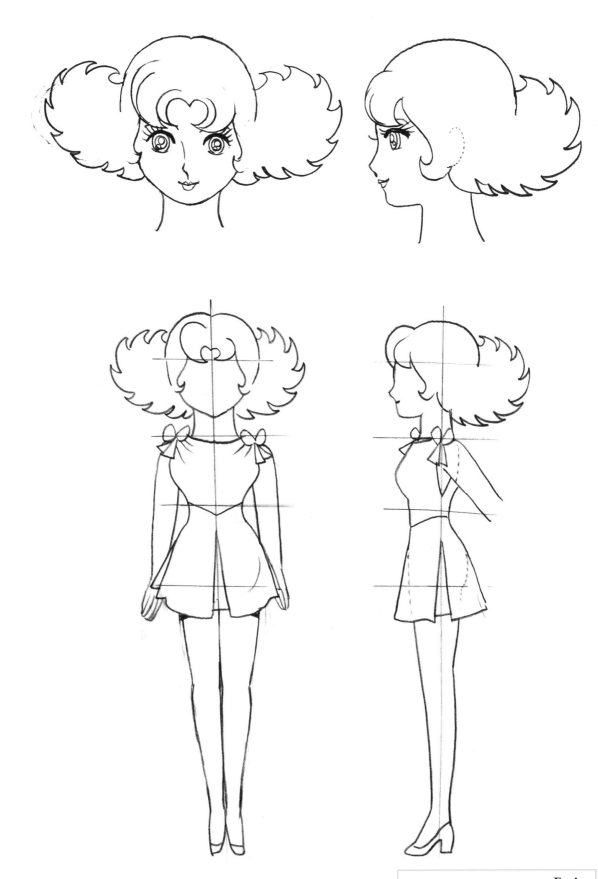

Emiya

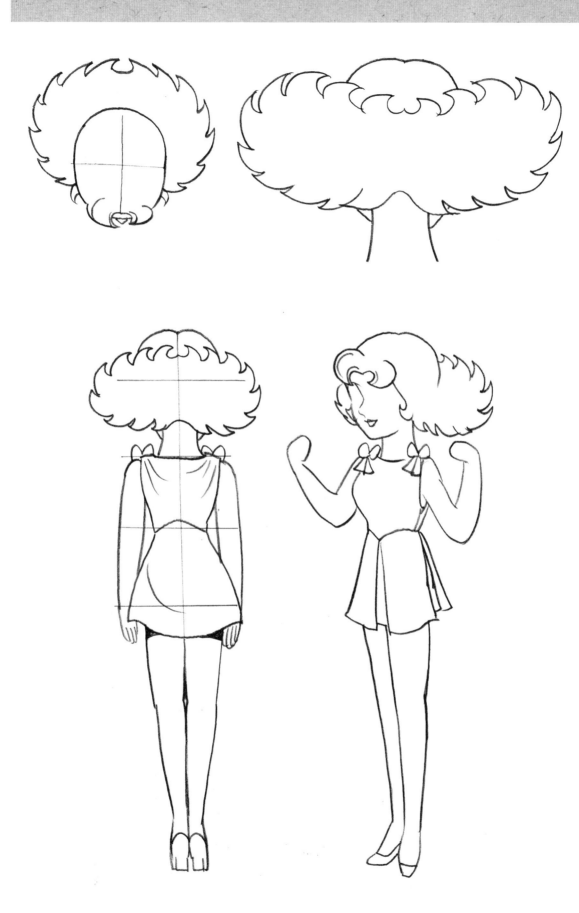

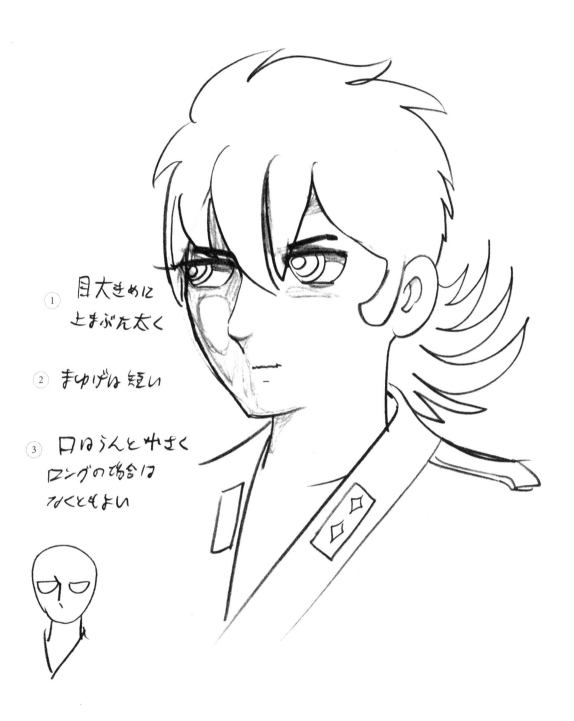

① 目大きめに
　上まぶた太く

② まゆげは短い

③ 口はうんと小さく
　ロングの場合は
　なくともよい

1. Large eyes with heavy eyelids.
2. Short eyebrows.
3. Mouth is short. Disappears entirely in long shots.

Gai Tanbara

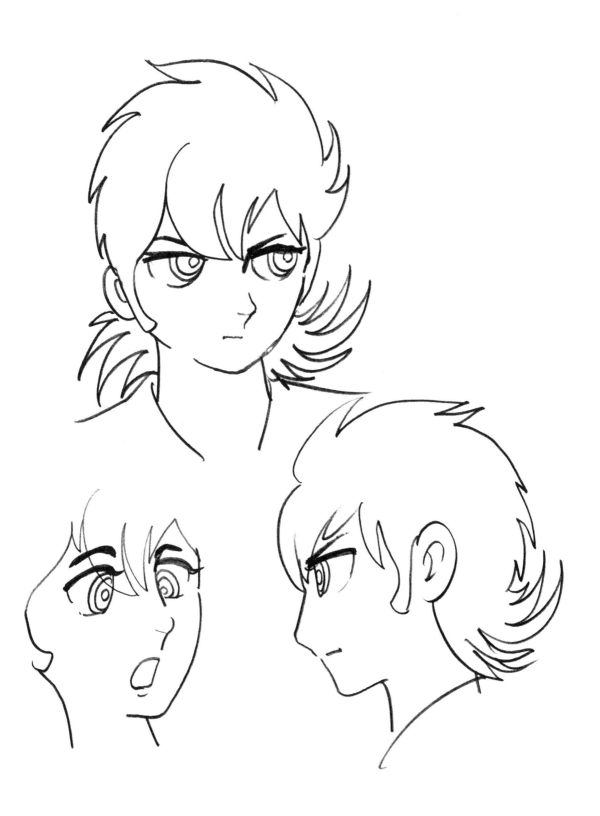

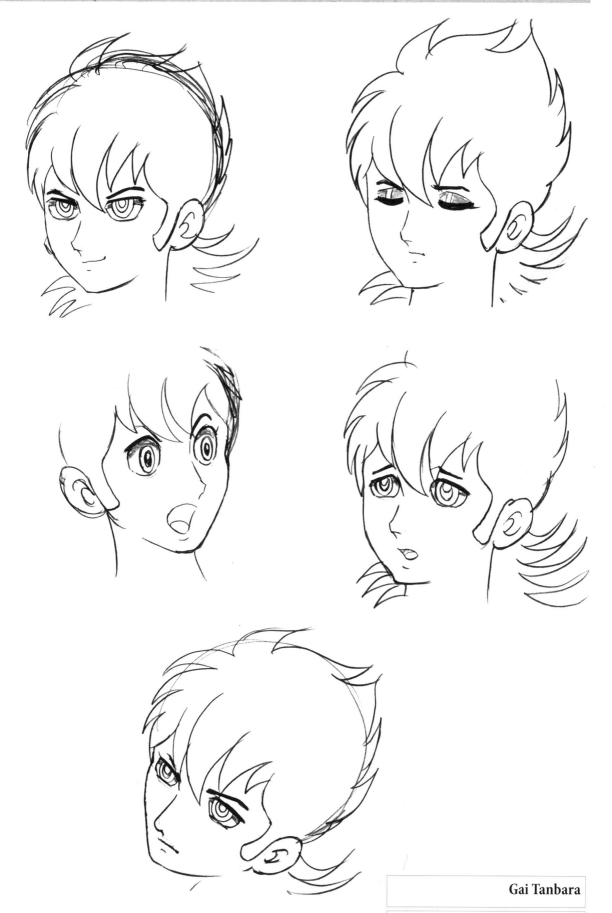

Gai Tanbara

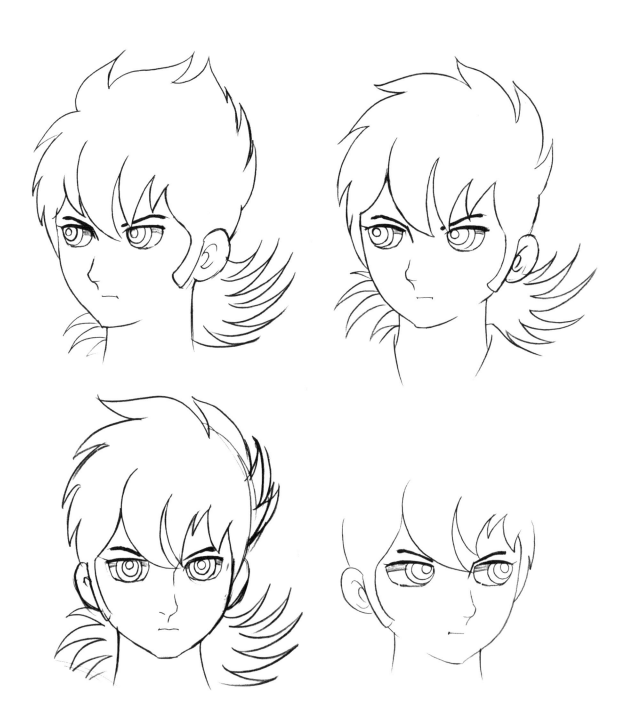

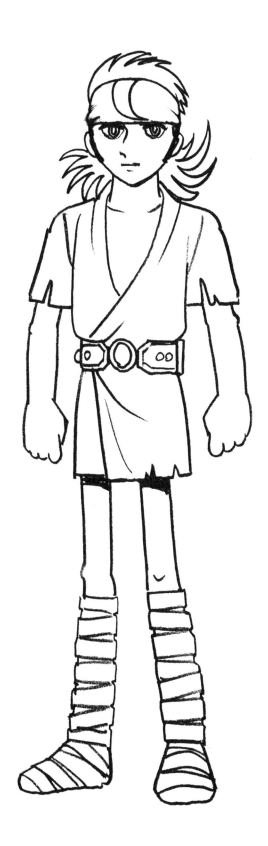
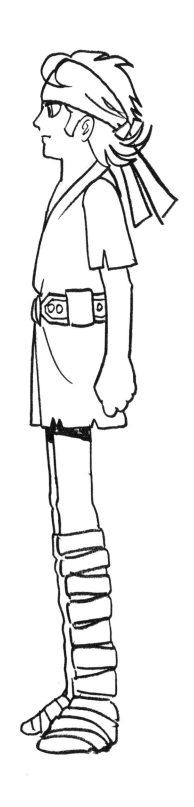

Gai Tanbara

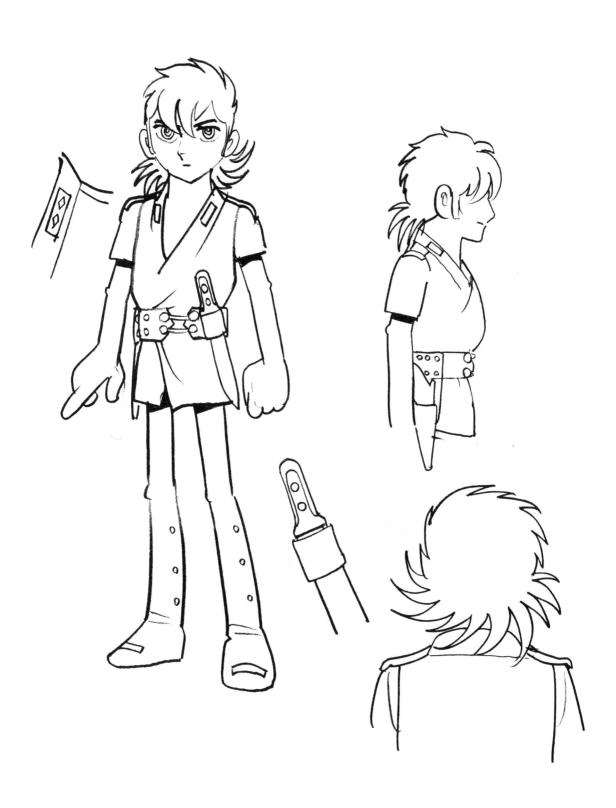

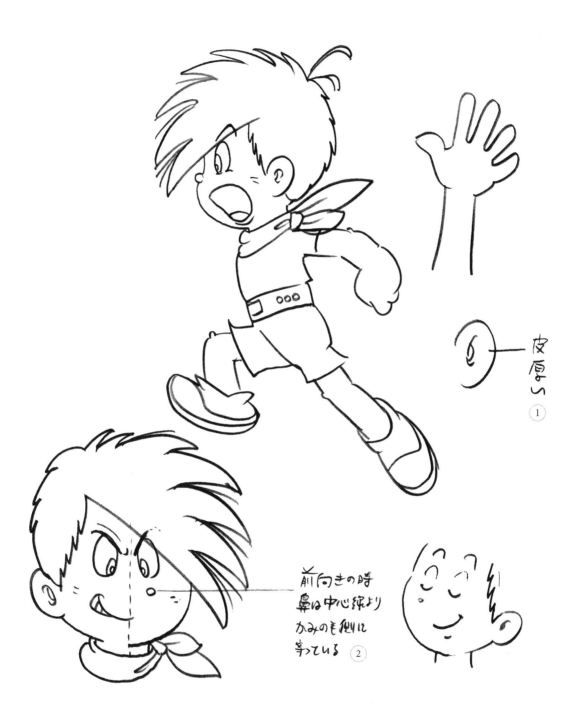

前向きの時
鼻は中心線より
かみの毛側に
寄っている ②

皮厚い ①

Bunretsu Tanbara

1. Thick skin here.
2. When facing forward, nose should be on the side where the hair is, off from the center line.

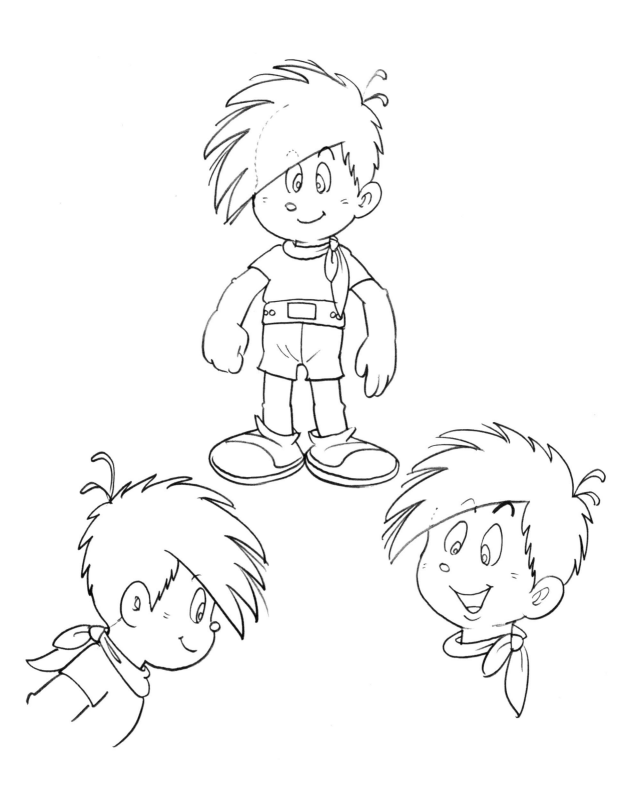

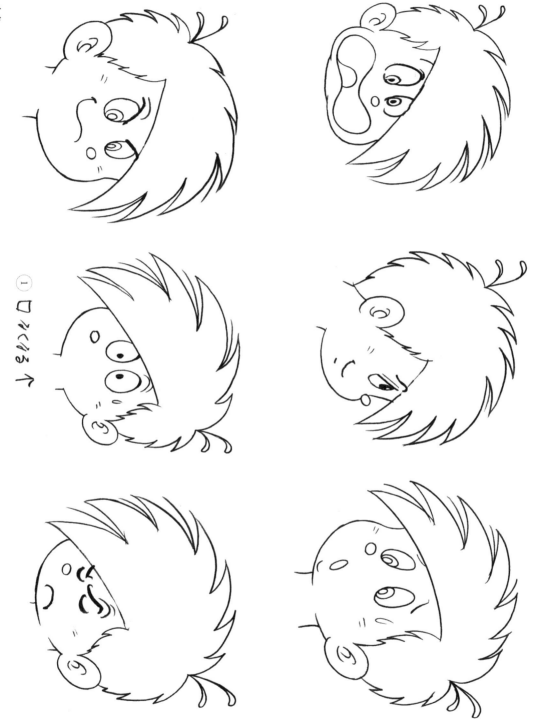

Bunretsu Tanbara

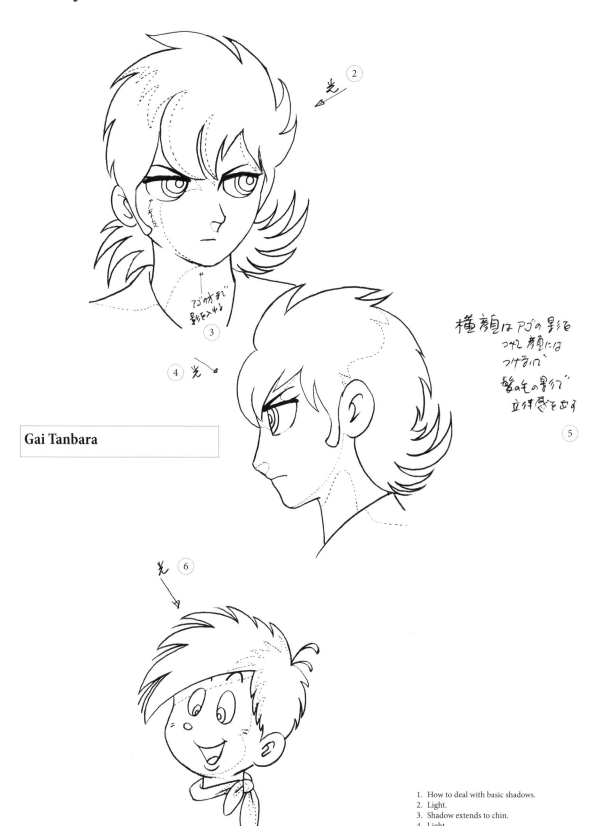

Gai Tanbara

Bunretsu Tanbara

1. How to deal with basic shadows.
2. Light.
3. Shadow extends to chin.
4. Light.
5. In the side profile, don't add shadows to his face. Use the shadows on his jawline and in his hair to bring out the dimensions.
6. Light.

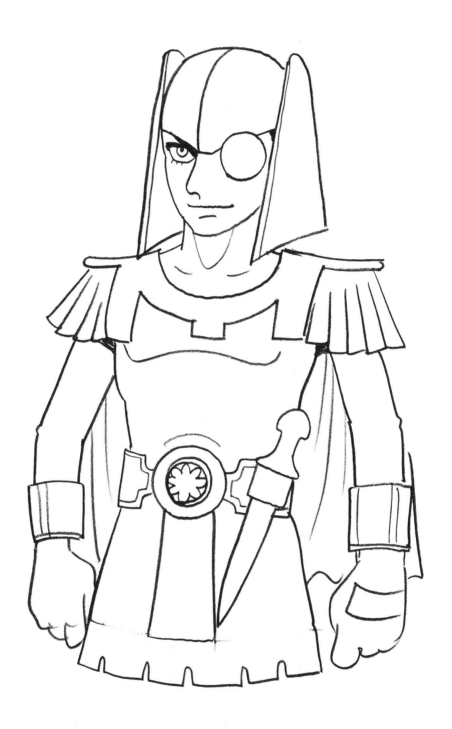

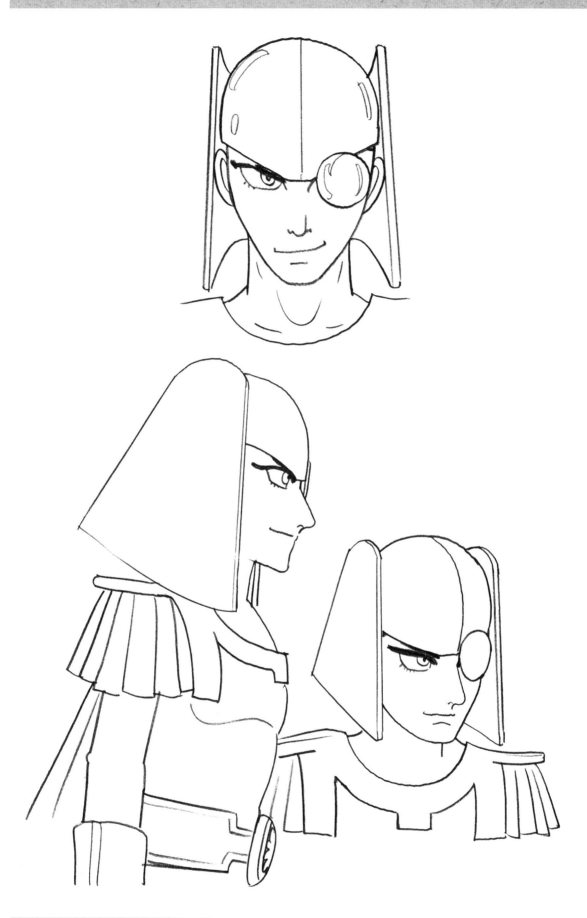

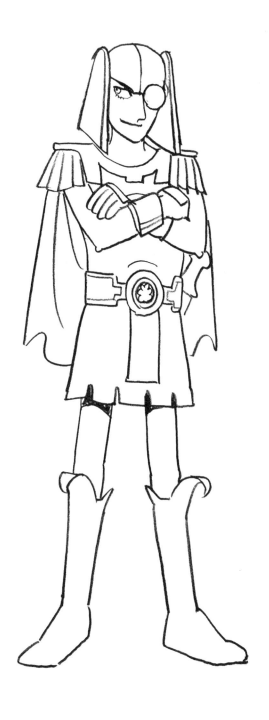
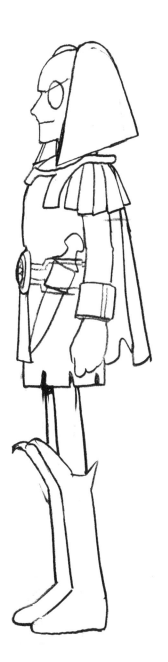

Pirar

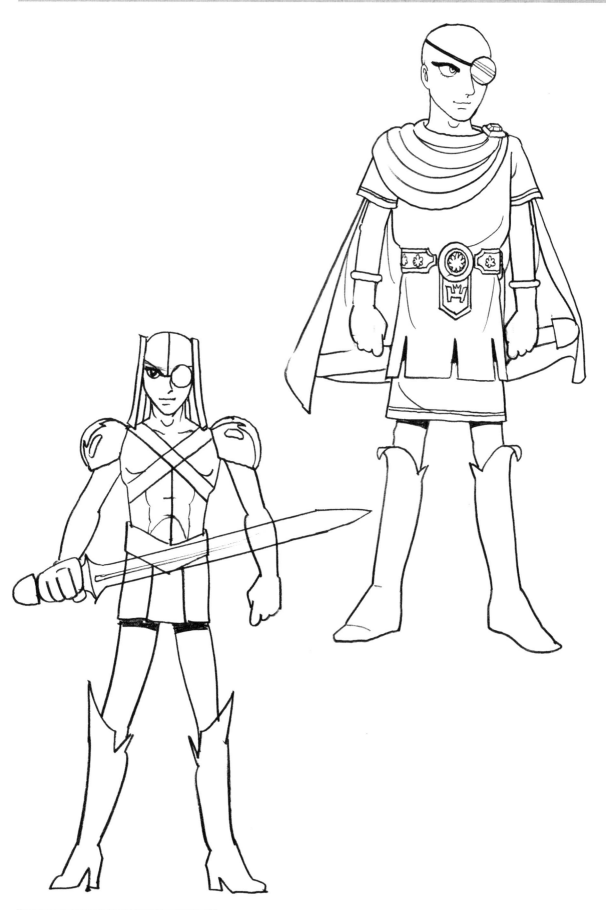

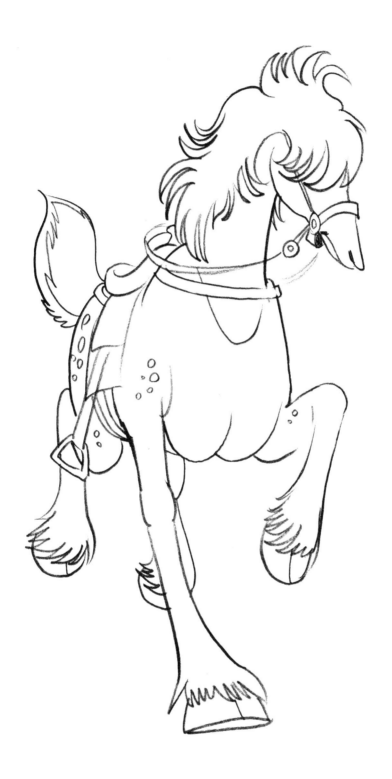

Jinba's horse

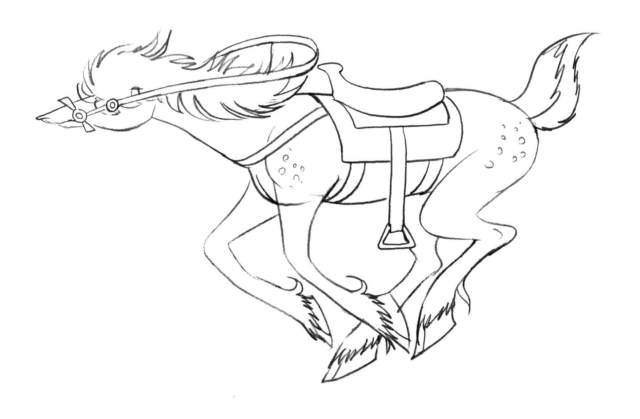

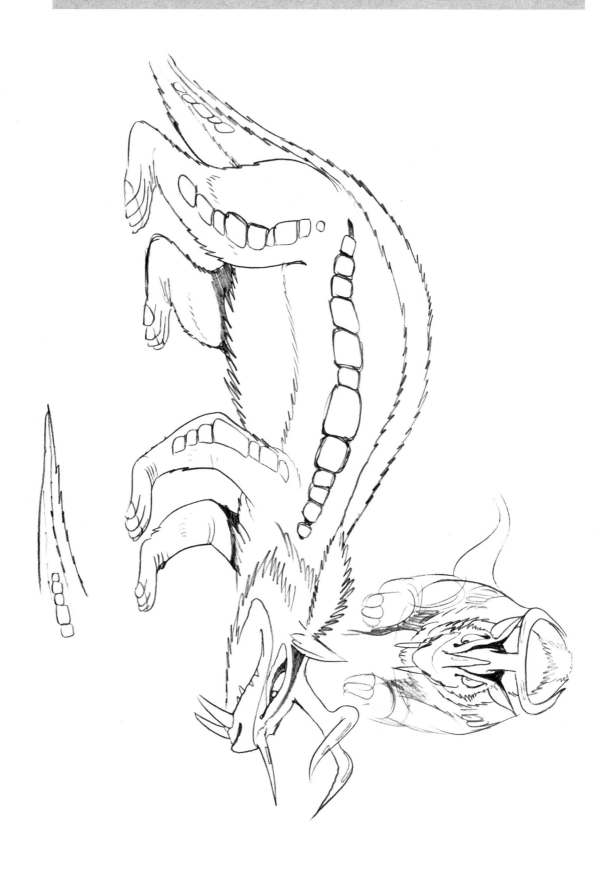

Fire dragon

大自然の魔獣 バギ

"BAGI, THE MONSTER OF MIGHTY NATURE"

Aired on Aug. 19th, 1984 on Nippon TV

BACKGROUND

A two-hour TV anime special that aired during the seventh "24-Hour Television: Love Saves the Earth". Osamu Tezuka drew his first original storyboard in a long while for this special, while at the same time creating original characters and taking on a number of production tasks in a whirlwind effort. Unlike past productions, none of Tezuka's typical characters are featured here. What's more, it's the only one of his stories to be set in the present day.

SYNOPSIS

Ryosuke's father is a crime reporter and his mother is a scientist. With neither parent at home to raise him, Ryosuke becomes a delinquent and joins a gang. On his 15th birthday, a cat named Bagi (who Ryosuke had raised as a child) appears before him, now as a woman, wanting to know what she really is. The two learn from Ryosuke's father, Sosuke, that Bagi was found outside Ryosuke's mother's laboratory, so they travel to the lab to learn the truth. It turns out that Bagi is a new life-form, born of recombinant DNA experiments.

Concept, Storyboard, Rendition, Character Design, Animation Director ◉	Osamu Tezuka
Planning ◉ Tadahiko Tsuzuki	
Producers ◉ Toru Horikoshi, Takayuki Matsutani	
Music Producer ◉ Haneda Kentaro	
Rendition ◉ Kimiharu Oguma	
Art Director, Setting Design ◉ Seiji Miyamoto	
Character Design ◉ Nishimura Hiroshi	

Original Art ◉ Hiroshi Nishimura, Junji Kobayashi, Masateru Yoshimura, Kaoru Kano, Shinji Seya, Kozo Masanobu, Yasuhiko Ogata, Kazuhiko Udagawa, Seiichi Kato, Hajime Jingu, Takateru Miwa, Yutaka Tanizawa, Shinya Takahashi, Akihiro Kanayama, Mayumi Hirota, Toshi Noma, Yuri Chiaki, Kazuo Ohara, Katsumasa Kanazawa, Shinichi Suzuki, Yumiko Kanaumi, Hideaki Shimada, Osamu Tezuka

Color Coordination ◉ Osamu Tezuka, Kazumi Suzuki, Yoshiko Masuda, Rika Fujita

Art Board ◉ Seiji Miyamoto, Setsuko Ishizu

Backgrounds ◉ Masaharu Hirashiro, Sadakazu Akashi, Testuhito Shimono, Setsuko Ishizu, Tadashi Nomura, Tezuka Productions Manga Section

Mechanical Design ◉ Kunio Aoi

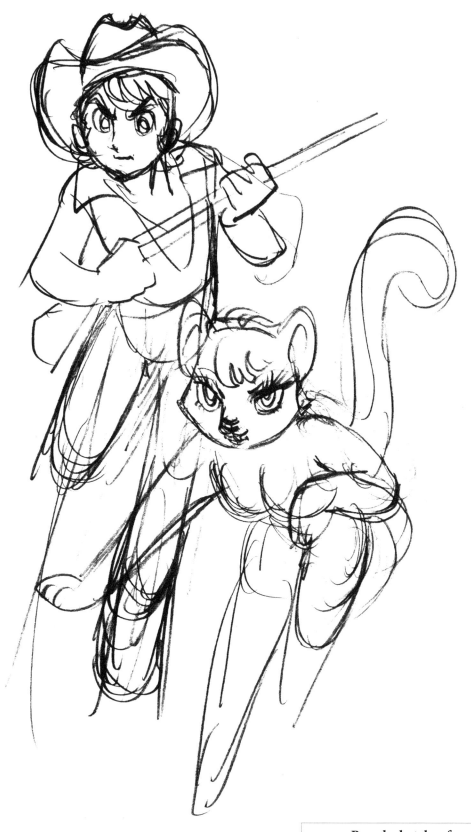

Rough sketches for stills

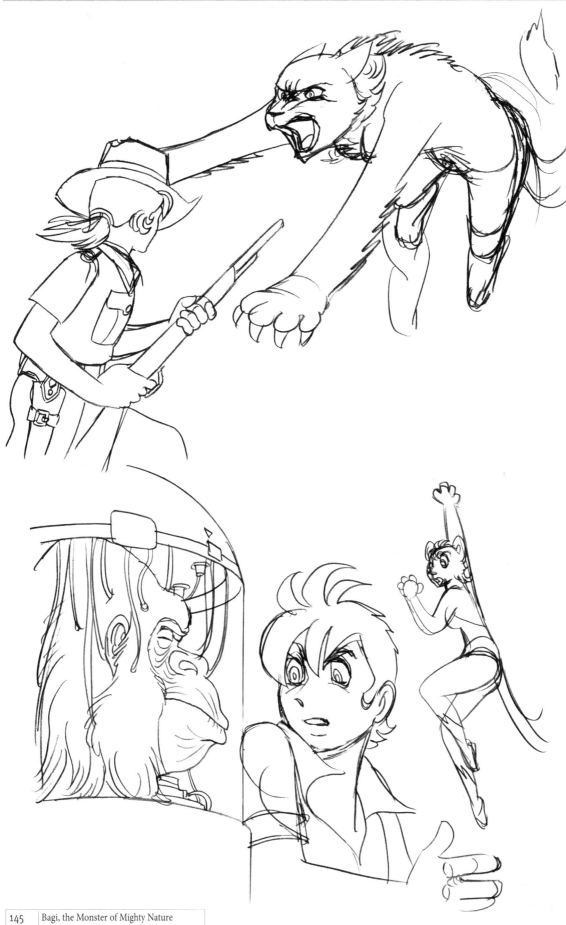

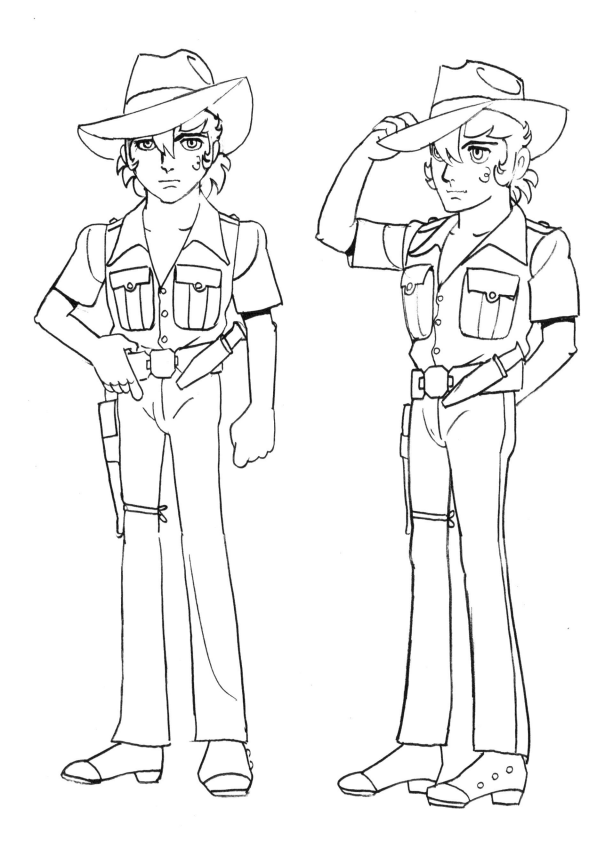

Ryosuke (hunter)

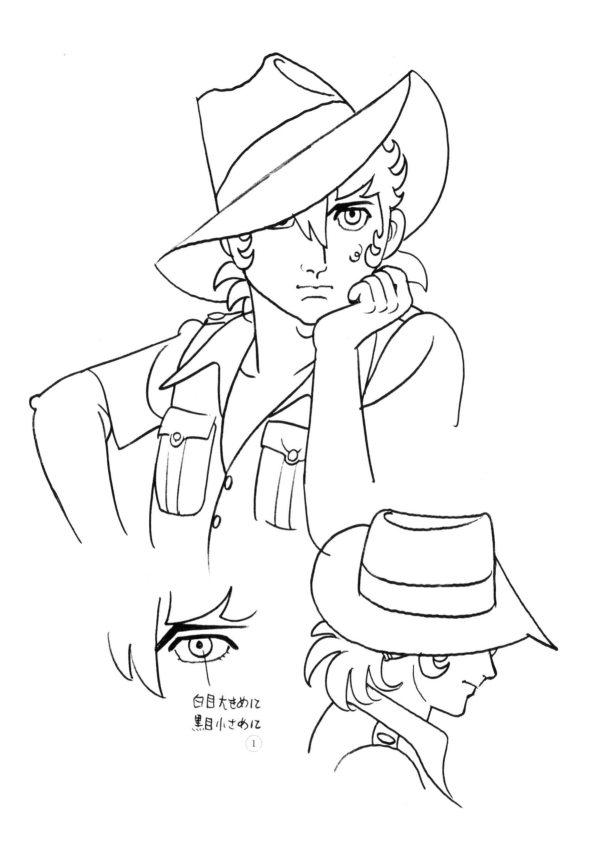

白目大きめに
黒目小さめに

①

1. Small black pupil in large white eye.

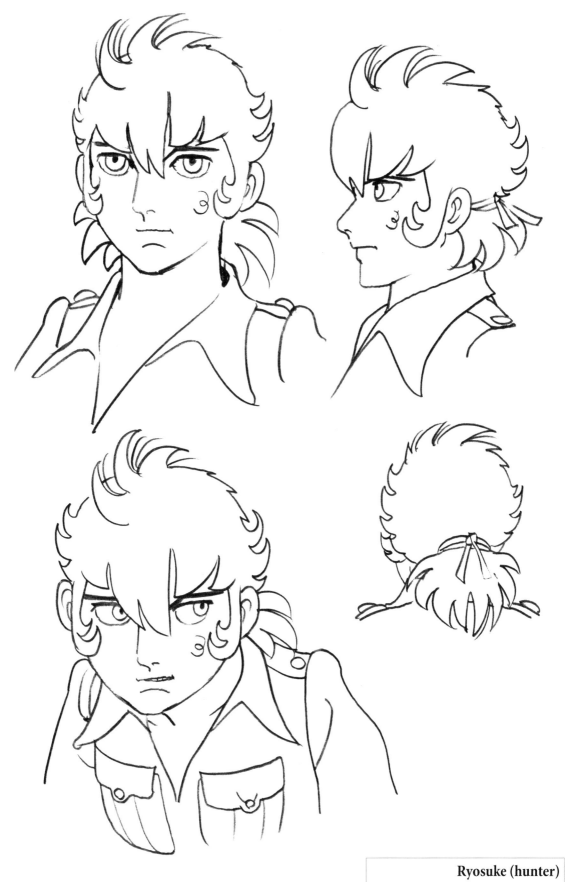

Ryosuke (hunter)

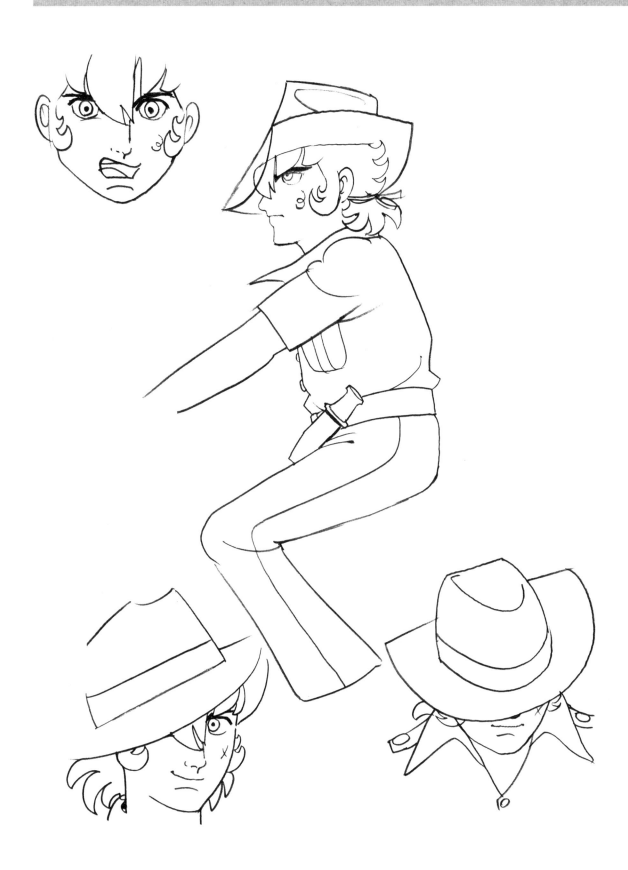

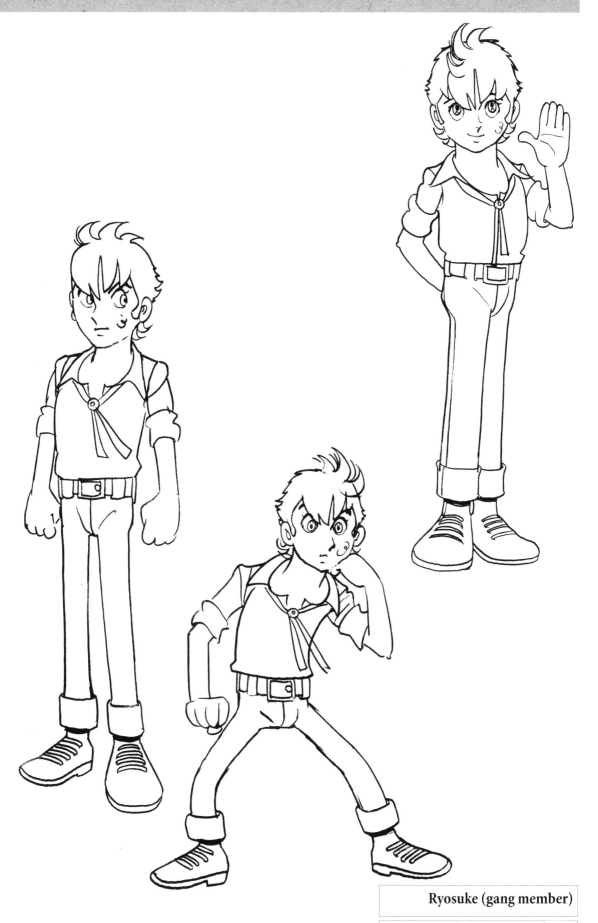

Ryosuke (gang member)

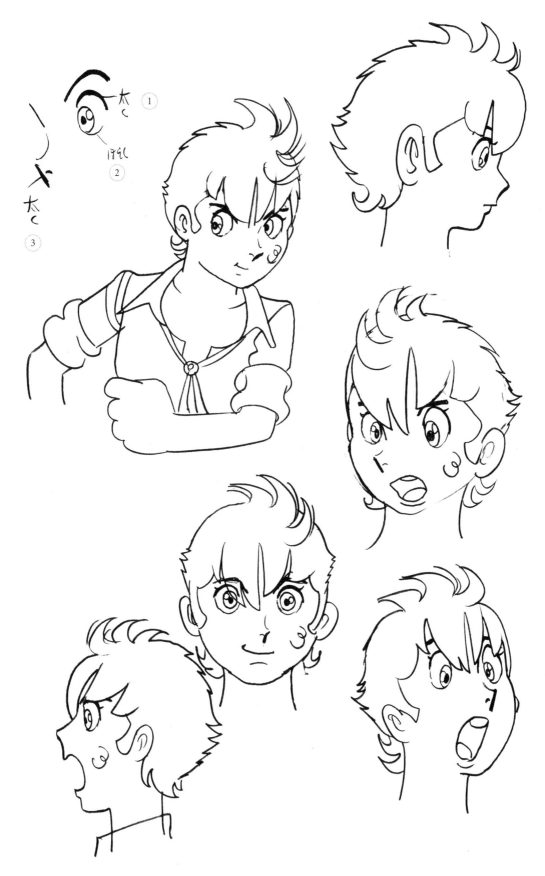

1. Thick.
2. Thin.
3. Thick.

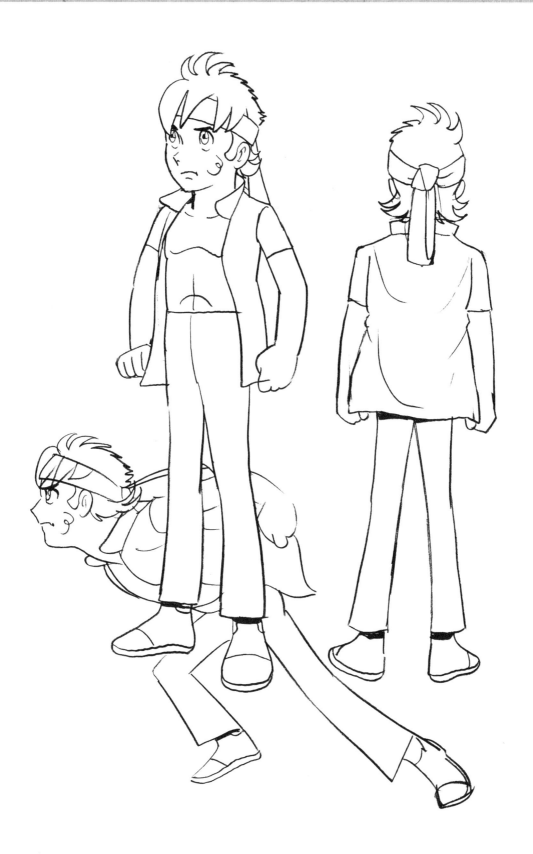

Ryosuke (gang member)

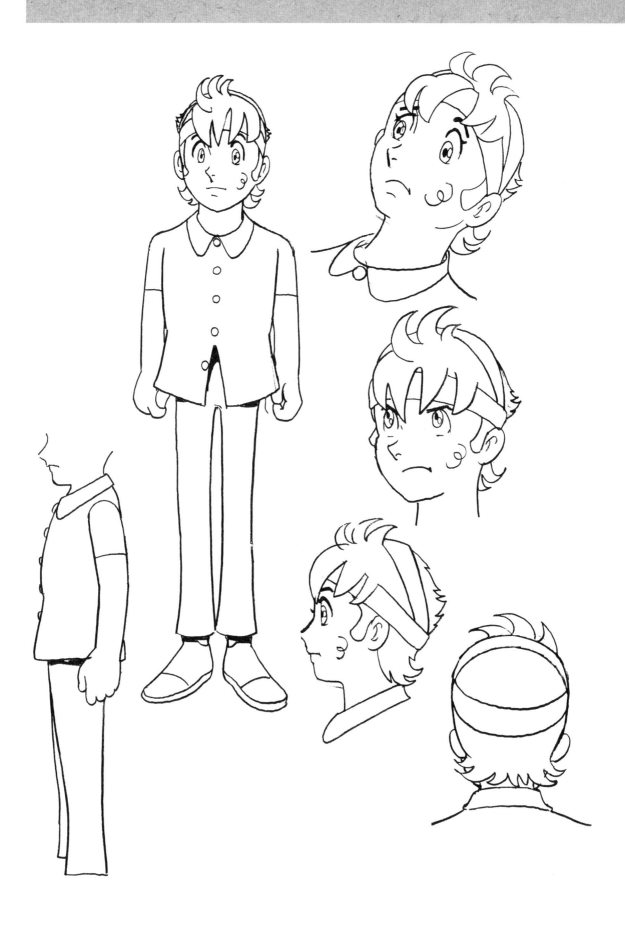

Child Ryosuke and young Bagi

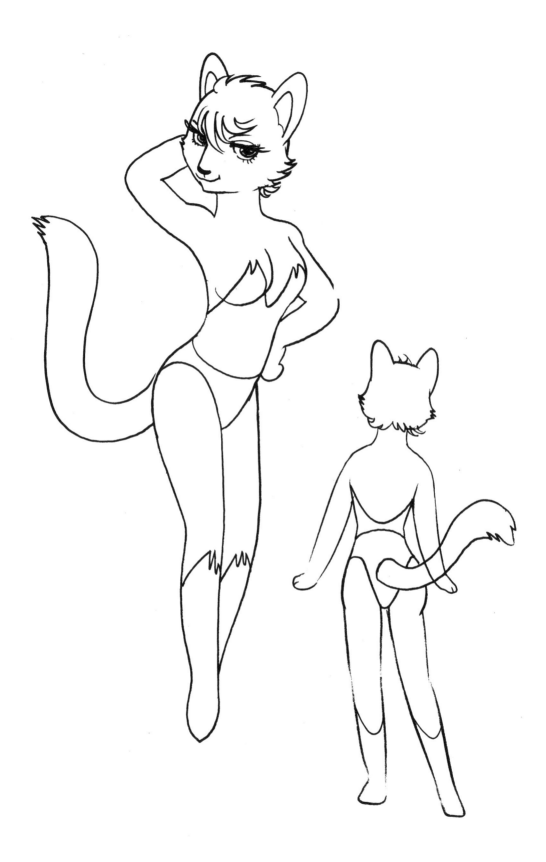

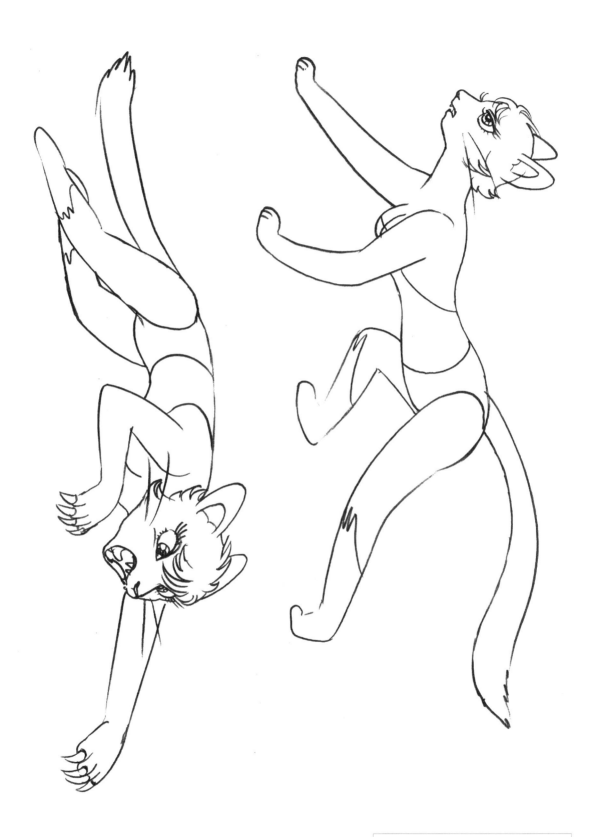

Bagi

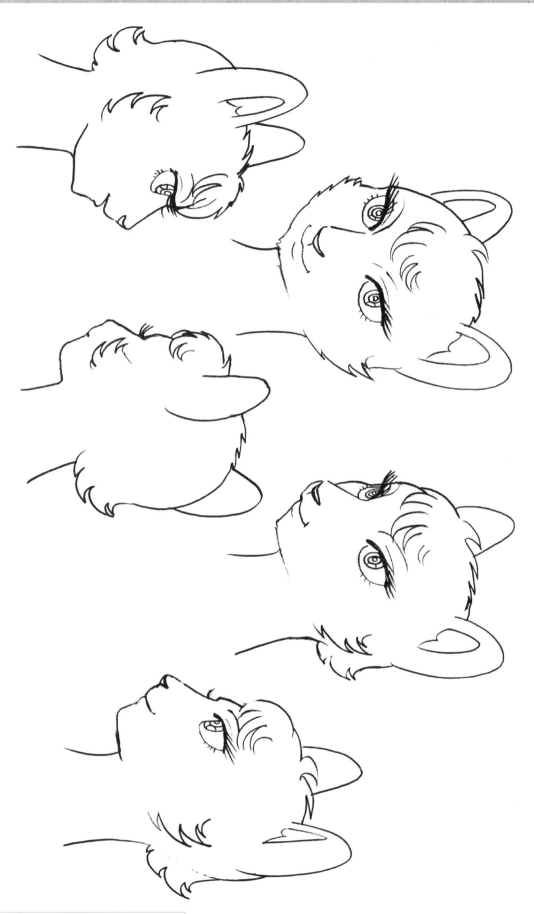

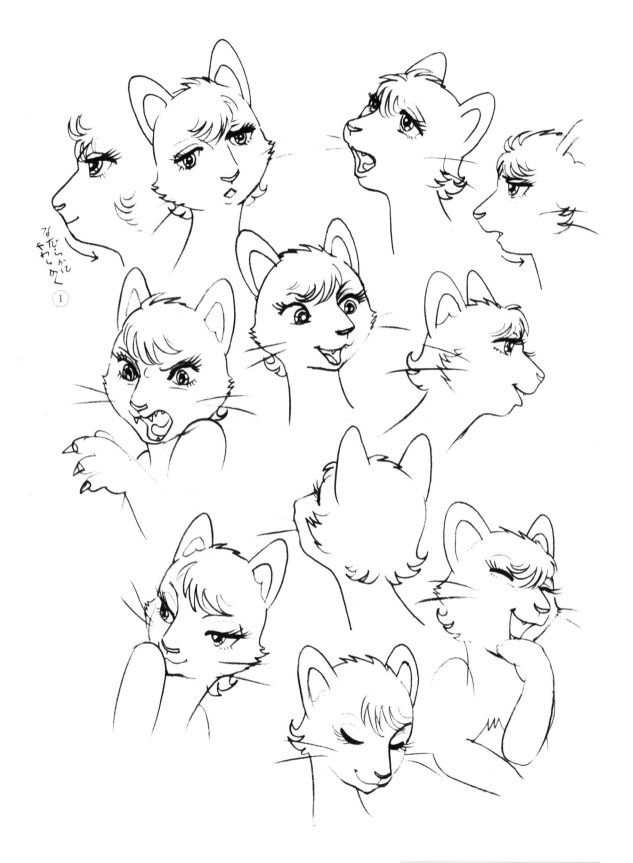

なだらかに
やわらい例

①

Bagi

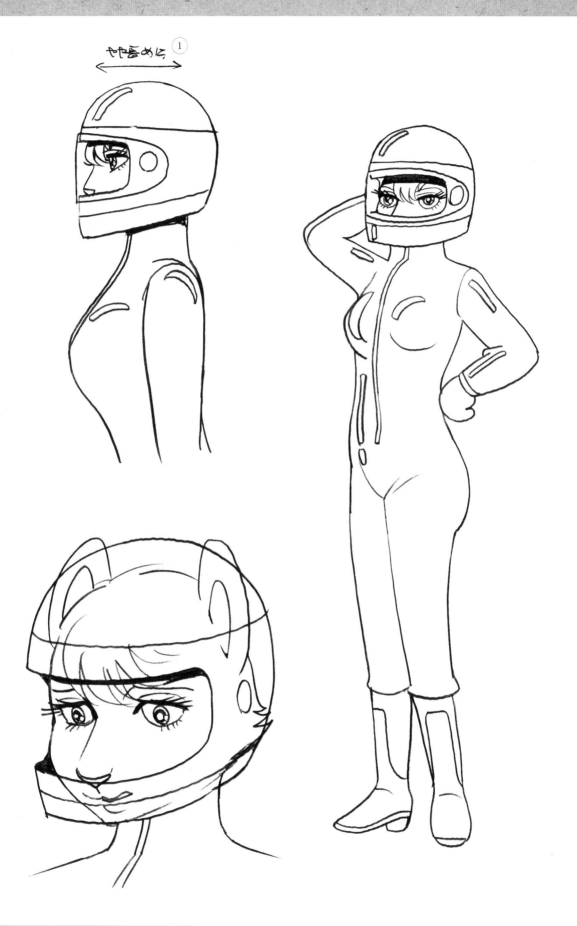

やや高めに

①

1. Fairly long.

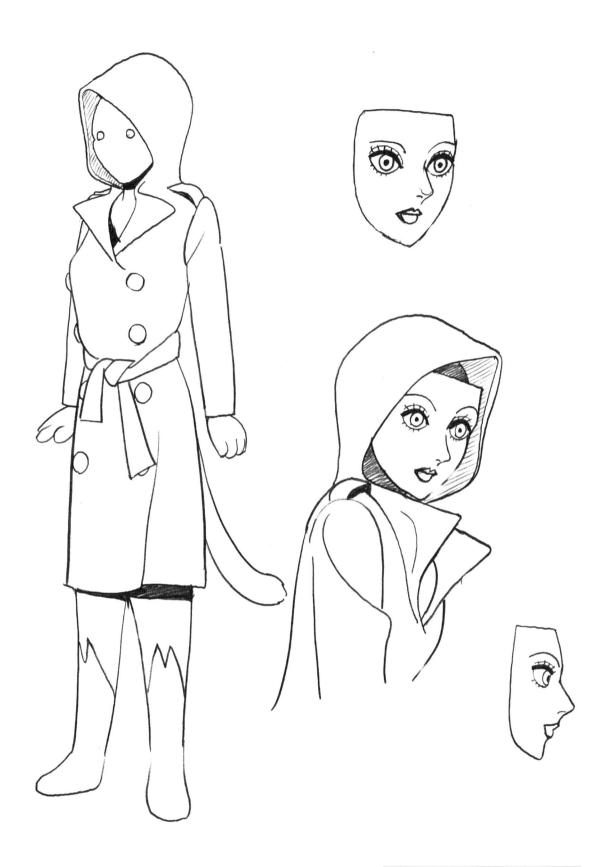

Bagi

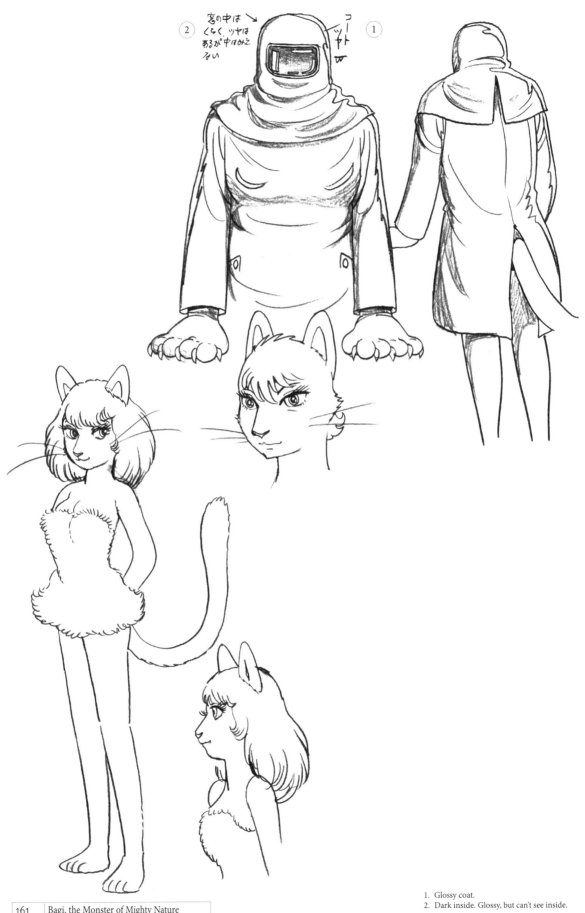

窓の中は
くらく、ツヤは
あるが中はみえ
ない

コートッ
ット
ツ

② ①

1. Glossy coat.
2. Dark inside. Glossy, but can't see inside.

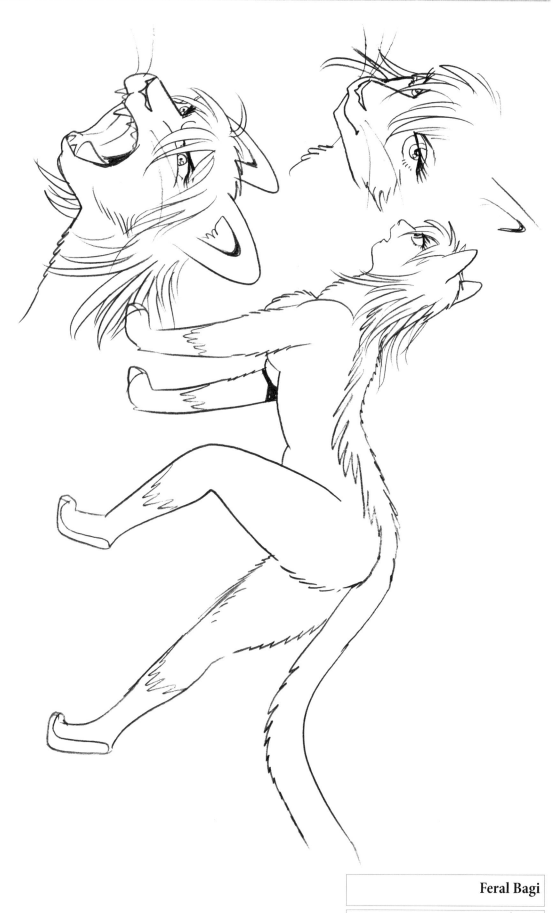

Feral Bagi

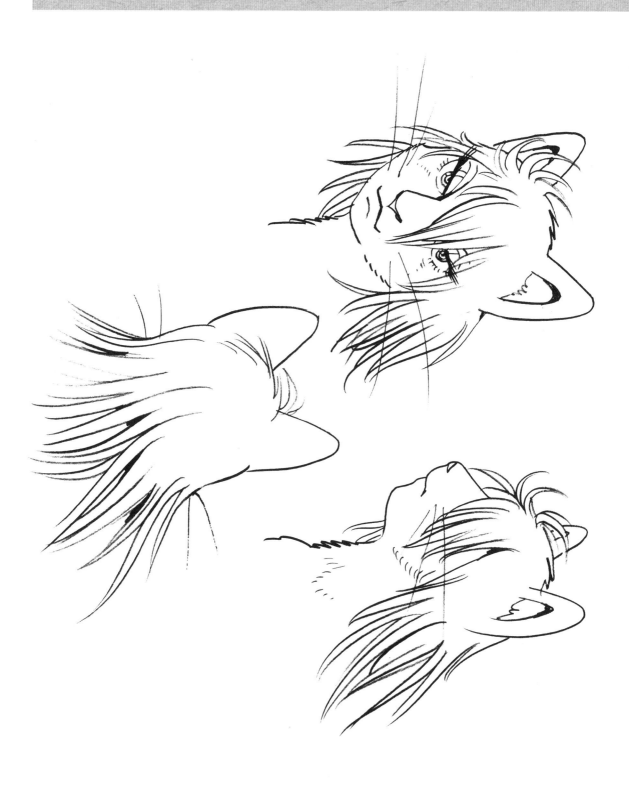

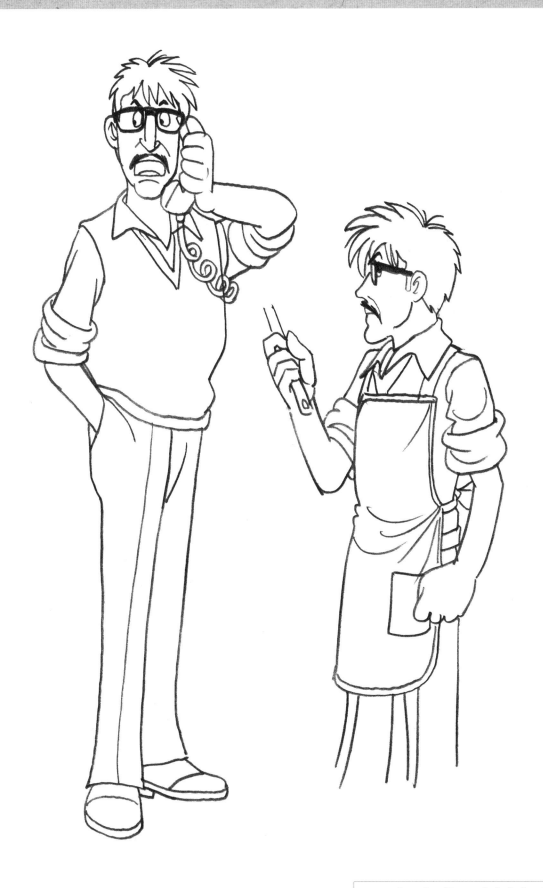

Sosuke (Ryosuke's father)

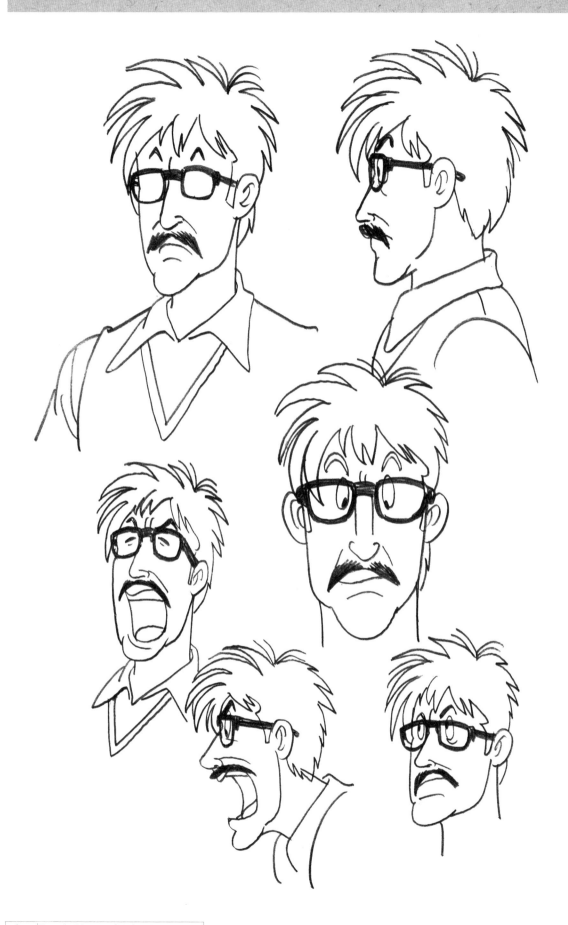

Bagi, the Monster of Mighty Nature

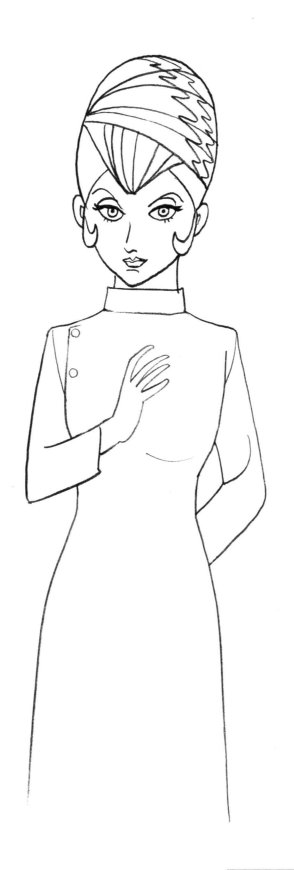

Professor Ishigami (Ryosuke's mother)

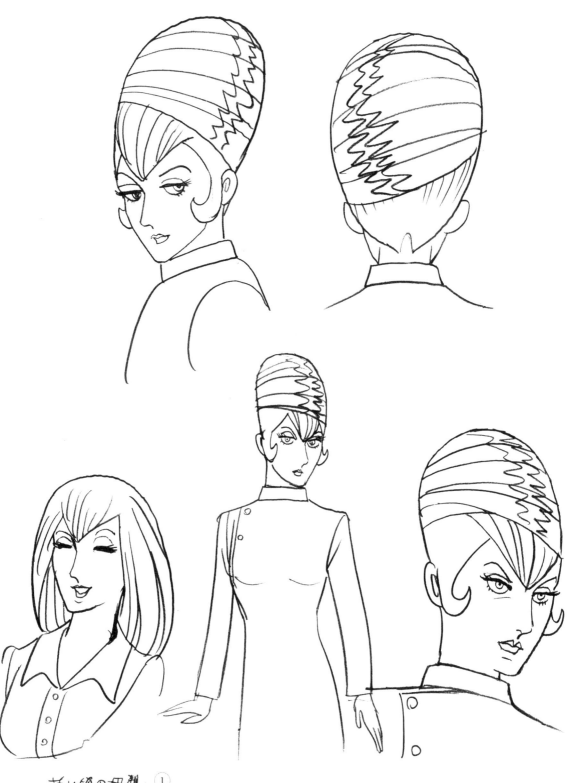

若い頃の母親 ①

1. In her younger years.

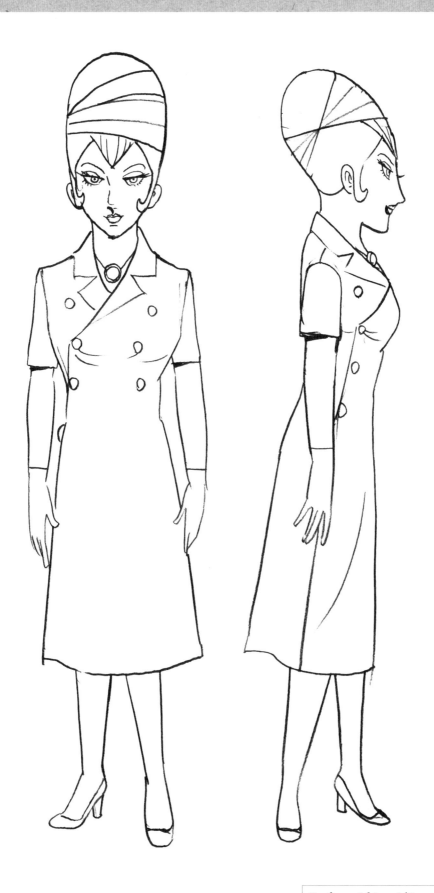

Professor Ishigami (Ryosuke's mother)

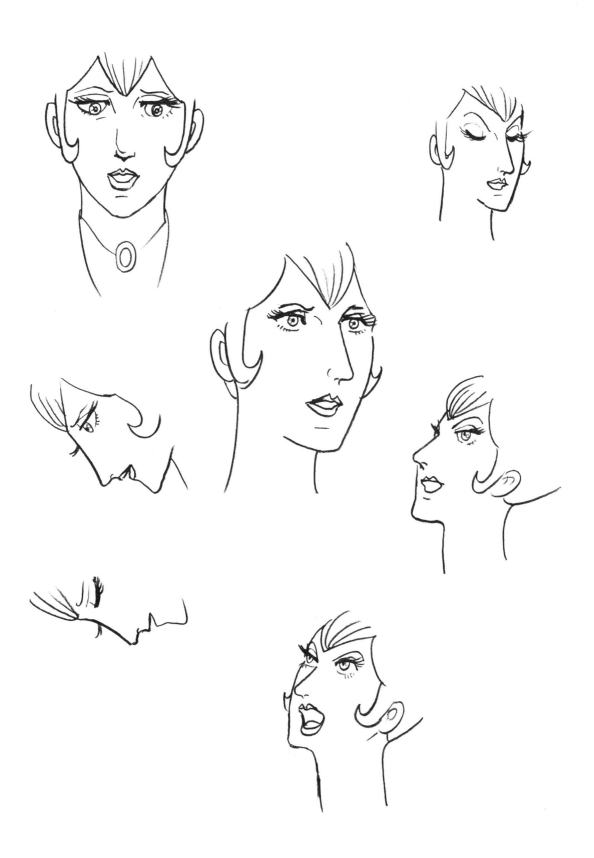

Bagi, the Monster of Mighty Nature

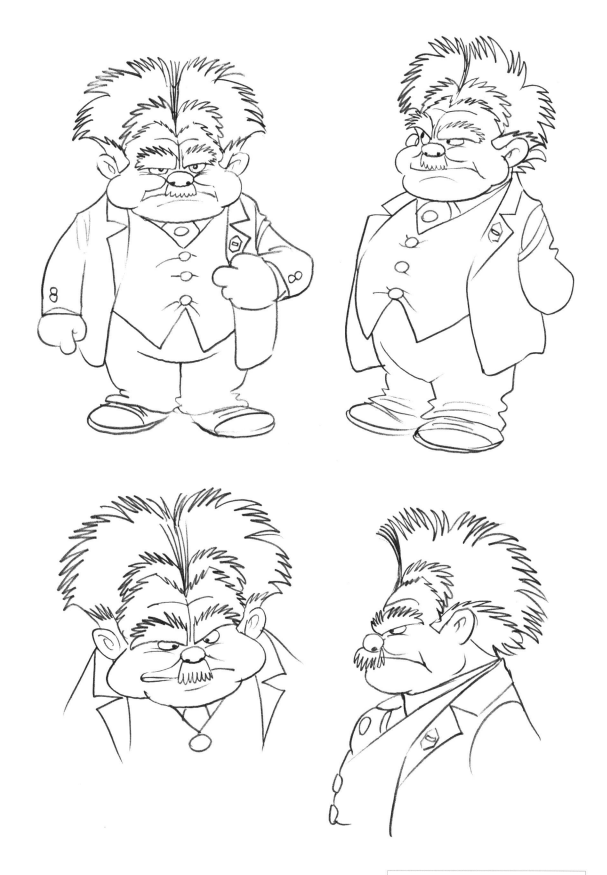

SuperLife Center Chief

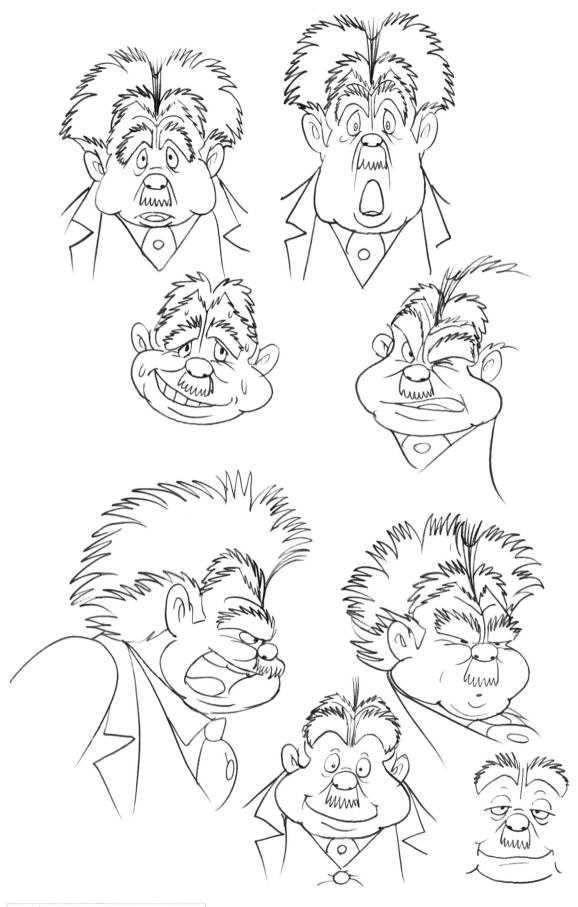

Bagi, the Monster of Mighty Nature

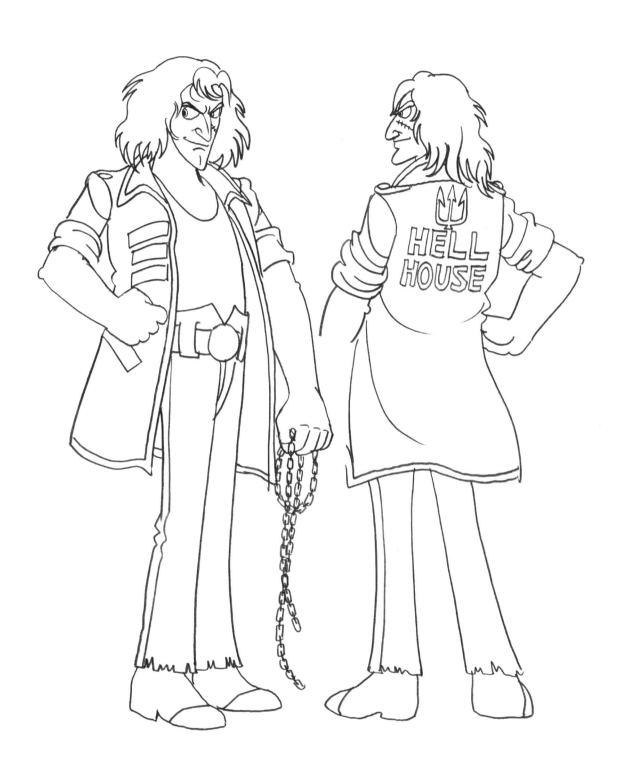

Gang member A (leader)

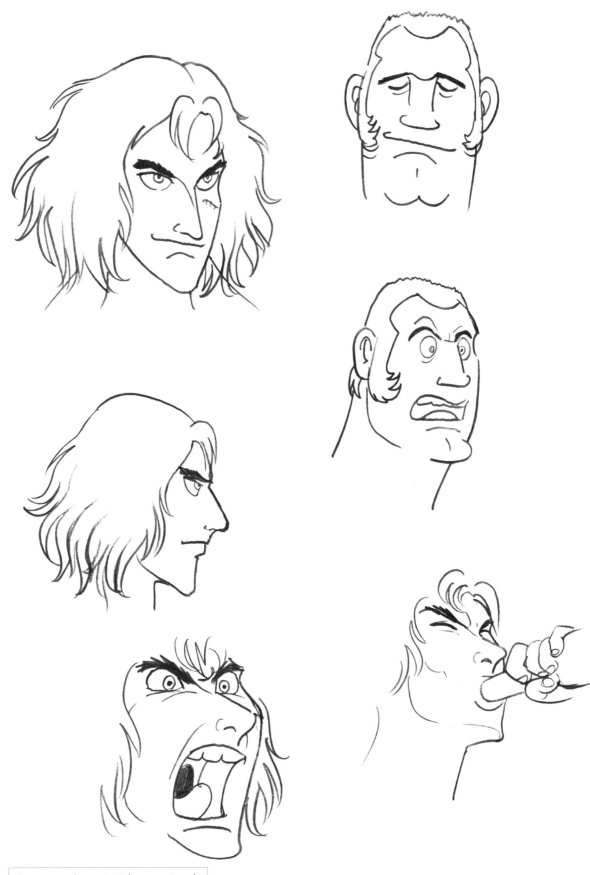

Gang members A, B (expressions)

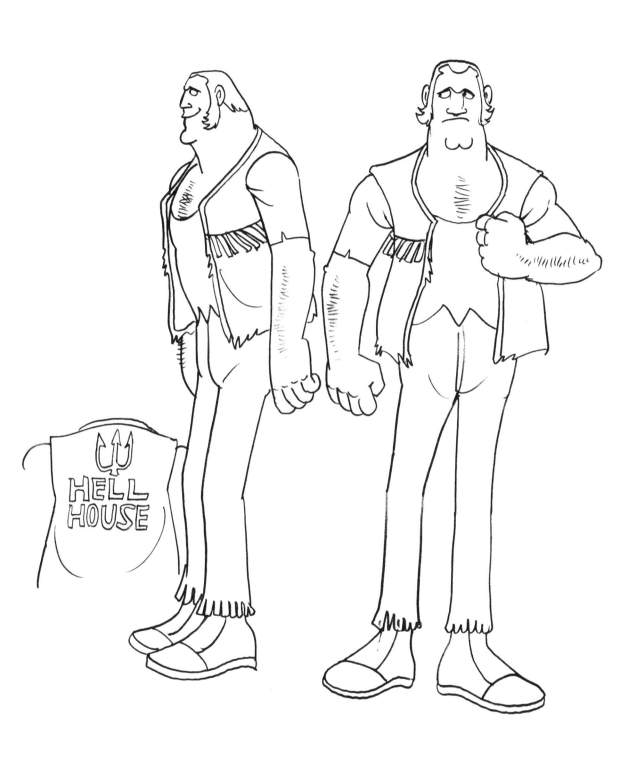

Gang member B

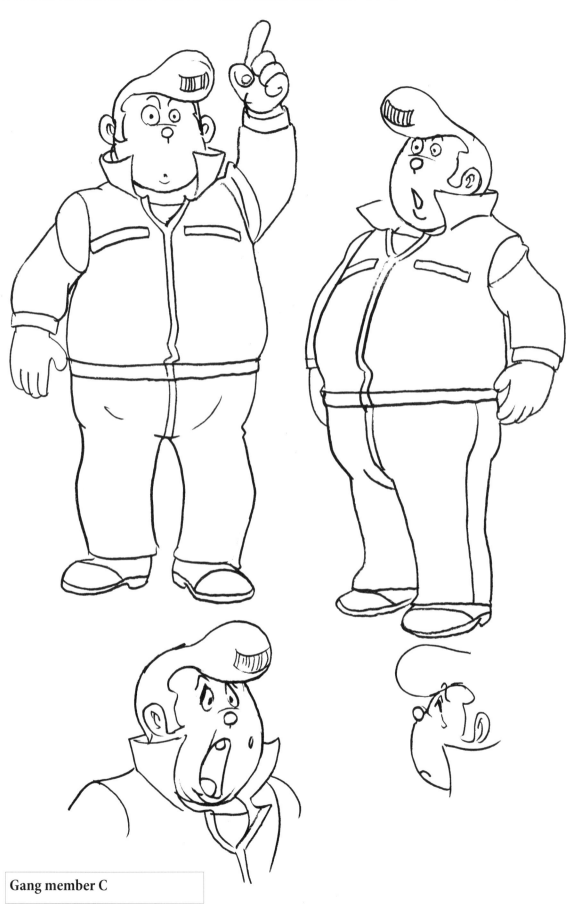

Gang member C

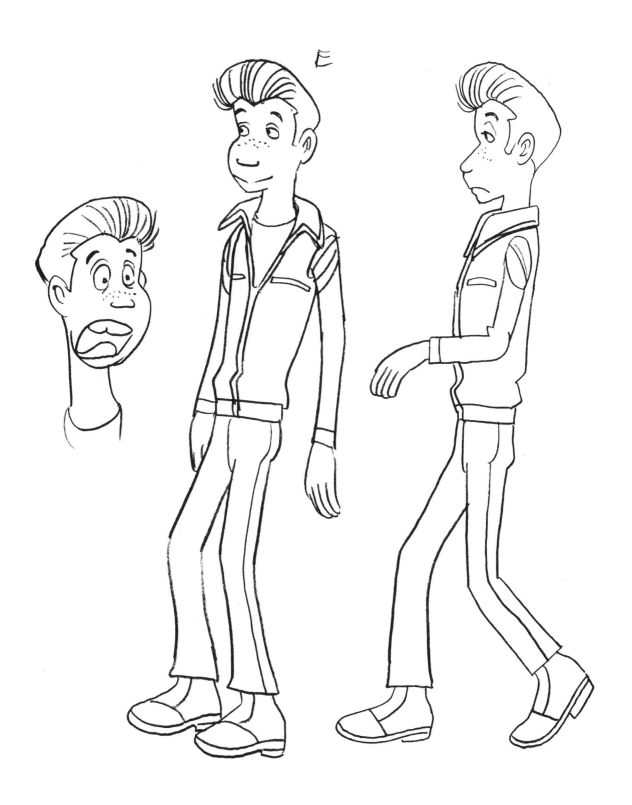

Gang member E

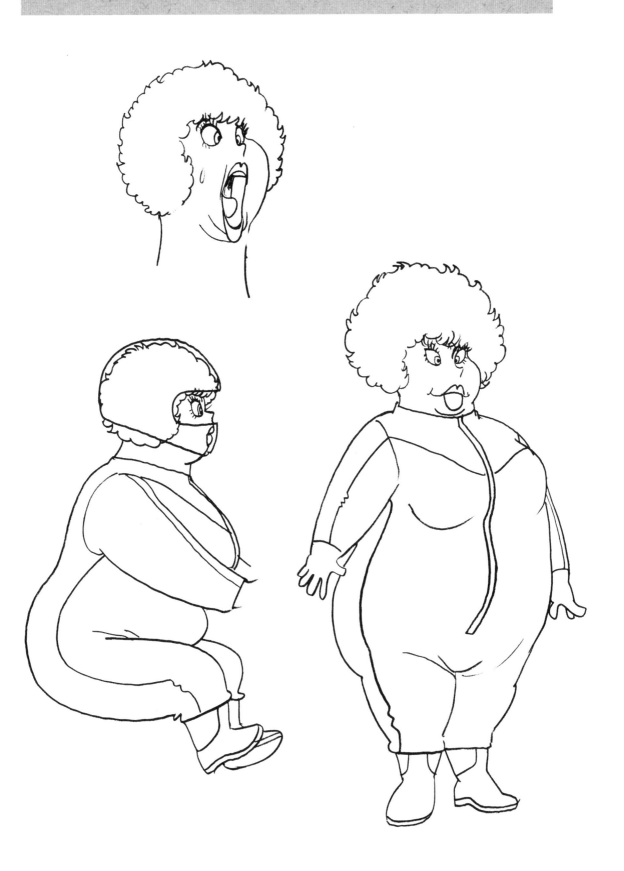

Gang groupie

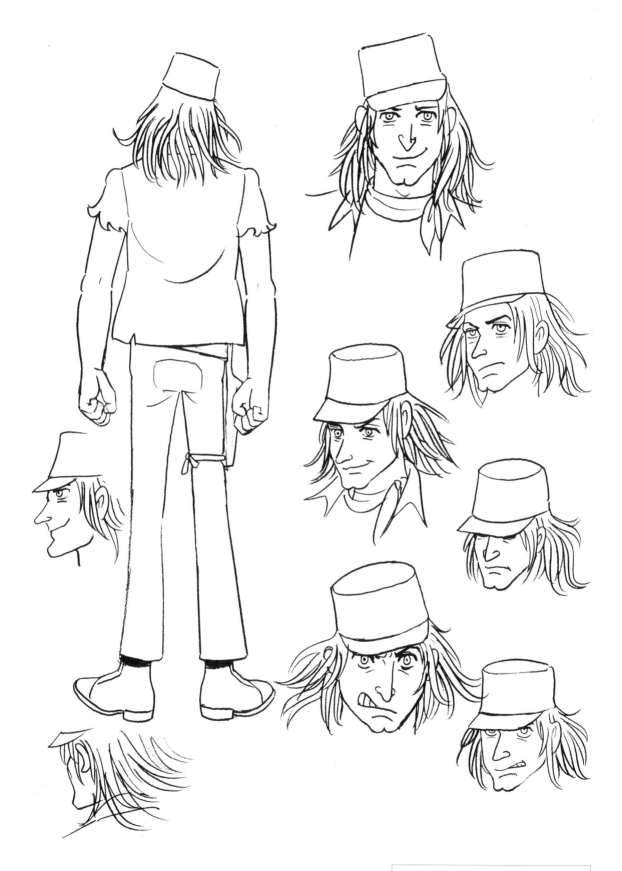

Cemen Bond

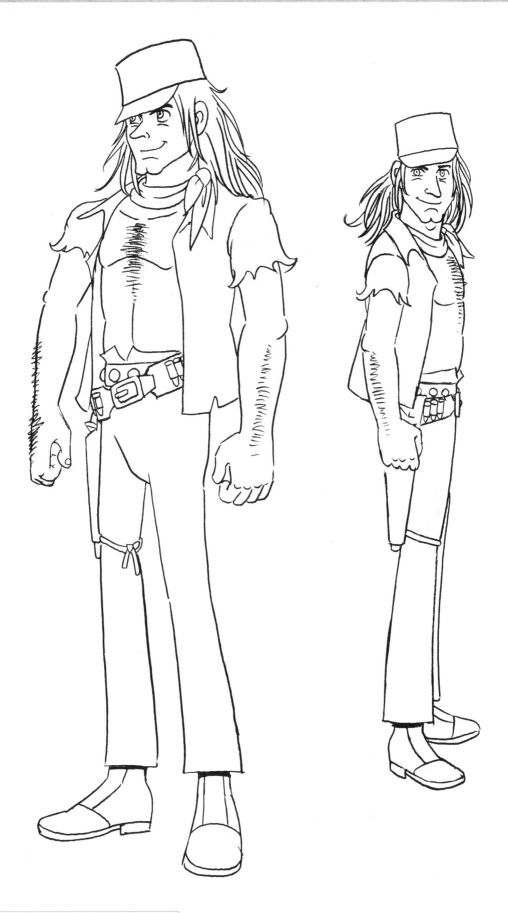

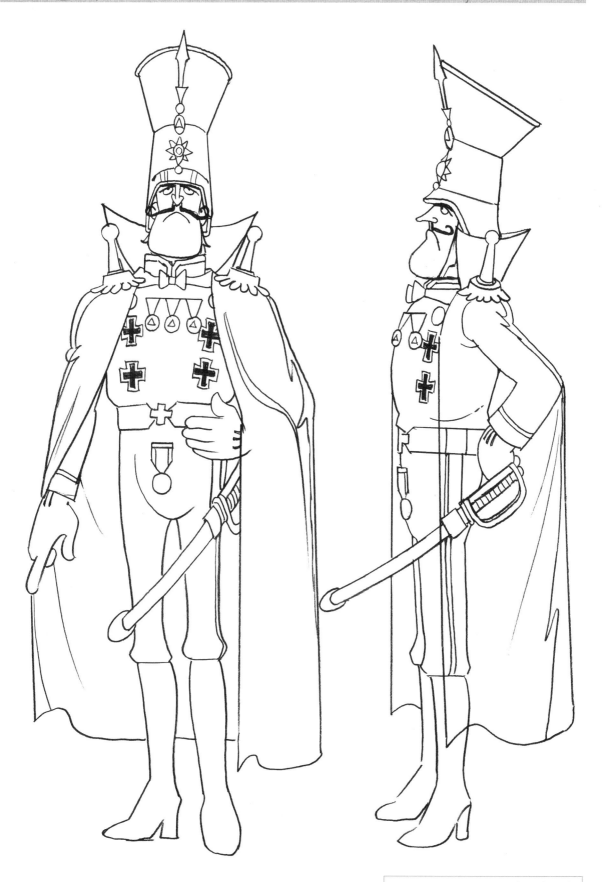

Colonel Sado

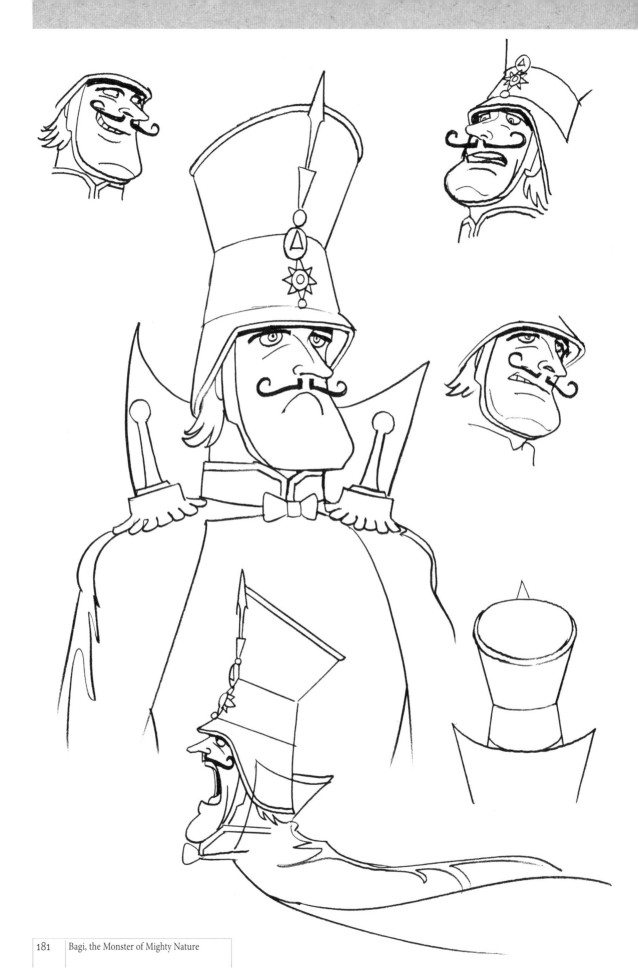

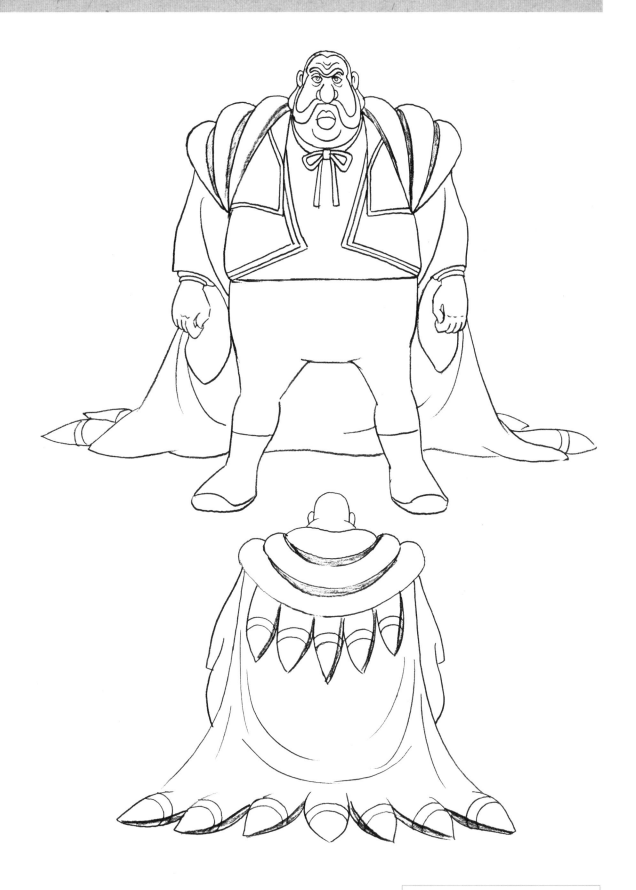

President

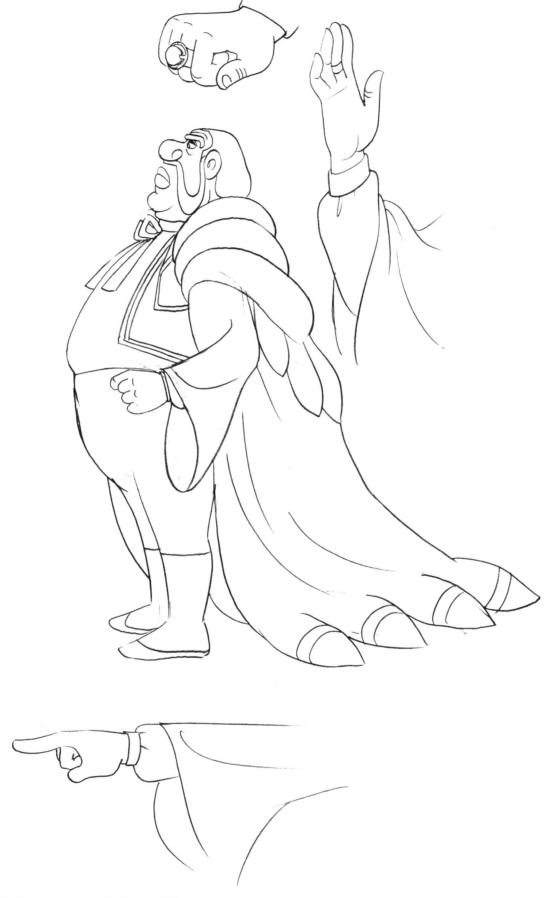

Bagi, the Monster of Mighty Nature

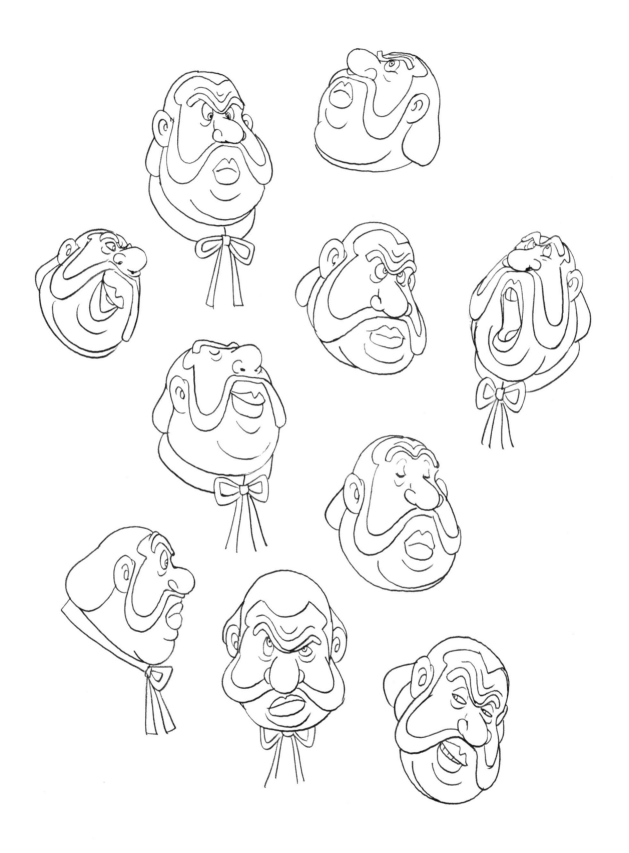

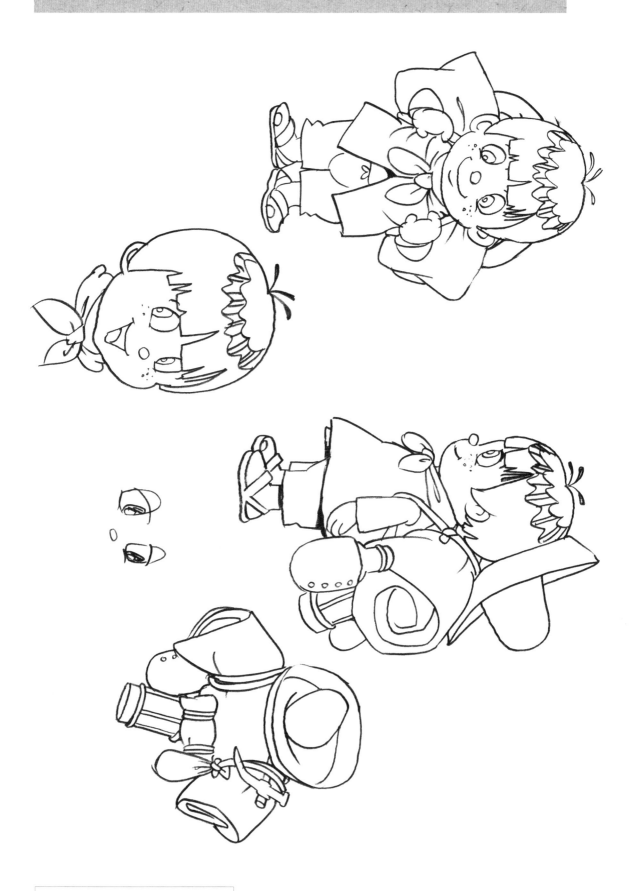

Chico

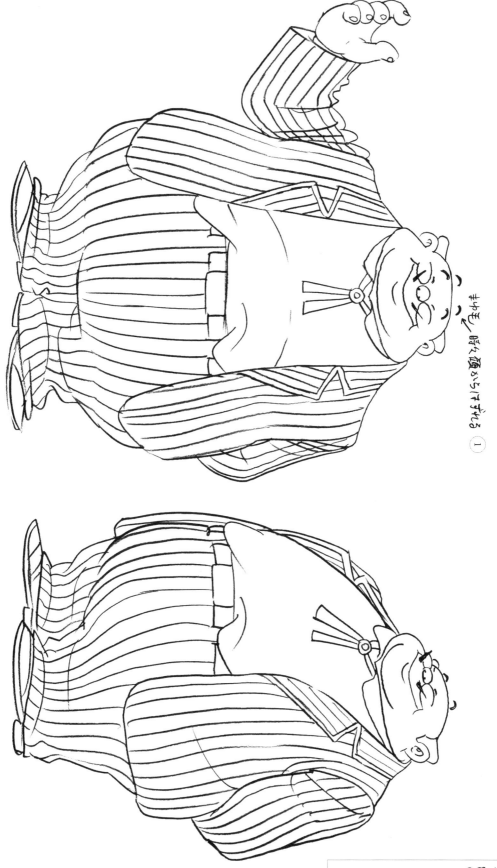

顔が暗く面から引き離れる

①

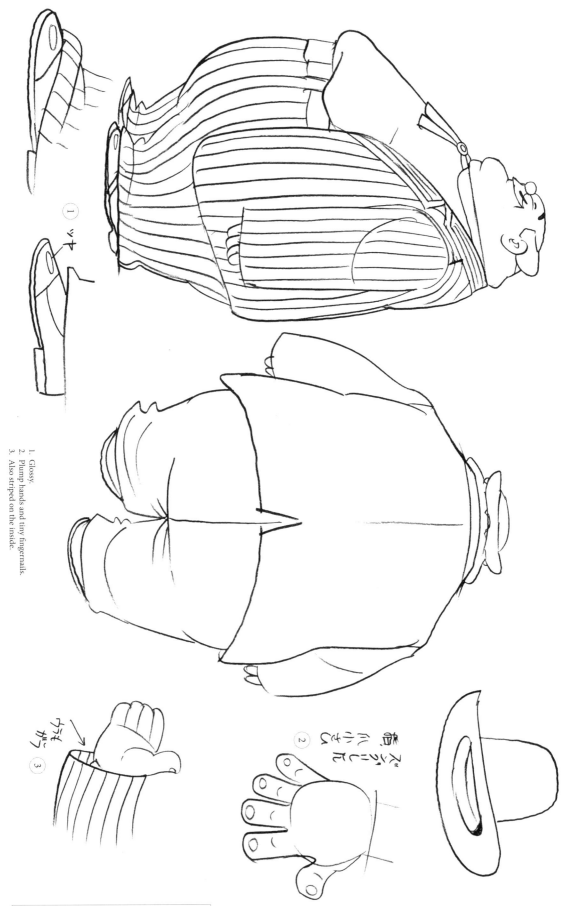

1. Glossy.
2. Plump hands and tiny fingernails.
3. Also striped on the inside.

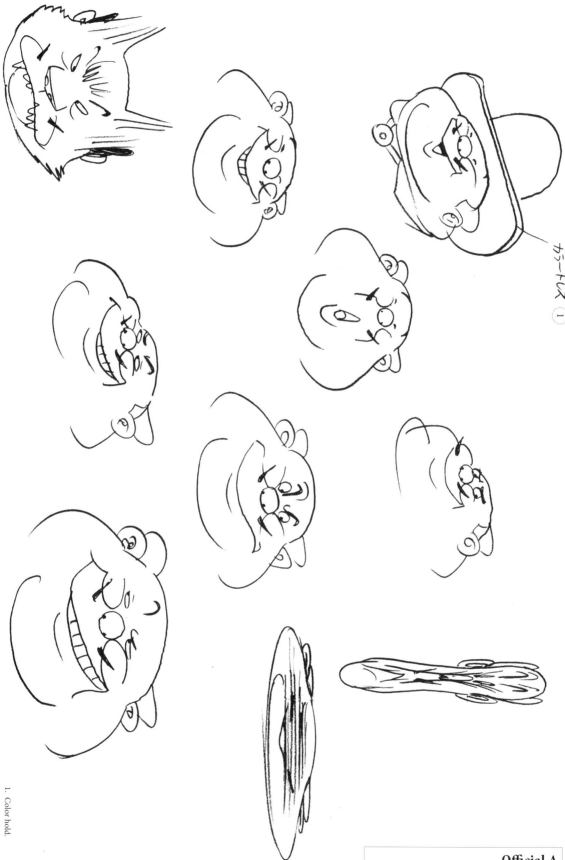

カラートレス ①

1. Color hold.

Official A

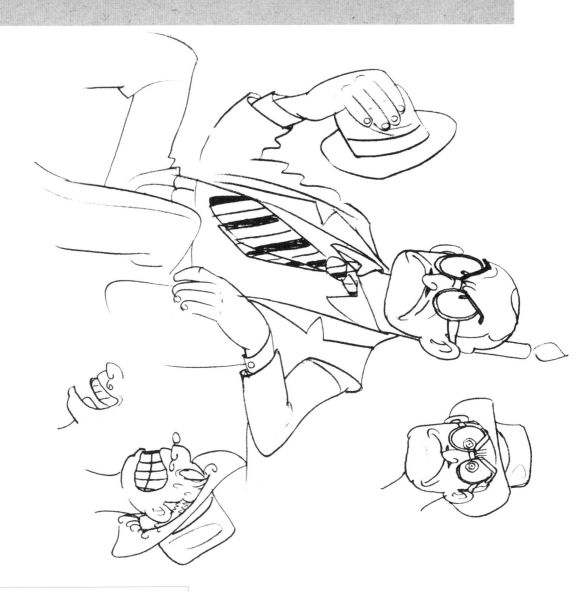

Official B (Lamp)

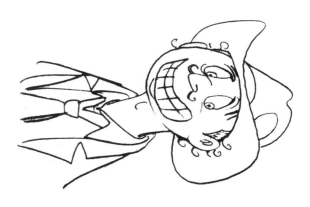

ハゲタ

①

1. Color hold.

Official C (Ham Egg)

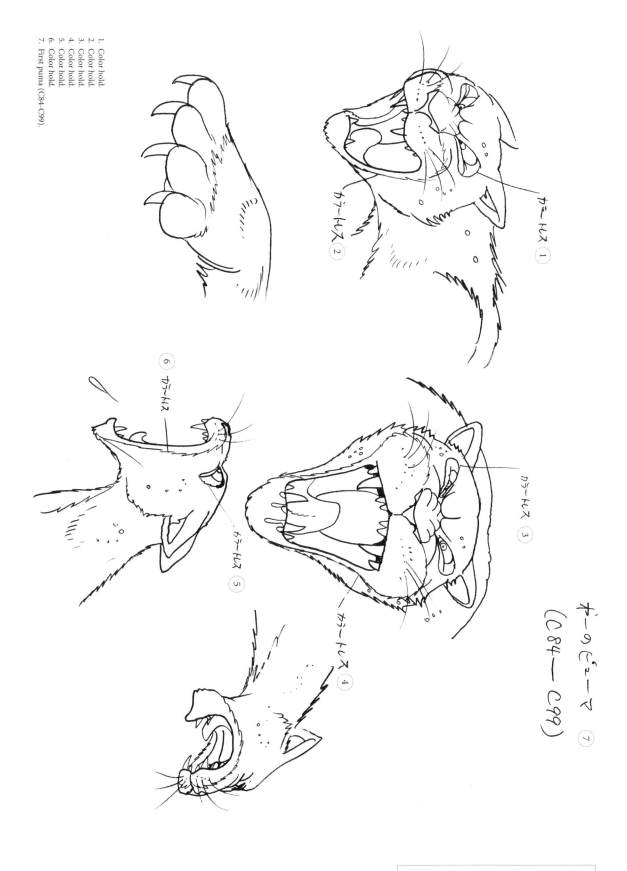

1. Color hold.
2. Color hold.
3. Color hold.
4. Color hold.
5. Color hold.
6. Color hold.
7. First puma (C84-C99).

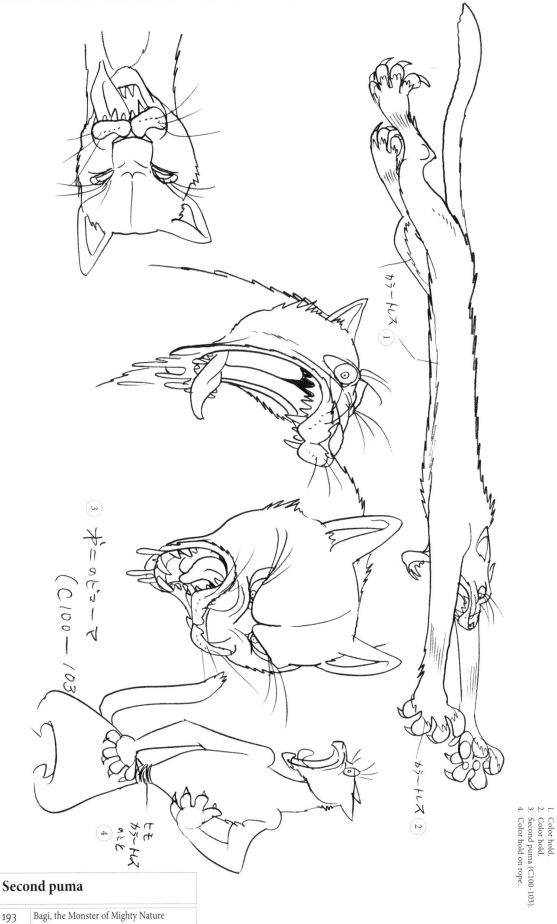

カラーホス ①

オニのピューマ
(C100→103)

カラーホス ②

モモ
カラーホス
あと ④

1. Color hold.
2. Color hold.
3. Second puma (C100-103).
4. Color hold on rope.

Second puma

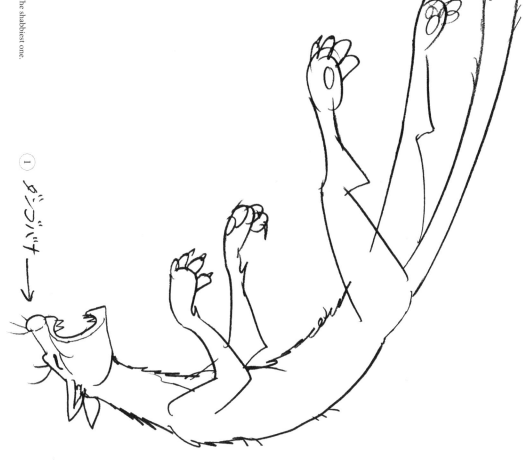

1. Nose like a dango.
2. Third puma. Really just a silhouette. The shabbiest one.

① ダンゴバナ →

② ダミのピューマ
はくんとじルエット
一番みすぼらしい

Third puma

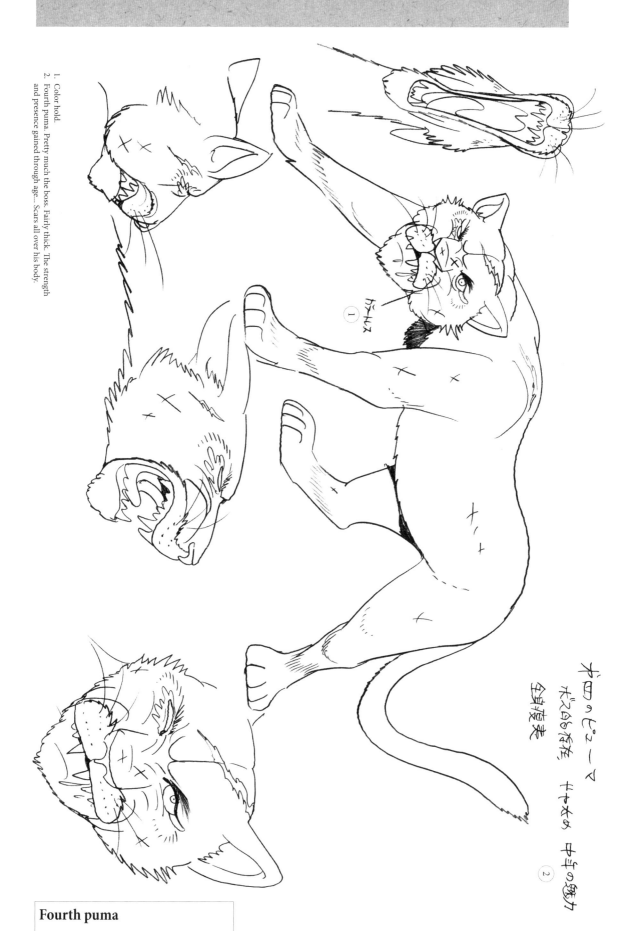

1. Color hold.
2. Fourth puma. Pretty much the boss. Fairly thick. The strength and presence gained through age... Scars all over his body.

Fourth puma

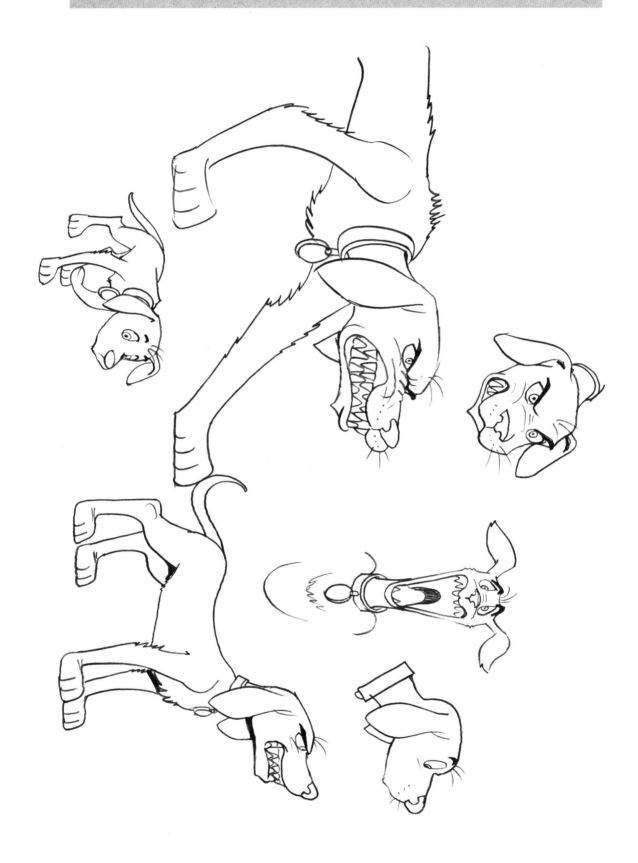

Dog (1)

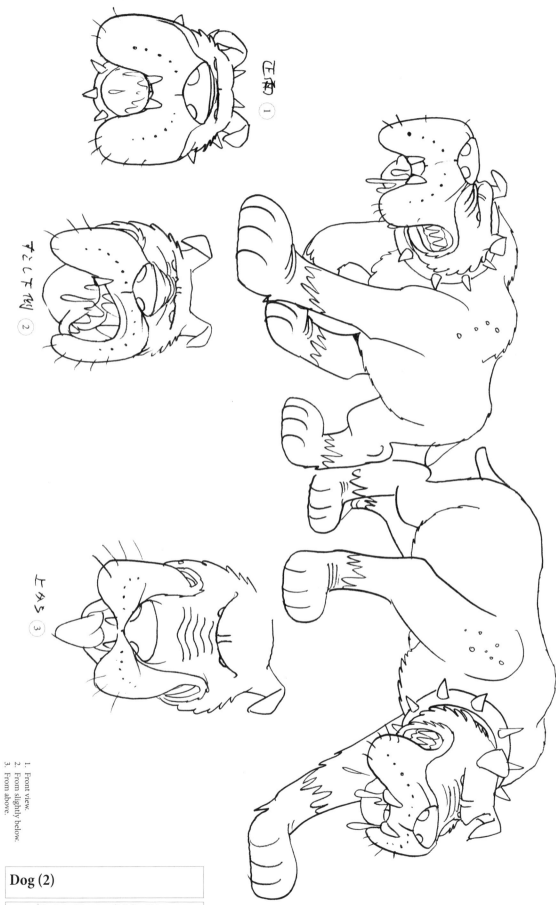

1. 正面 ①
2. すこし下から ②
3. 上から ③

1. Front view.
2. From slightly below.
3. From above.

Dog (2)

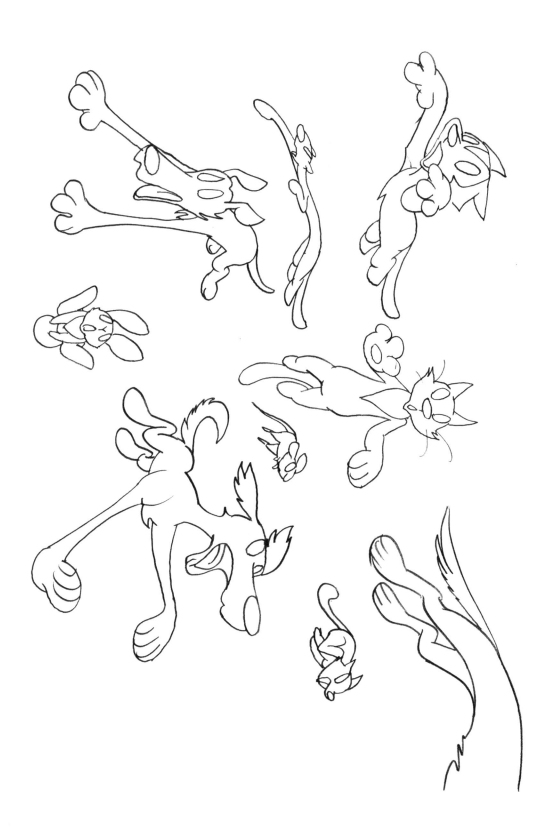

Escaping animals (1)

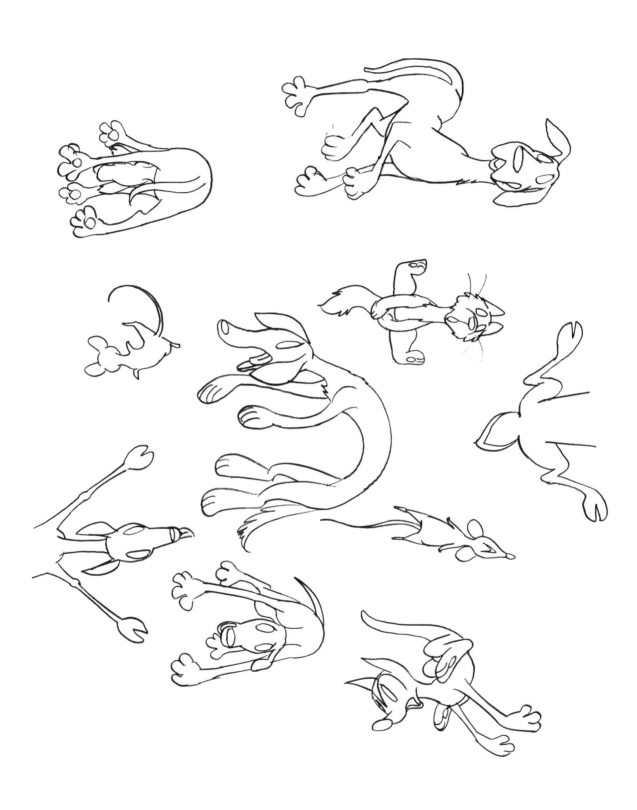

Escaping animals (2)

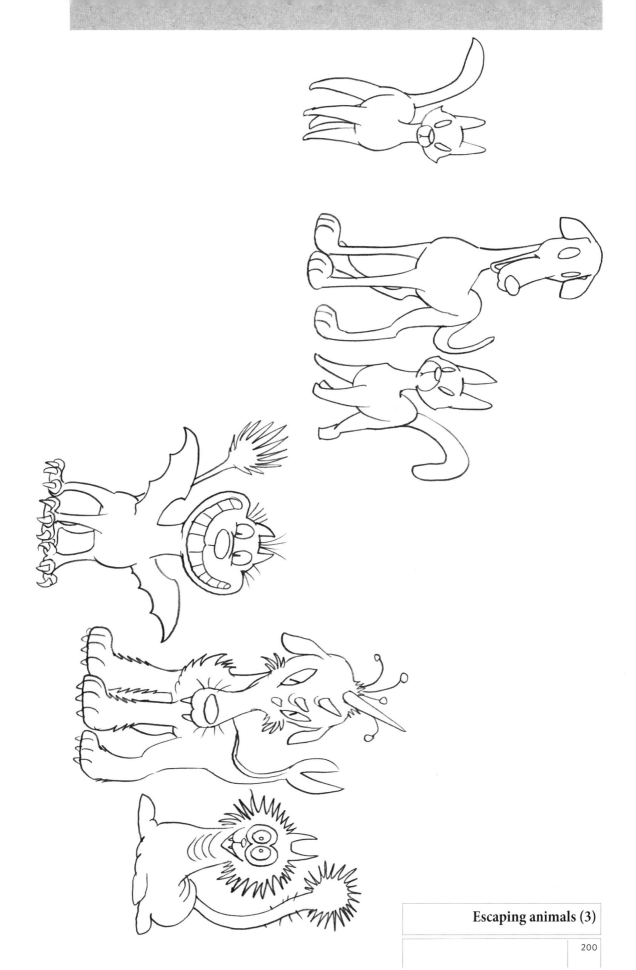

Escaping animals (3)

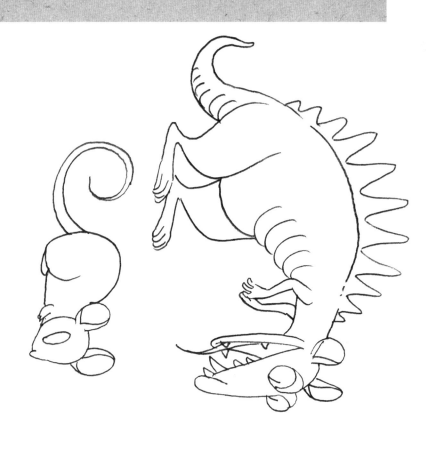

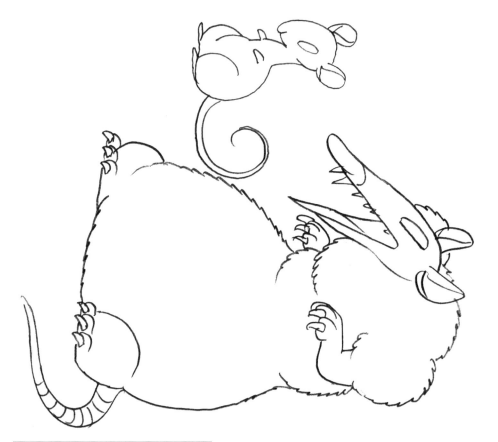

Escaping animals (4)

Bagi, the Monster of Mighty Nature

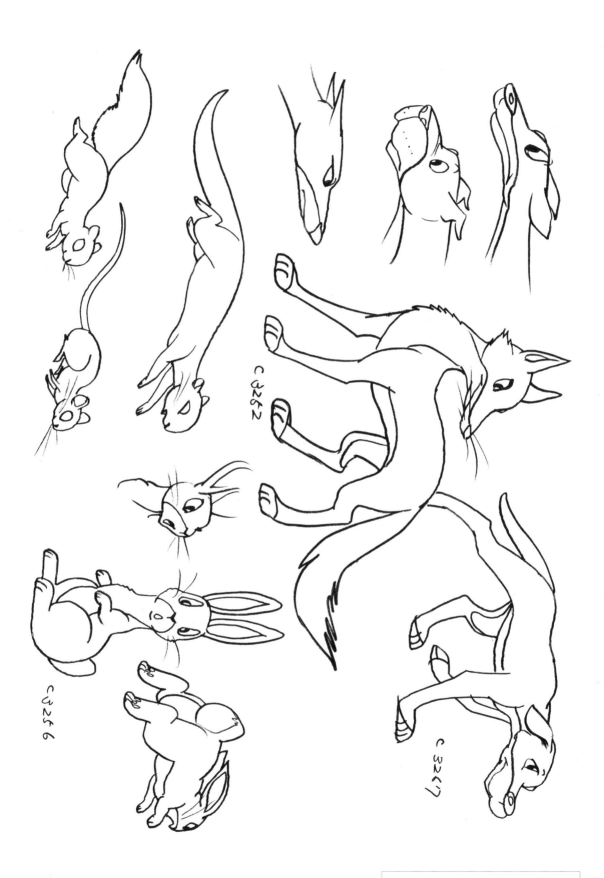

Animal test subjects

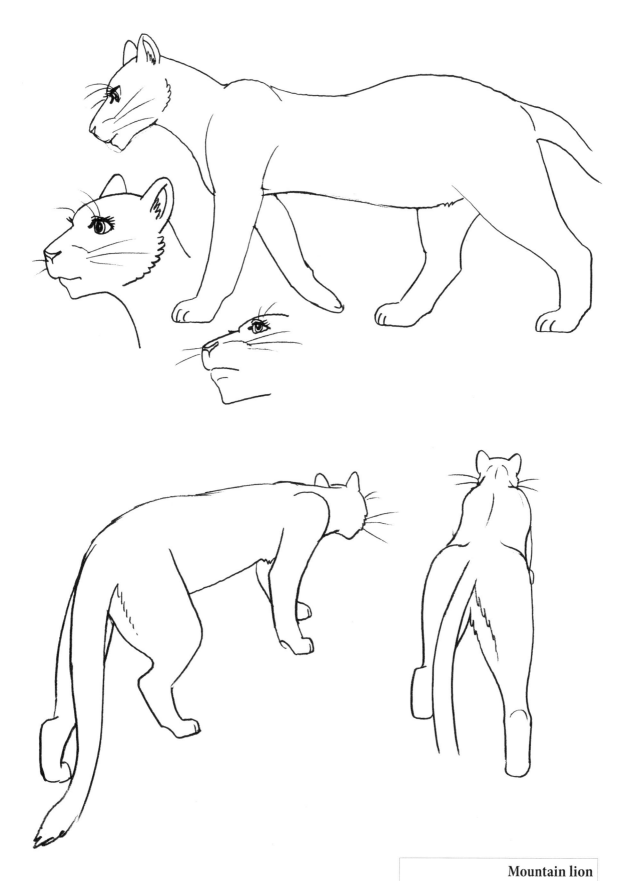

Mountain lion

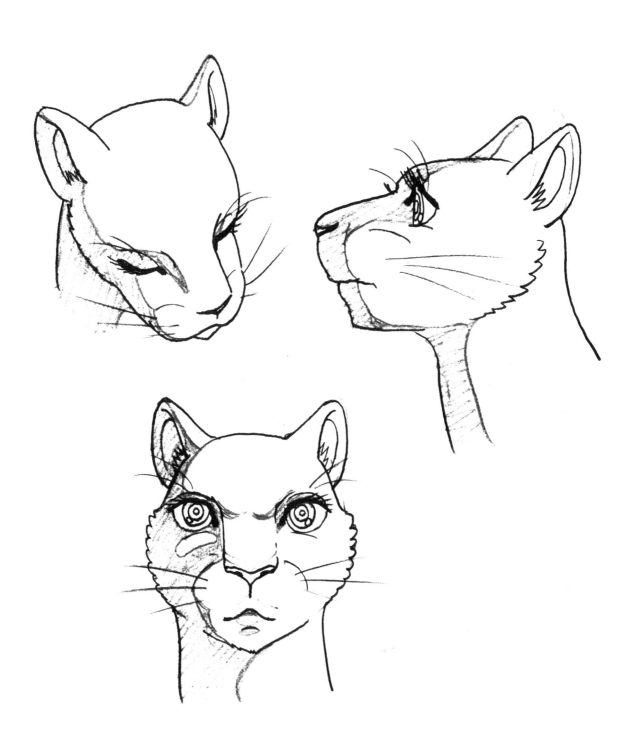

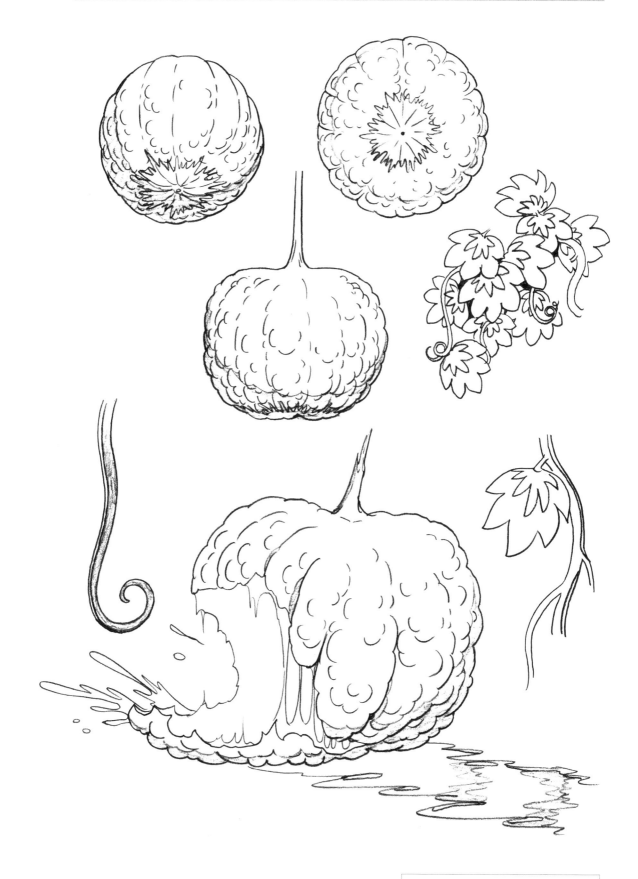

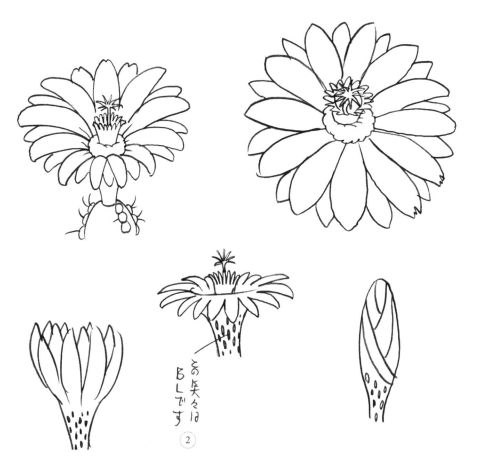

花はカラーのハンドトレスになります
動画 BLでかかないで下さい ①

この矢々は
BLです ②

トロッコの上の 野菜 ③

Cactus flowers

Vegetables in the back of the trolley

1. Flowers should be hand-traced with color. Please don't add black during animation.
2. Make these spots black.
3. Vegetables in the back of the trolley.

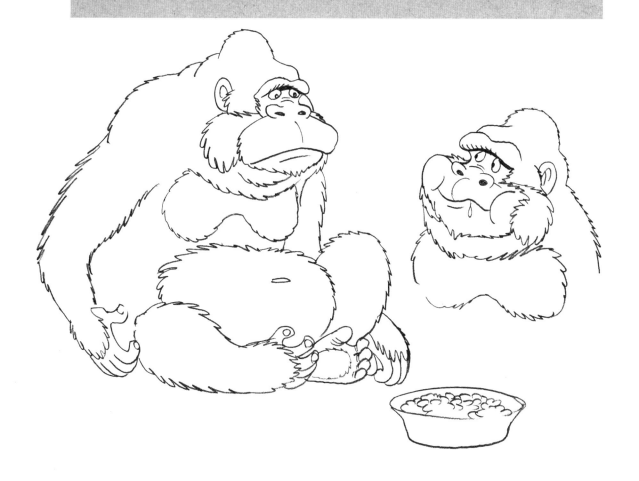

Gorilla test subject

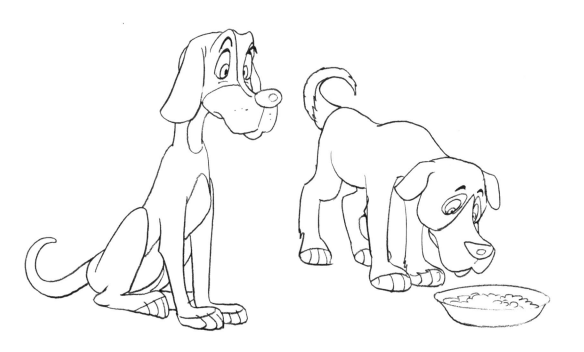

Dog test subject

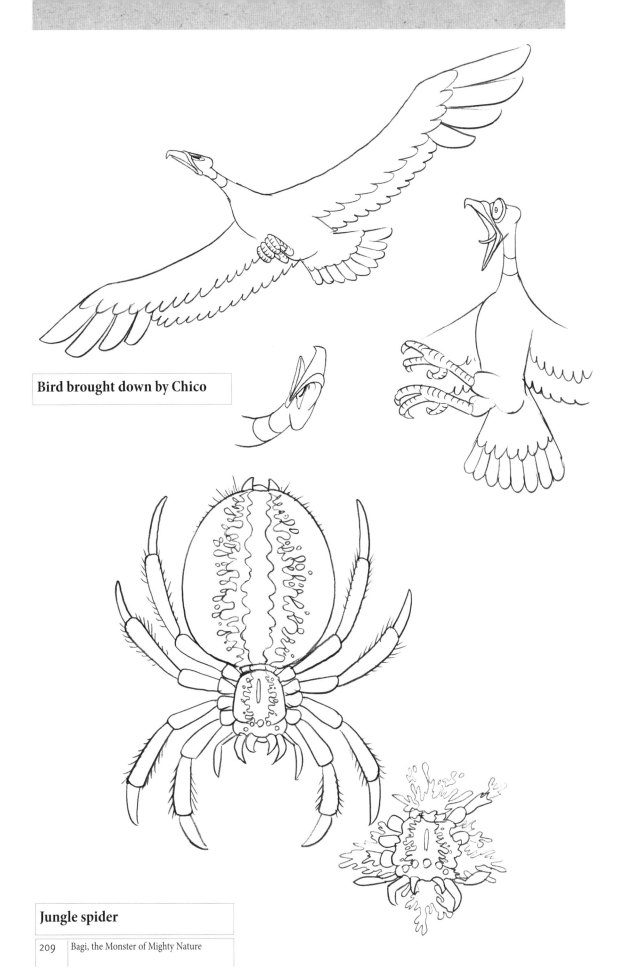

Bird brought down by Chico

Jungle spider

Bagi, the Monster of Mighty Nature

Frilled lizard / Lizard

Centipede / Mole

銀河探査2100年

Aired on Aug. 24th, 1986 on Nippon TV

"GALAXY INVESTIGATION 2100: BORDER PLANET"

BACKGROUND

A two-hour TV anime special that aired during the ninth "24-Hour Television: Love Saves the Earth". Done in omnibus format (with five parts), the characters and basic color palette vary from episode to episode. Although Osamu Tezuka created the concept, directed, and wrote the screenplay, he left most of the creative process to others. As a result, it's been said that the film doesn't feel very "Tezuka-ish". Furthermore, only a small number of the original characters are Tezuka's creations.

SYNOPSIS

Subaru, Purokion, and Mira have all been friends since childhood. Both Subaru and Purokion come to love Mira, but in the end, she marries Purokion. However, Purokion is killed by a disease from space. Mira becomes ill as well, but the disease's advance is stopped when she's put into cryogenic sleep. In order to discover a cure, Subaru sets out to investigate four planets at which the rocket that brought the pathogen had stopped previously.

Concept, Screenplay, Director ◎ Osamu Tezuka

Planning ◎ Tadahiko Tsuzuki

Producers ◎ Hidehiko Takei, Takayuki Matsutani, Hideo Nagai (Tohoku Shinsha)

Music Producer ◎ Kentaro Haneda

Rendition ◎ Osamu Uemura, Shuji Iuchi, Wataru Mukojima, Ryonosuke Natsuki, Mamoru Hamatsu, (support by Kazuhiko Hosaka)

General Animation Director ◎ Shinya Takahashi

Animation ◎ Nobuhiro Okaseko, Sachiko Kamimura

Character Design, Mechanical Design ◎ Shohei Ohara

Art Director, Setting Design ◎ Hageshi Katsumata

Original Art ◎ Yasuhiko Ogata, Hideto Kojima, Akihiro Kanayama, Junji Kobayashi, Kaoru Kano, Komasa, Yasuhiro Seo, Toshi Noma, Shinji Seya, Takafumi Hayashi, Takatsuna Senba, Masateru Yoshimura, Yutaka Tanizawa

Backgrounds ◎ Sadakazu Akashi, Setsuko Ishizu, Taro Ito, Masami Saito, Tetsuto Shimono and others

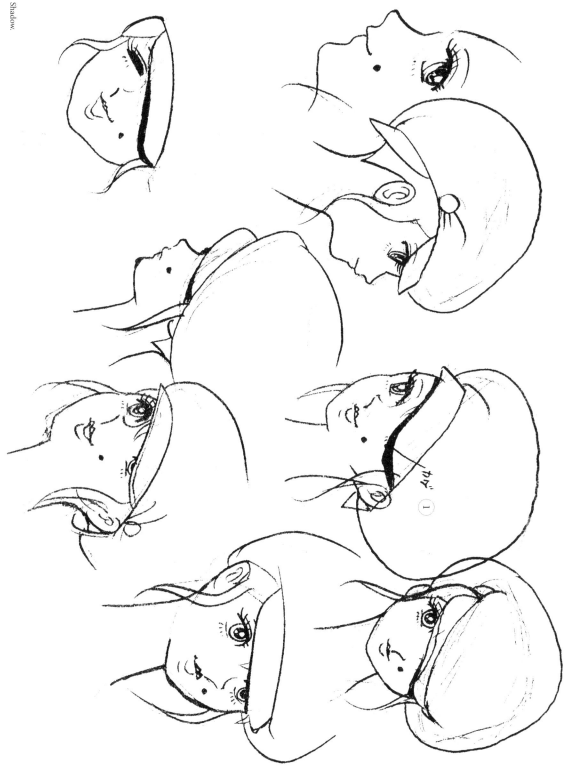

Michelle

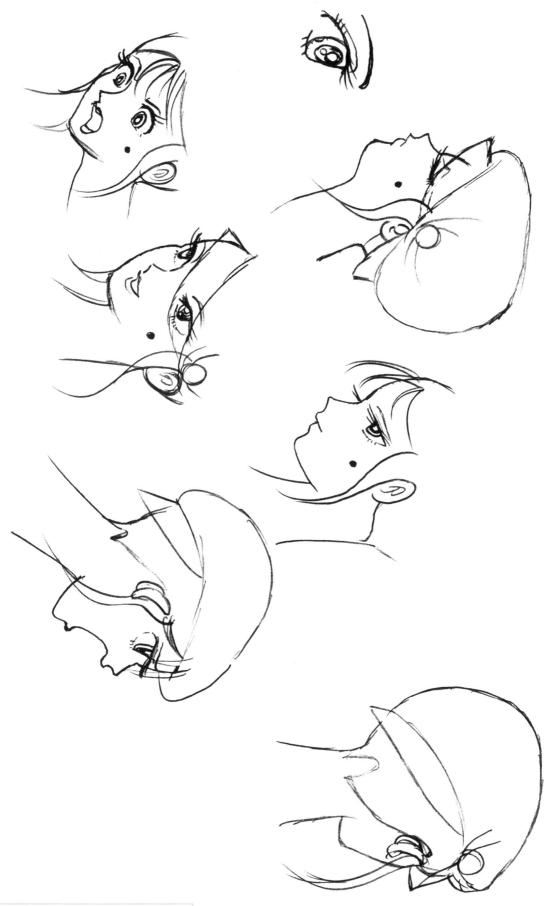

Michelle

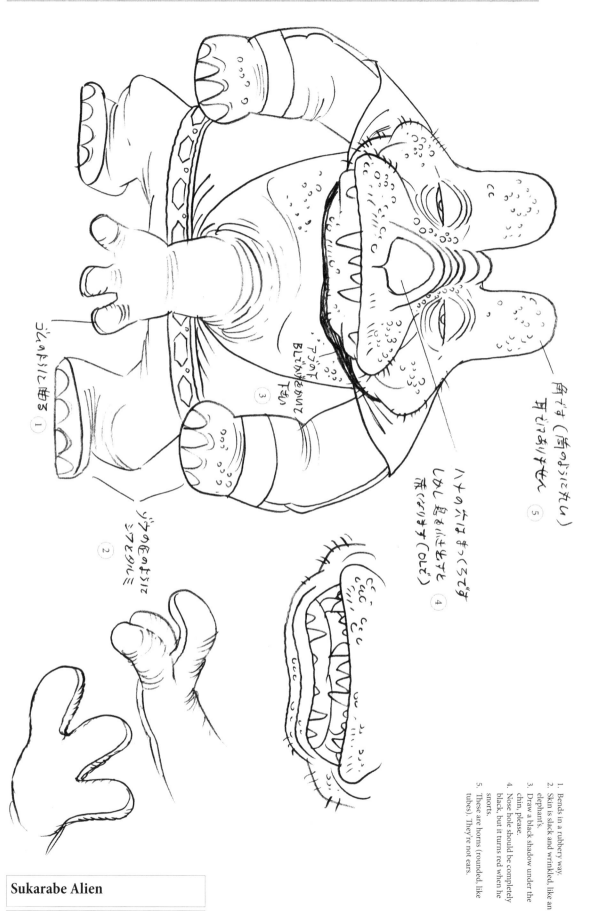

1. Bends in a rubbery way.
2. Skin is slack and wrinkled, like an elephant's.
3. Draw a black shadow under the chin, please.
4. Nose hole should be completely black, but it turns red when he snorts.
5. These are horns (rounded, like tubes). They're not ears.

Sukarabe Alien

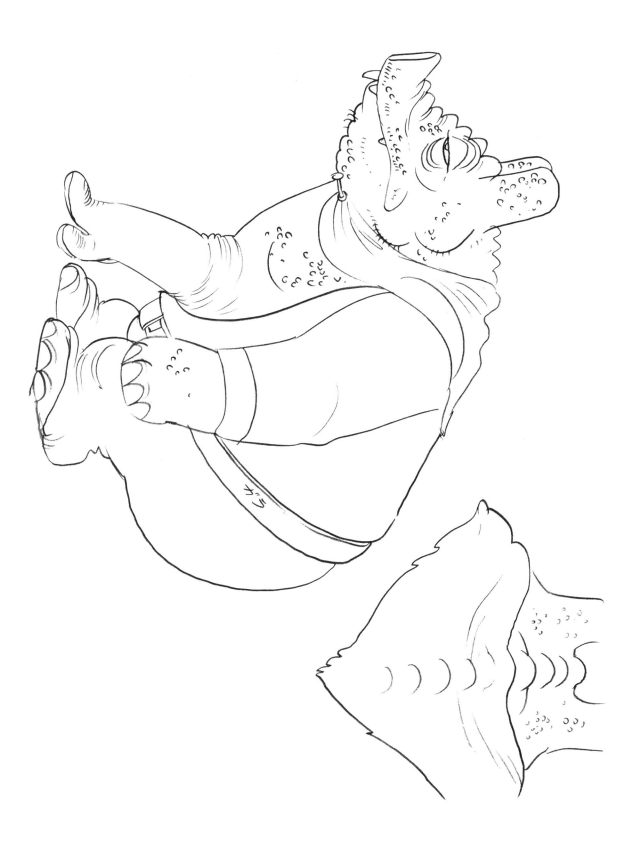

Sukarabe Alien

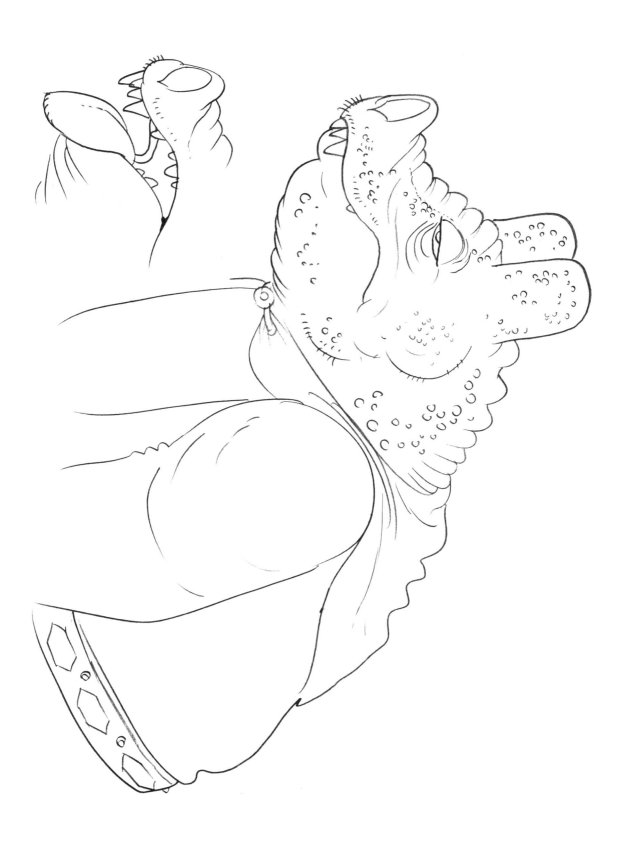

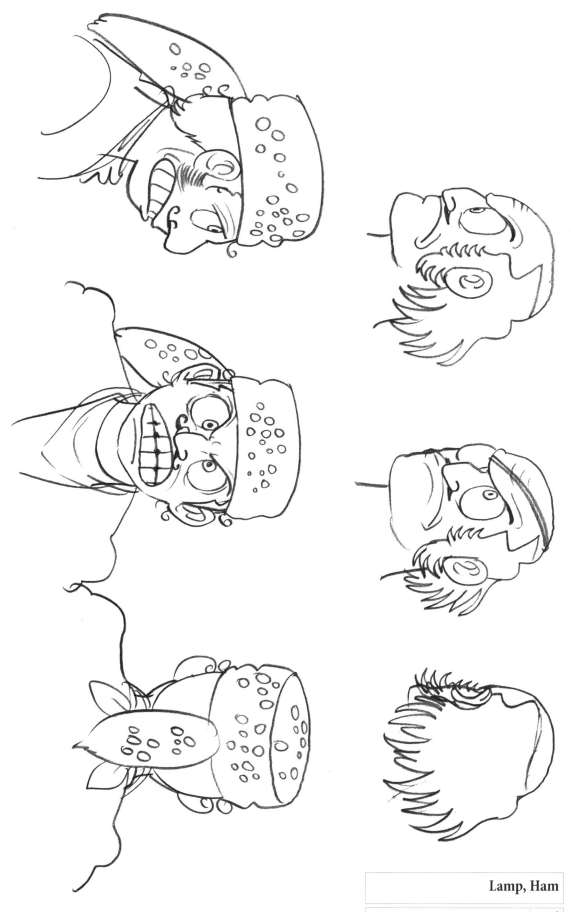

Lamp, Ham

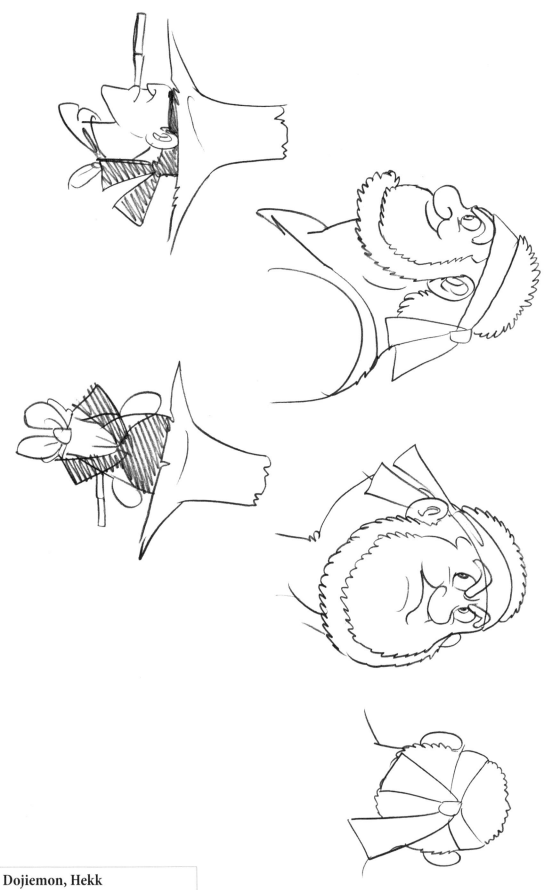

Dojiemon, Hekk

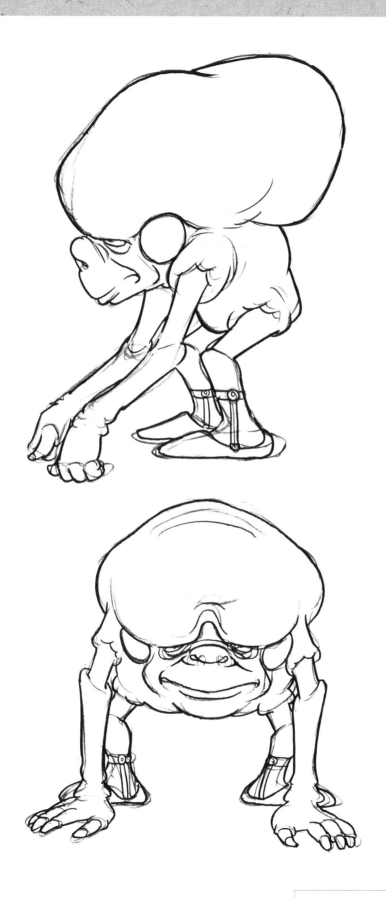

Fully-grown Bronzeman

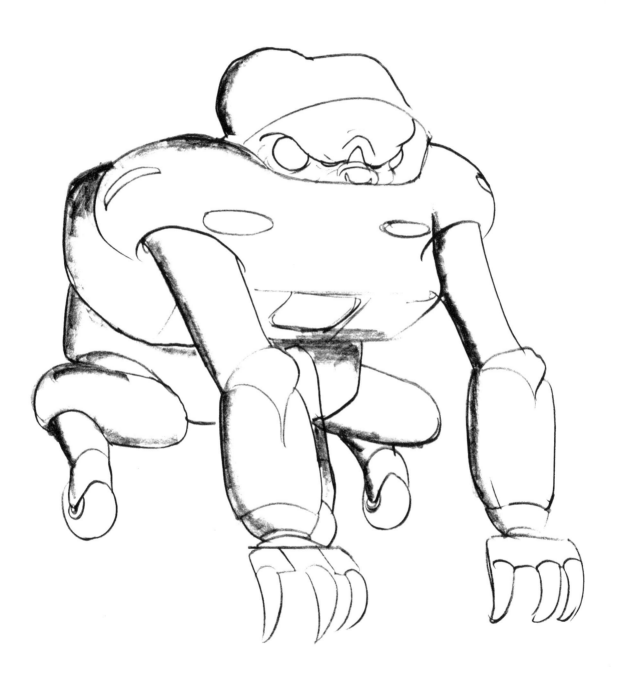

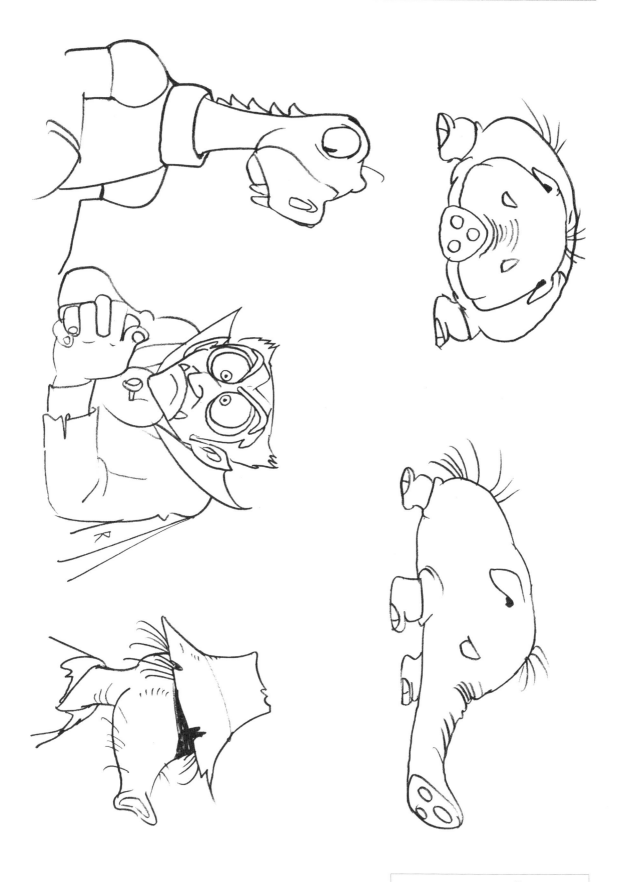

AFTERWORD

HARUJI MORI
Chief Archivist, Tezuka Productions

Within this book are sketches of the various characters from the two-hour TV anime specials than ran during Nippon TV's annual charity segment, "24-Hour Television: Love Saves the Earth". These sketches - or designs, even - would become the creative basis for the animators as they drew art and created animations for the films. Osamu Tezuka created a large number of original characters for this film series, so we planned this book as a way to introduce them all. More surprising than just the sheer number of supporting characters, though, is the diversity of creatures and beasts, which speaks to Osamu Tezuka's love of animals. Many of these characters appear only in single scenes, so most have not received anywhere near the level of exposure of the more prominent leading characters. As such, we've tried to showcase at least a portion of these, which could be considered Osamu Tezuka's "unknown works".

Osamu Tezuka stopped producing anime after the 1973 bankruptcy of his studio, Mushi Productions. However, the stunning successes of his manga series, such as "Black Jack" (serialized in Weekly Shonen Champion) and "The Three-Eyed One" (serialized in Weekly Shonen Magazine), brought him such popularity that Nippon TV commissioned him to create the first two-hour TV anime special for their "Love Saves the Earth" charity segment. This first special, "One Million-Year Trip: Bander Book", drew in a record-setting 24.7% of viewers in Tokyo, despite the fact that it aired on a Sunday afternoon. Thanks to the success of "Bander Book", the two-hour anime films were made into an annual series.

Nevertheless, there were years when Osamu Tezuka was not involved. In 1980, for instance, Osamu Tezuka was too busy to create a film for the series, so he entrusted the matter to Hisashi Sakaguchi, who had already proven himself with "Bander Book". Sakaguchi created "Fumoon", based on Osamu Tezuka's 1951 manga "Nextworld".

Osamu Tezuka was once again otherwise occupied in 1982, so Toei Doga Studios (now Toei Animation) created an anime version of the science-fiction manga "Andromeda Stories" (written by Ryu Mitsuse and illustrated by Keiko Takemiya).

For 1985's film, Osamu Tezuka wrote a synopsis of his hit manga "The Three-Eyed One" to be used as the basis for an anime adaptation by Toei Doga Studios.

No anime was aired in 1987 or 1988, but the 1989 revival brought about "The Tale of Osamu Tezuka: My Son Goku". However, Osamu Tezuka fell ill that year, so he could not contribute to the project beyond discussing the plot. Osamu Tezuka passed away in February of 1989, but Tezuka Productions used his ideas as well as his manga "My Son Goku" (serialized in Manga King from February 1952 to March 1953) to complete production of the aforementioned anime film.

Osamu Tezuka's original anime films for this series are as follows:

1978: "One Million-Year Trip: Bander Book"

1979: "Undersea Super Train: Marine Express"

1980: "Fumoon"

1981: "Bremen 4: Angels in Hell"

1983: "A Time Slip of 10,000 Years: Prime Rose"

1984: "Bagi, The Monster of Mighty Nature"

1985: "The Three-Eyed One: Prince of Devil Island"

1986: "Galaxy Investigation 2100: Border Planet"

1989: "The Tale of Osamu Tezuka: My Son Goku"

Osamu Tezuka created characters for stories beyond the ones showcased here, of course. A portion of those characters appears in Osamu Tezuka: Design Works (published by Shogakukan Creative, Inc. on May 27th, 2013), so please be sure to enjoy that book as well.

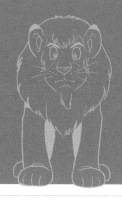

OSAMU TEZUKA'S ANIMATION CHARACTER ILLUSTRATIONS

JAPANESE EDITION CREDITS

Author
OSAMU TEZUKA

Publisher
HIROSHI SATO

ENGLISH EDITION CREDITS

English Translation
CALEB D. COOK

Copy Editing
ASH PAULSEN

Layout and Design Adaptation
MATT MOYLAN

UDON STAFF
Chief of Operations: ERIK KO
Director of Publishing: MATT MOYLAN
Senior Editor: ASH PAULSEN
VP of Sales: JOHN SHABLESKI
Senior Producer: LONG VO
Marketing Manager: JENNY MYUNG
Production Manager: JANICE LEUNG
Japanese Liaison: STEVEN CUMMINGS

TEZUKA OSAMU ANIME CHARACTER SETTEI GASHU © Osamu Tezuka
2014 Originally published in Japan in 2014 by Shogakukan Creative INC, Tokyo.
English translation rights arranged with Shogakukan Creative INC, Tokyo,
through TOHAN CORPORATION, Tokyo.

Published by UDON Entertainment Corp., 118 Tower Hill Road, C1,
PO Box 20008, Richmond Hill, Ontario, L4K 0K0 CANADA

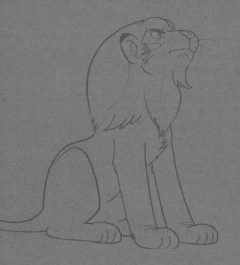

www.UDONentertainment.com

First Printing: October 2015
ISBN-13: 978-1-927925-38-6
ISBN-10: 1-927925-38-X

Printed in Hong Kong